IMAGES
of America

CLEVELAND CZECHS

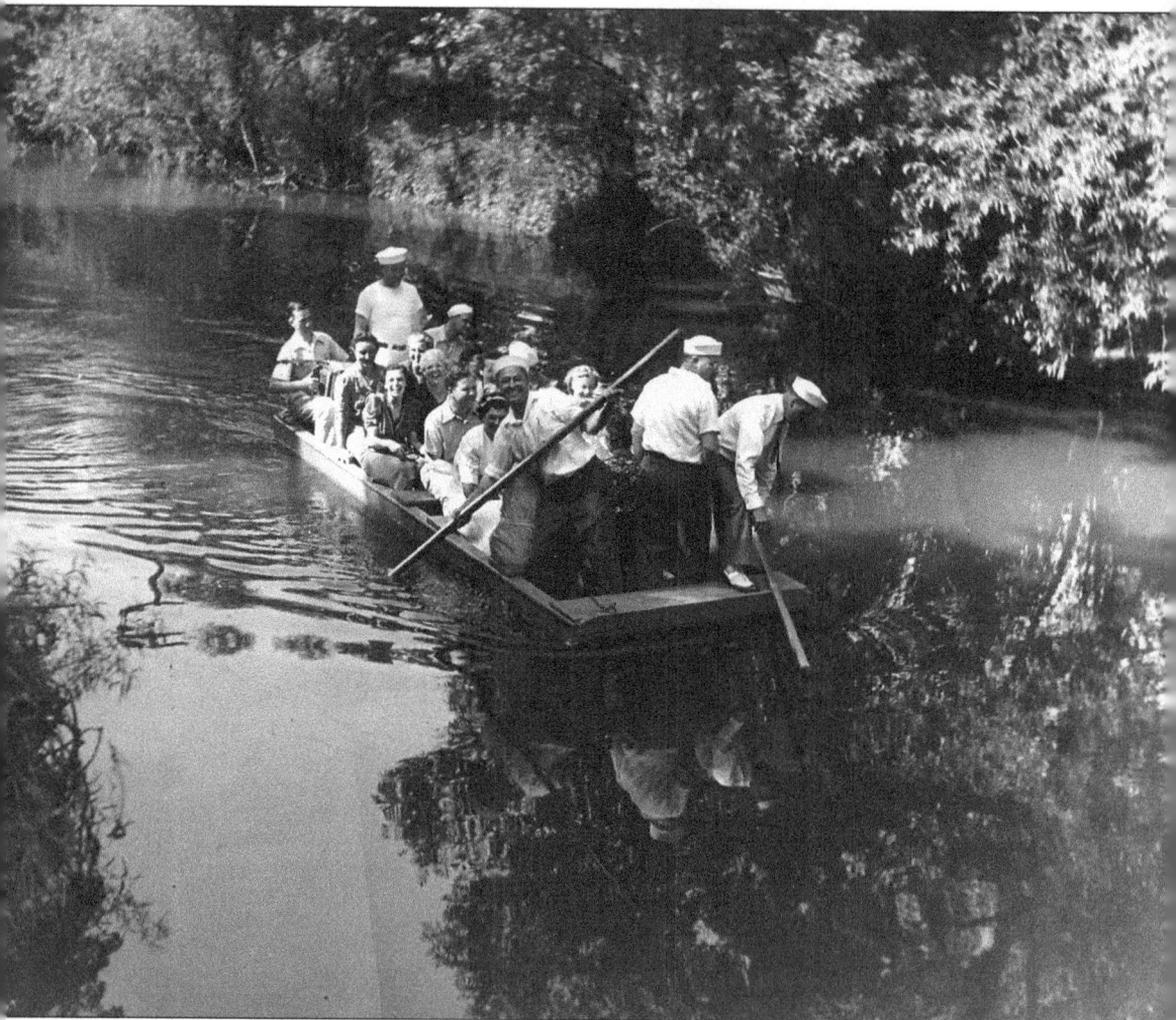

The Odd Fellows Fresh Air Camp in Glenwillow is a frequent gathering place not only for the mainly Czech unit of the International Order of Odd Fellows but also for many others in the Czech community. Shown here is a group from the 1950s in a boat propelled from the front by Charles Kubelik. (Courtesy of Sokol Greater Cleveland.)

On the cover: Part of the annual exhibitions at Delnicka Telocvicna Jednota (DTJ) has been the ladies program, which features women in old-country costumes re-creating the dancing traditions that their parents brought to the United States. (Courtesy of DTJ Historical Archives.)

IMAGES
of America

CLEVELAND CZECHS

John T. Sabol and Lisa A. Alzo

ARCADIA
PUBLISHING

Published by Arcadia Publishing
Charleston, South Carolina

Library of Congress Control Number: 2008920506

For all general information contact Arcadia Publishing at:
Telephone 843-853-2070
Fax 843-853-0044
E-mail sales@arcadiapublishing.com
For customer service and orders:
Toll-Free 1-888-313-2665

Visit us on the Internet at www.arcadiapublishing.com

*To members of the Cleveland Czech community, who helped
to make this "their" book, and to Jeanne Sabol, who helped
in more ways than she can imagine to make this book possible.*

CONTENTS

ACKNOWLEDGMENTS

To say this book is a collaborative effort is more than an understatement. Besides the mutual thanks that the authors owe each other, a great many other individuals deserve recognition because of their continuing efforts to keep the Czech spirit alive.

The following organizations and individuals played key roles by sharing their histories and providing—at times—much-needed guidance and patience during the photo- and history-gathering process. We are most grateful to the following individuals and organizations for their help in obtaining the photographs that appear in this book: Marion Adams, Archives of the Diocese of Cleveland and its director Christine Krosel; the diligent staff at the Cleveland Public Library/Photograph Collection; the Czech Cultural Center of Sokol Greater Cleveland (formerly Bohemian National Hall), particularly the energetic Betty Hosticka; the great resources, human and otherwise, at the Cleveland Press Archives at Cleveland State University; the Czech Catholic Union; Delnicka Telocvicna Jednota (DTJ) and its venerable historian Helen Havlina; Jane Tucek Donovan; Thomas Donovan; the Fairview Park Branch of the Cuyahoga County Public Library; Ellen Howard; the late Dr. Ferdinand Hruby; Joseph Kocab, whose encyclopedic memory has had a profound impact on this book; Our Lady of Lourdes Parish; Judge Ralph Perk Jr.; Fr. Kenneth Pleiman, Society of the Precious Blood (CPPS), and St. Adalbert Church; Sr. Annette Amendolia, Sisters of Nortre Dame (SND), administrator of St. Procop Parish; Ruth Novak and St. Wendelin Parish; Richard Pergler; Greg Sejd; Andrew Hudak, director, and Joe Hornack, assistant director, of the Slovak Institute and Library; Sokol Greater Cleveland; John Straka; Mary Kay Wisnieski, and any others we may have inadvertently overlooked.

Since work started on this book, two Cleveland parishes that played key roles in developing Cleveland's Czech community—St. Adalbert and St. Procop—have been designated for closing by the Cleveland Catholic Diocese. This process continues at this time.

There are some who know first-hand the time it takes to produce a book such as this, particularly my wife Jeanne. And there are Czech grandparents and a Czech mother, who never let their grandson and son forget his heritage. This work would not have been possible without their persistent—yet unknowing—assistance.

INTRODUCTION

A funny thing happened to Czech immigrants on their way to Nebraska, Wisconsin, and other points in the Midwest. Cleveland got in the way.

For many of the early Czech settlers in Cleveland, this city was a way station on the route from the East Coast to already-established colonies of their countrymen in the Midwest. The city's bustle and commerce or perhaps its intellectual atmosphere apparently made Cleveland more attractive to these immigrants than their original destinations.

Many of Cleveland's early Czech immigrants were intellectuals who had fled to the United States to escape the repercussions and possible imprisonment growing out of the revolution that had occurred in Europe in 1848. Some had even spent some time in prison because of their part in the revolutionary movement. Because of the conditions under which they left their homeland, they came to America intending to stay. Their first settlement was established around 1853 in Brooklyn, west of the Cuyahoga River. Another settlement followed in the 1860s, as some Czechs moved further east, building homes near Forest (East 37th Street), near Woodland Avenue, and on Croton Street (Croton Avenue), where they established the gathering-places Perun Hall and Slovanska Lipa, and established the city's first Czech parish, St. Wenceslaus, in 1867. The west side Czech community formed St. Procop Parish in 1872. They also established a Sokol gymnastics group and the Cyril Congregational Church on West 43rd Street.

In his 1895 book, *History of Czechs in America*, Jan Habenicht lists 13 distinct Czech neighborhoods on the east and west sides of Cleveland; although some of these were only a few blocks in size. Habenicht goes on to say that most of the immigrants at that time came from Pisek, Tabor, Prague, and Ceske Budejovice.

Throughout their movements in Cleveland and Cuyahoga County, the Czechs generally preferred to build their own homes rather than move into older housing. From a handful of early settlers in the 1850s, the colony grew to more than 3,200, according to a survey taken in 1869, which showed there were 696 Czech families in the city. Their success in their new country was aided by their low illiteracy rate, estimated to be about 1.5 percent.

The second of three waves of Czech immigration occurred after 1870, as life in the United States was much more attractive than conditions in Bohemia at that time. Universal military service for all males in the Austro-Hungarian Empire was yet another factor, according to the *Encyclopedia of Cleveland History*. The post-1870 wave of immigrants peaked between 1900 and 1914.

Although they shared the same language, the Czechs who came to America were almost evenly divided in their attitude toward religion. Although they were mainly Catholic in their

homeland, many took advantage of the new freedom offered in America, put religion aside, and were commonly referred to as freethinkers. For more than a generation, the Catholic and the freethinking Czechs grew almost as separate communities living in the same neighborhood. This coexistence was not without its heated moments, as Catholics and freethinkers established separate community anchors, the Catholics setting up churches and the freethinkers founding halls, which served as community anchors and even housed ethnic schools.

As the community grew with the flood of immigrants, the Czechs eventually migrated south across Cleveland's Kingsbury Run to Broadway. By 1886, a new St. Wenceslaus Church was under construction at Forest (East 37th) Street and Broadway to serve a population of professionals, skilled workers, and even barrel-makers for John D. Rockefeller's Standard Oil Company. Freethinking Czechs migrated along the same route, establishing Probulov Hall and later Bohemian National Hall, which is now on the National Register of Historic Places.

The neighborhoods they established sought to meet all the needs of their residents. Besides establishing retail outlets, the Czechs established three thrift institutions, including the Oul (Czech for owl) Savings and Loan Company, People's Savings and Loan Association, and First Federal Savings and Loan Company, which has grown into CharterOne Financial.

Another group also moved east along Woodland and Quincy Avenues, where they founded St. Adalbert Parish in 1883, the same year the Czechs on Broadway were establishing Our Lady of Lourdes Church. They would go on to establish two more parishes along their migration path by 1911.

As the community grew, Cleveland's cultural life grew in lockstep as many Czechs were making contributions to the arts. And within their own community, they established dramatic and singing societies, where they performed works by famous Czech composers or playwrights. Three Czech language newspapers kept them informed about life in their homeland, and the progressive strength of the Czech community was an important factor in establishing the country of Czechoslovakia after World War I. Fr. (later Msgr.) Oldrich Zlamal, a noted Cleveland Catholic priest, urged the city's Czechs and Slovaks to begin a campaign in 1915 to establish a unified homeland. On October 22, 1915, Czech and Slovak representatives signed the Cleveland Agreement at Cleveland's Bohemian National Hall, which called for a unified federal state of Czechs and Slovaks. Three years later their efforts resulted in the signing of the Pittsburgh Agreement on June 15, 1918, which affirmed more strongly the need to establish what eventually would become the country of Czechoslovakia.

Physical training and gymnastics have strong roots in the Czech culture, and Czechs brought the Sokol movement to Cleveland, producing four separate Sokol lodges in the city. Yet another group, the Workers Gymnastic Union (abbreviated in Czech as DTJ), established and still maintains a facility and community in Auburn Township in neighboring Geauga County.

As years passed, many in the Czech community healed the wounds that had split the Catholic and freethinking community. A pivotal event in the history of Cleveland Czechs was the visit of Cardinal Josef Beran of Czechoslovakia in 1966. Not only was he a Catholic cardinal who had been persecuted for his faith, but for the non-Catholic freethinkers, he was also a Czech national hero.

Although Cleveland's Czechs have been assimilated in the past 150 years, their presence in the community is still evident in the several halls that still serve as gathering places for third- and fourth-generation Czechs. Two Czech radio programs can also be heard each weekend. After 150 years, Cleveland's Czechs are proud of their contribution to the community in general, but they are equally proud of their individuality and the traditions of their ancestors.

One

EARLY TIMES

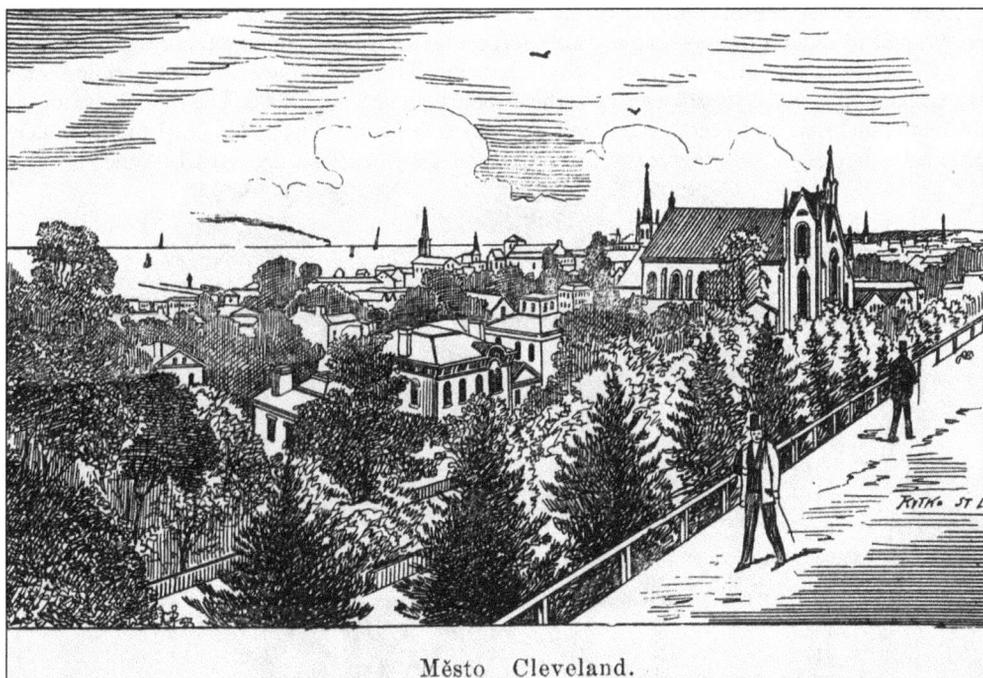

Město Cleveland.

Czech immigrants would have experienced a scene like this in 1890, according to *Kratke Dejiny a Seznam Cesko-Katolickych Osad*, a book written in that era. However, it is a far cry from the description in *The Story of My Life*, by Cleveland Czech industrialist Frank Vlchek, which noted "unpaved roads filled with mud, no paved sidewalks. . . . Aside from that the houses were entirely new, several happily painted, in front of the homes a lawn and a garden with flowers and behind the house were gardens with a variety of vegetables. . . . We heard Czech spoken everywhere and it reminded me of Bohemia." (Courtesy of the Czech Cultural Center of Sokol Greater Cleveland.)

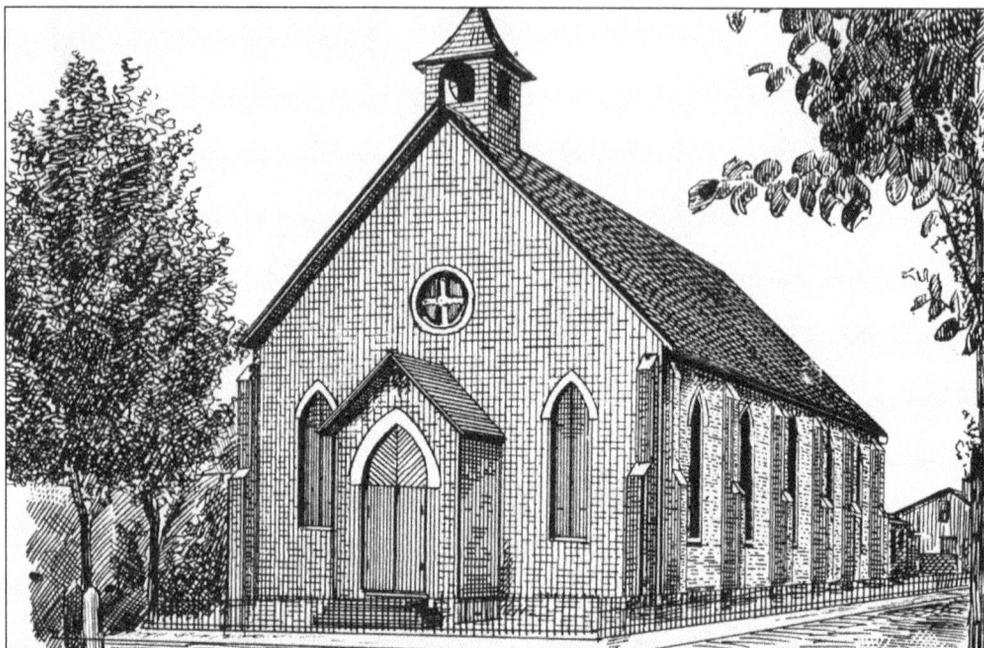

St. Wenceslaus Church, the mother church of Cleveland's Czech Catholic community, was established in 1867 at the corner of Arch (East 34th) Street and Burwell Avenue. Led by founding pastor Fr. Anthony Krasny, the parishioners built this structure at a cost of $5,000. The official opening of the new church was on December 22, 1867. St. Wenceslaus School opened in 1870 and eventually included eight grades. (Courtesy of the Czech Cultural Center of Sokol Greater Cleveland.)

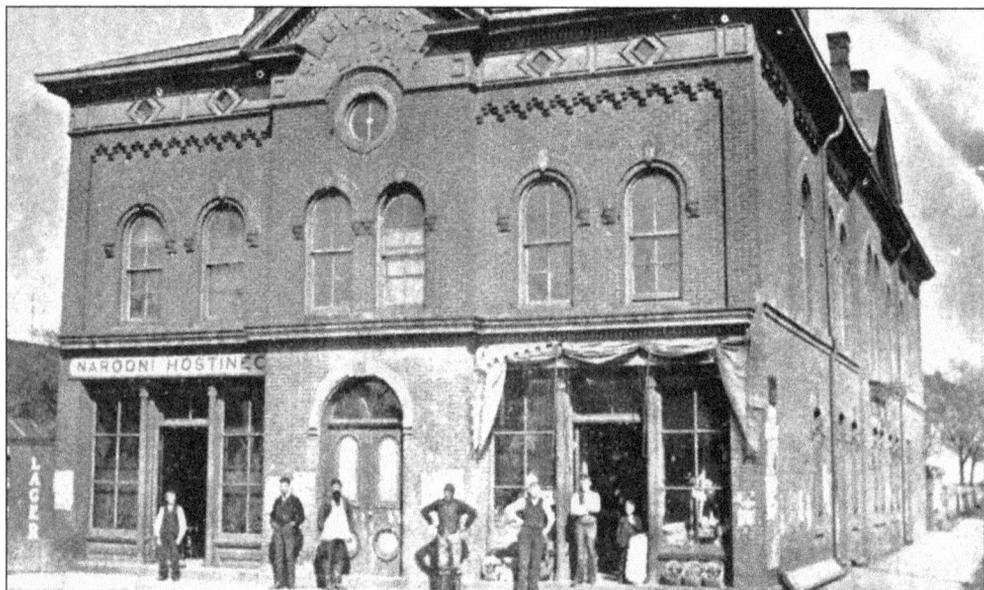

At the same time, Czech freethinkers established Slovanska Lipa (Slavic Linden or Lime Tree) on nearby Croton Street (Croton Avenue). The Slovanska Lipa was one of the early societies formed by Czechs in the United States and was named for a political society formed in their homeland during the revolution of 1848, according to the *Harvard Encyclopedia of American Ethnic Groups.* (*The Czech Settlement and the Life of Its Society Members—1895.*)

In 1872, Rev. Anton Hynek was appointed as founding pastor of St. Procop Parish serving the West Side Czech community near Burton (West 41st) Street and Clark Avenue—a neighborhood known as Kuba. In 1873, he was named as the fourth pastor of Cleveland's first Czech Catholic parish, St. Wenceslaus, where he served till his death in 1917. (Courtesy of the Czech Cultural Center of Sokol Greater Cleveland.)

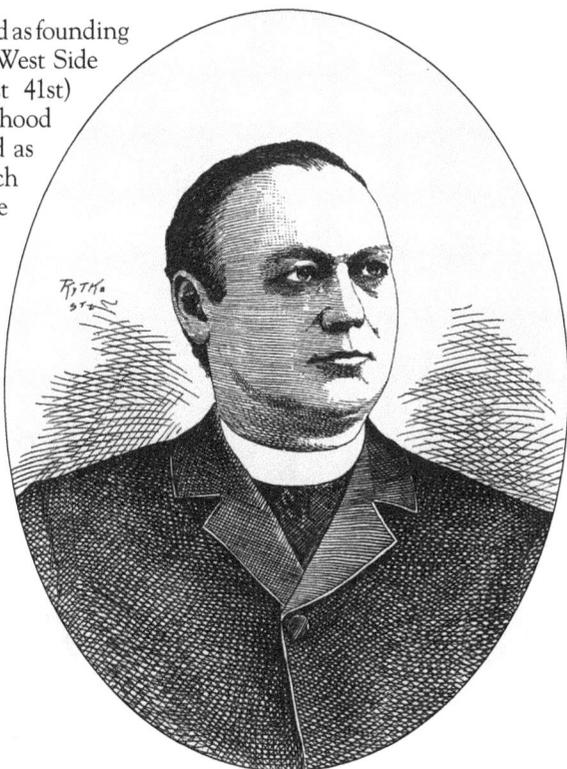

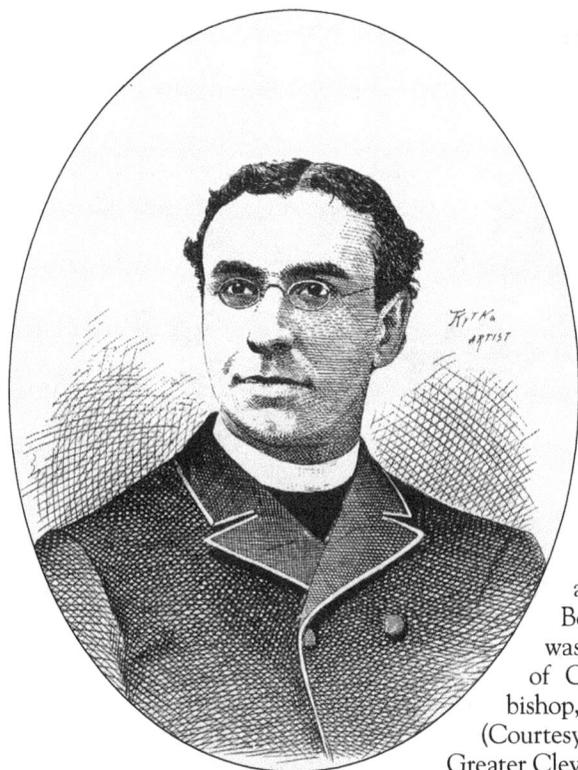

Rev. Josef Koudelka was a renaissance man among Cleveland Czech clergy. Serving shortly after ordination as the second pastor of St. Procop Parish, he also wrote several textbooks and supervised for a year the national Bohemian newspaper *Hlas*. In 1908, he was named as the first auxiliary bishop of Cleveland and later became auxiliary bishop, then bishop, of Superior, Wisconsin. (Courtesy of the Czech Cultural Center of Sokol Greater Cleveland.)

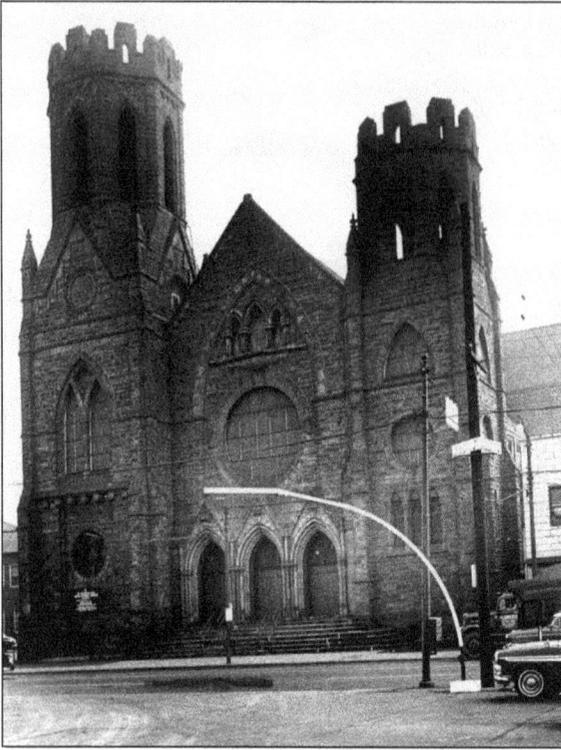

From its founding in 1867 till it closed in 1963, St. Wenceslaus Church served as the mother church of Cleveland's Czech Catholics, following the migration patterns of the Czech community. As the city flourished, more bridges were built to span such valleys as Kingsbury Run. As a result, many Czechs built homes in the area surrounding Forest (East 37th) Street and Broadway. (Photograph by Tony Tomsic; courtesy of Cleveland Press Archives, Cleveland State University Library Special Collections.)

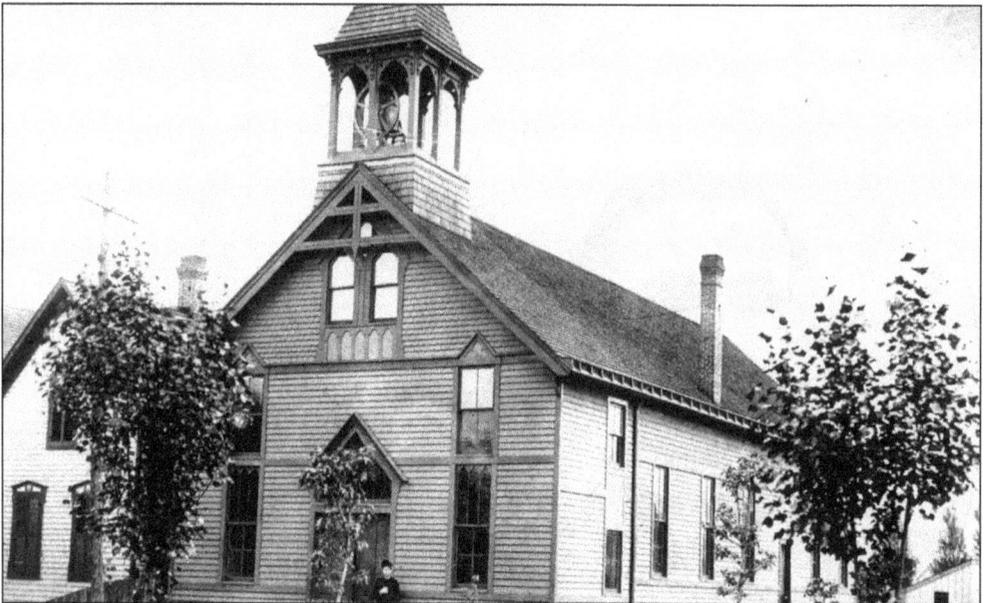

As Cleveland's growing industry, especially the Standard Oil Company refinery, encroached on Cleveland's original Czech settlement, residents began to move south along Broadway. Another group moved further east along Garden Street (Central Avenue), an area known at the time as "East Cleveland." After several years of walking four miles along unpaved roads, open fields, and railroad tracks, the residents of this area, then known as East Cleveland, succeeded in establishing St. Adalbert Parish in 1883. (Courtesy of St. Adalbert Parish.)

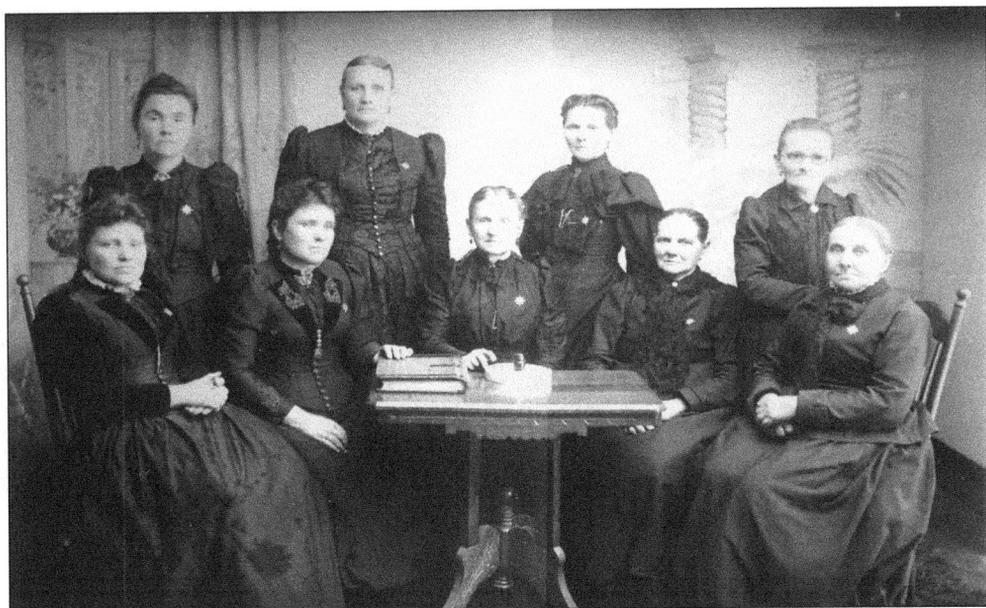

The Union of Czech Women (Jednota Ceskych Dam) was founded in Cleveland in 1870, and had 23,000 members by 1920, according to the *Harvard Encyclopedia of American Ethnic Groups*. Founding members are F. Simkova, K. Havlicek, K. Hoffmanova, M. Karasek K. Richlikova, M. Hajkova, R. Franke, J. Jankova, and M. Pival. The group is now part of the Czech fraternal society CSA Fraternal Life. (Courtesy of the Czech Cultural Center of Sokol Greater Cleveland.)

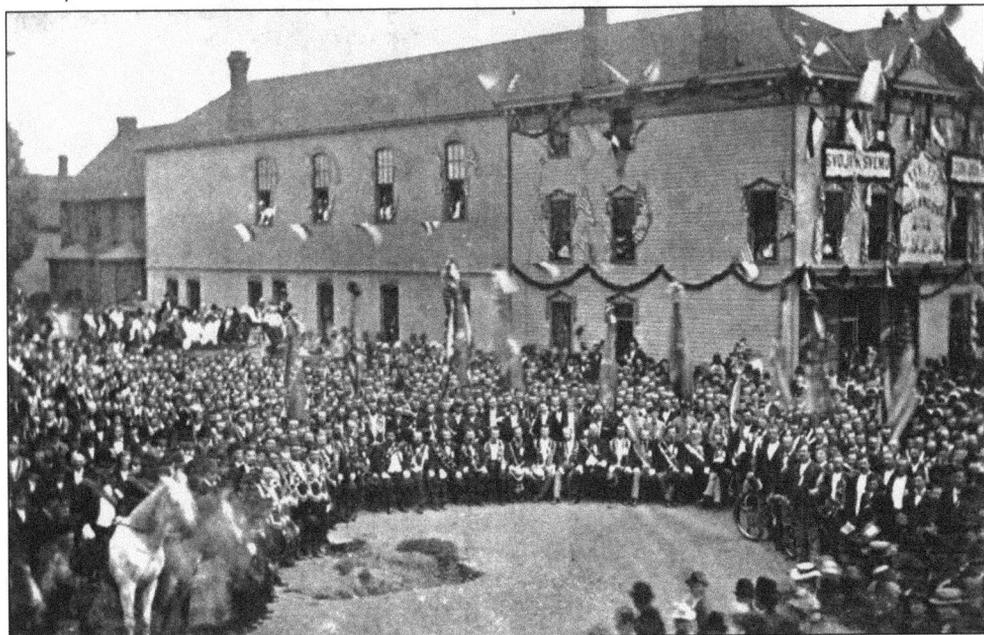

The Czech Slavonic Benevolent Society (abbreviated in Czech as CSPS) started in the United States in 1854 in St. Louis, according to the *Harvard Dictionary of American Ethnic Groups*. The society quickly grew, establishing several lodges in Cleveland. This 1878 photograph shows a society gathering in Cleveland at what appears to be the Slovanska Lipa Hall on Croton. (*The Czech Settlement and the Life of Its Society Members—1895*.)

13

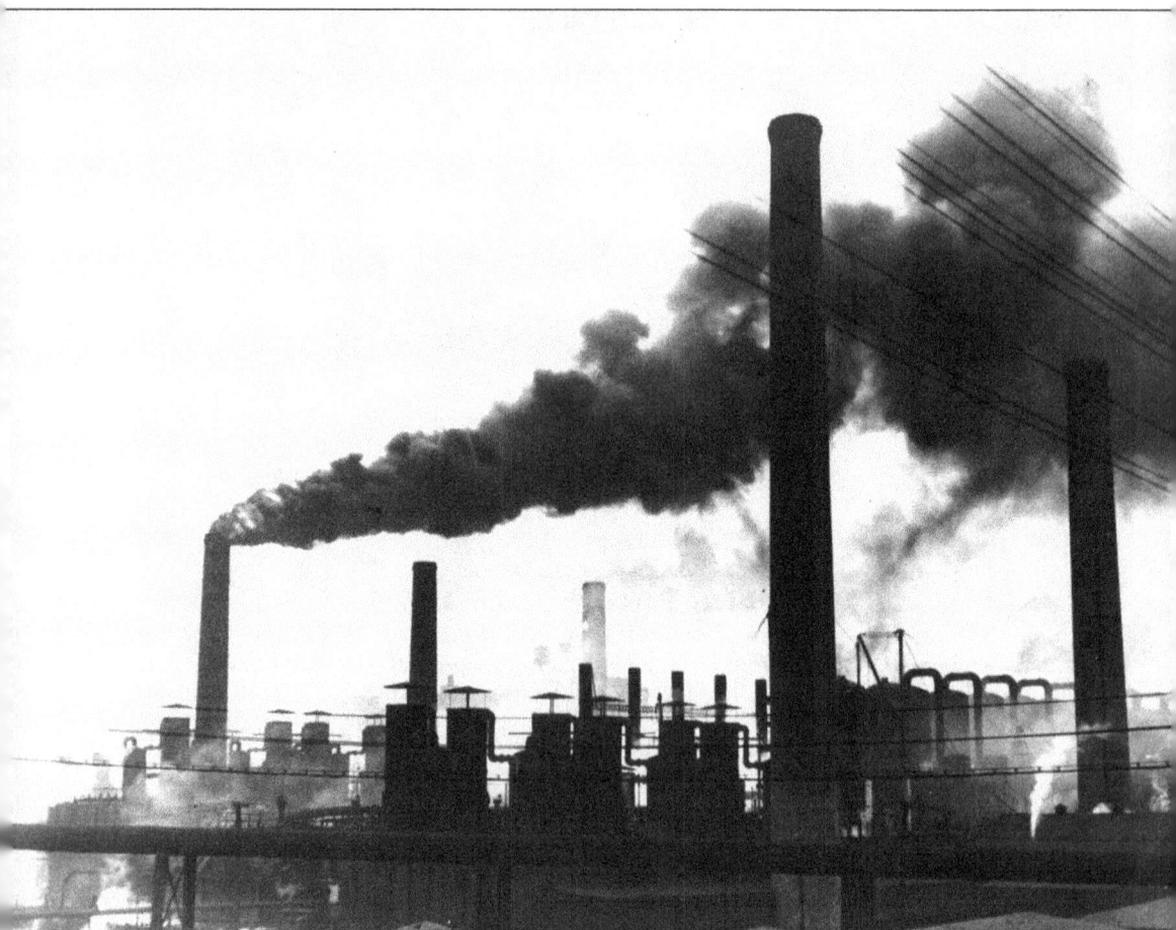

The arrival of many early Czech settlers in Cleveland coincided with the founding of the Standard Oil Company of Ohio by John D. Rockefeller in 1870. Many Czech grandfathers would proudly tell their grandchildren how they "made barrels for Mr. Rockefeller." Some even told stories—possibly apocryphal—about turning down the oil tycoon's offer of stock in the fledgling company. As Czechs moved on to other employment, the Standard Oil refinery remained in the neighborhood, making its mark, as these smokestacks show in this 1931 photograph. (Courtesy of the Cleveland Public Library/Photograph Collection.)

Two

ZIZKOV AND "EAST CLEVELAND"

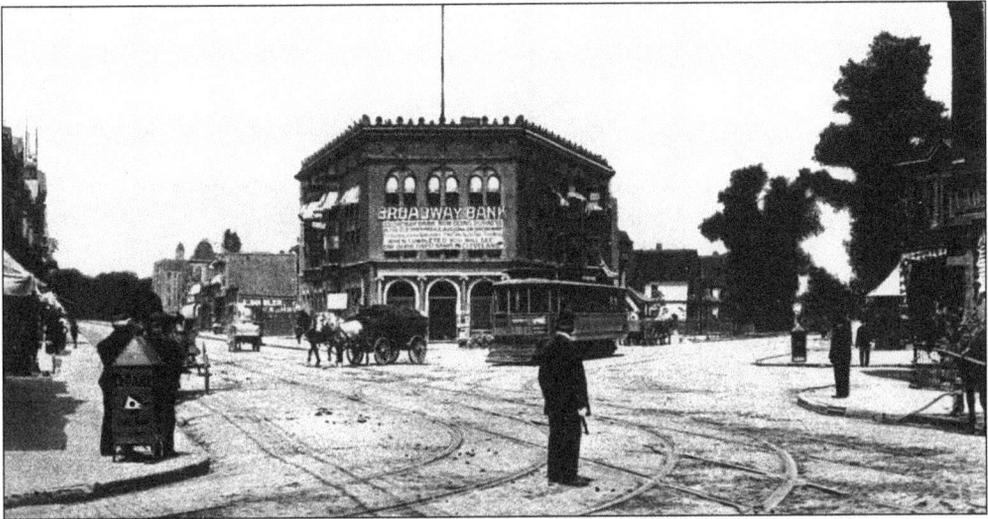

The very heart of the early Czech community in Cleveland was East 55th Street and Broadway—an area known to the Czechs as Zizkov. In this photograph, taken around 1908, Our Lady of Lourdes Church would be out of the photograph to the left, and Bohemian National Hall, Broadway Methodist Church, Probulov Hall, and St. Wenceslaus Church would be a short distance away on Broadway, veering off to the left. On the right is East 55th Street, where several Czech funeral homes and the headquarters of the first Catholic Slovak Union were located. The building at the center was first a bank, then Fisher's Dry Goods. Behind it was the Broadway branch of the Cleveland Public Library, a building that still stands and one of the remaining 10-sided buildings in the United States. (Courtesy of Dr. Ferdinand Hruby.)

Joseph and Anna (Horazdovsky) Lusk (right) immigrated to the United States in 1881, settling along Petrie (East 49th) Street in the area near Our Lady of Lourdes Church. They later built a home on East 50th Street south of Fleet Avenue in what would become the Karlin area. Shown in this photograph from approximately 1884 are their son John and daughter Anna. The woman on the left is unidentified. (Courtesy of John Sabol.)

Probulov Hall on Broadway, shown here in March 1918, was named for a village in Pisek, the region in Bohemia where many of Cleveland's original Czechs were born. One of the more prominent natives of Probulov was Matthew Zeman, founder of the Zeman Iron Works. (Courtesy of Cleveland Press Archives—CSU Library Special Collections.)

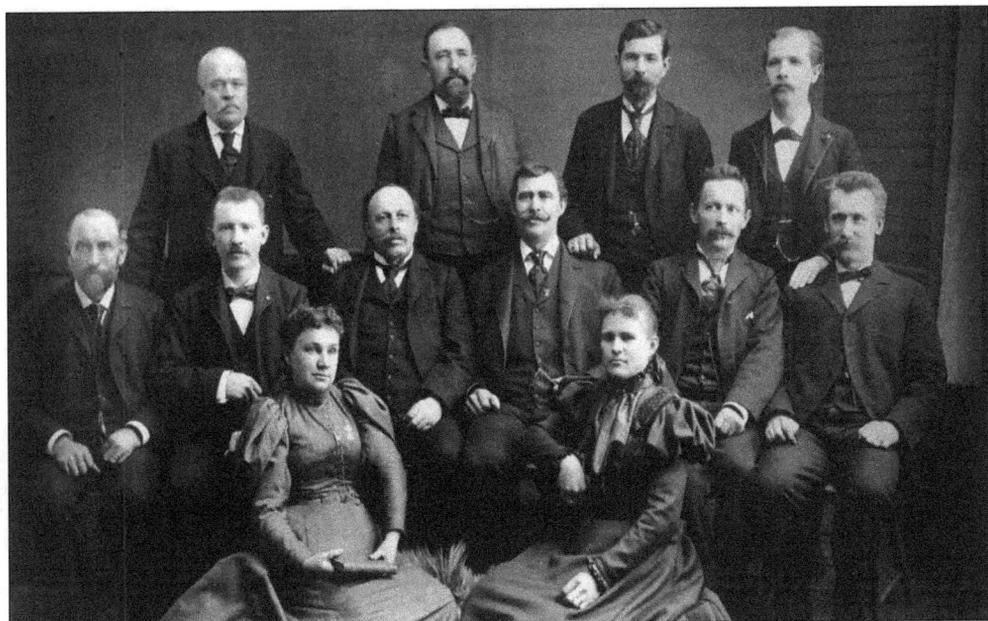

The original directors (including two women) of the Bohemian National Hall are shown around 1897, when the hall was opened. From left to right are (first row) Anna Bubak and Albina Touzimsky; (second row) Vaclav Sanda, Josef Frcka, Vaclav Vanek, Anton Petras, Vaclav Altman, and Josef Blaha; (third row) Jakub Becvar, Josef Linek, Jan Ondracek, and Frantisek Skala. (Courtesy of the Czech Cultural Center of Sokol Greater Cleveland.)

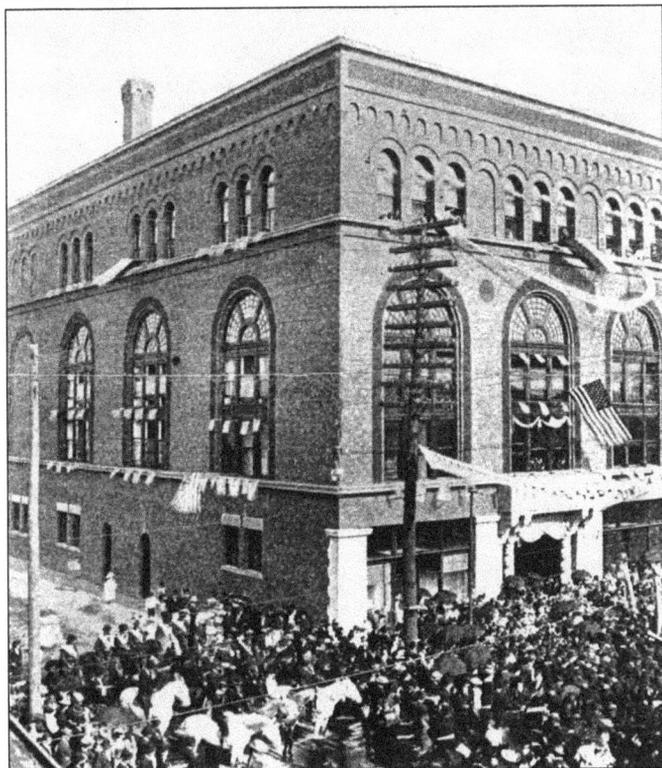

According to the *Encyclopedia of Cleveland History*, Bohemian National Hall, on Broadway near East 49th Street, was the first hall in the city to be owned by a nationality group. The lodge Bratri v Kruhu first proposed the hall in 1887, calling on local freethinkers to erect the structure. The cornerstone was laid in 1896, and the hall was opened and dedicated on October 26, 1897. (Courtesy of Cleveland Press Archives—CSU Library Special Collections.)

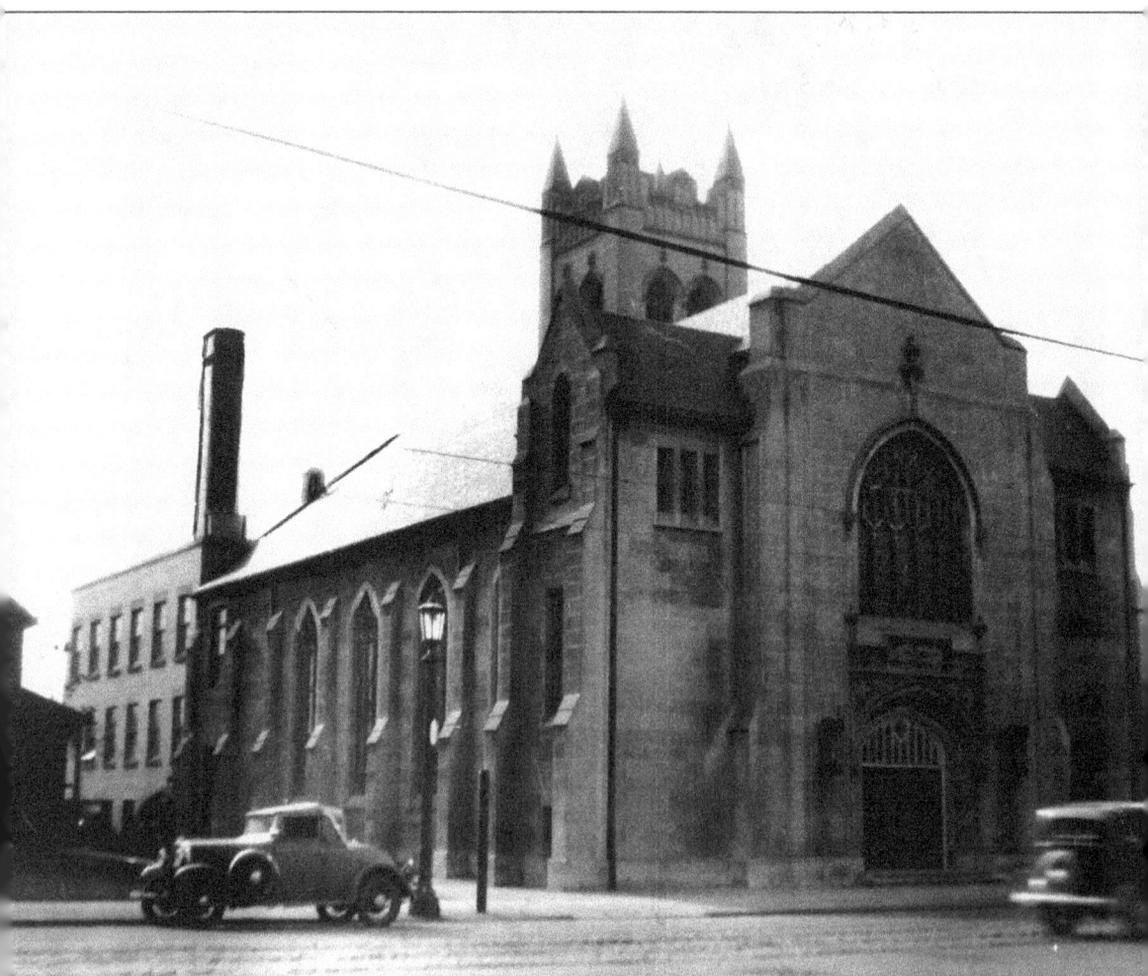

Besides the Catholic churches that serve as anchors in the various Czech neighborhoods, Broadway Methodist Church, founded in 1872, also served the Czech community as well as a variety of other parishioners. The church erected this building (shown in 1932) at 5246 Broadway. Broadway Methodist Church's commitment to the Czech community is evident in its use of the Czech language in its services well into the mid-20th century. The church is also the site of the largest representation in the United States of the *Last Supper* by Leonardo da Vinci. (Courtesy of Cleveland Press Archives—CSU Library Special Collections.)

Czechs migrating southeast along Broadway quickly filled the area around Willson Avenue (East 55th Street) and Broadway, and Our Lady of Lourdes Church (shown in an early sketch) was established there in 1883. Fr. Stefan Furdek was recruited in Europe to serve the new parish. On his way to the United States, he visited the shrine of Our Lady of Lourdes in France and vowed to name a parish in honor of Our Lady of Lourdes. (Courtesy of Our Lady of Lourdes Parish.)

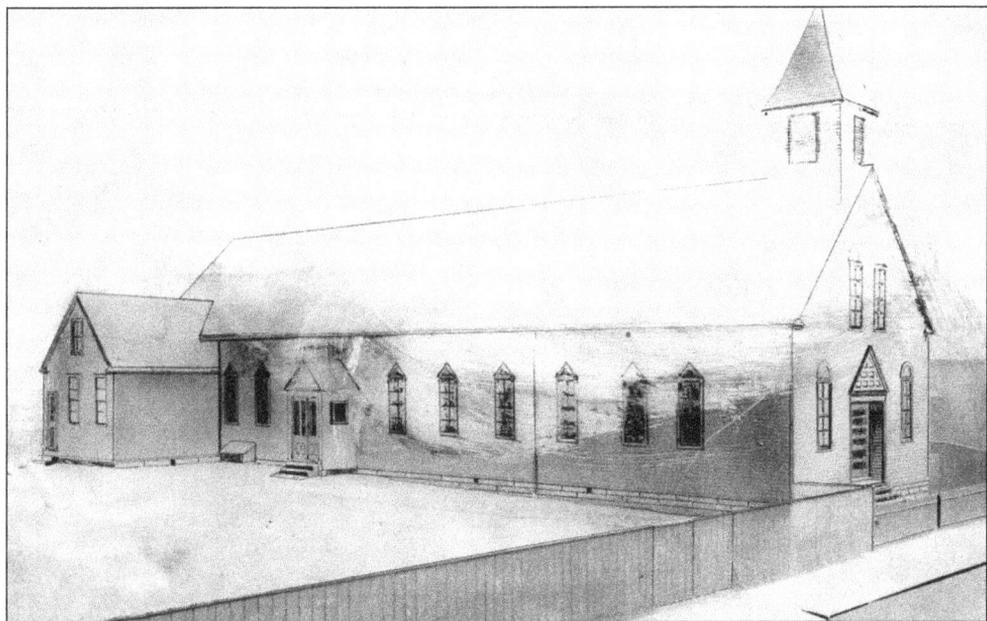

This is another view of the first church and rectory of Our Lady of Lourdes Parish. This church and rectory soon became too small for the growing congregation, and ground was broken for the present gothic structure in 1891. (Courtesy of Our Lady of Lourdes Parish.)

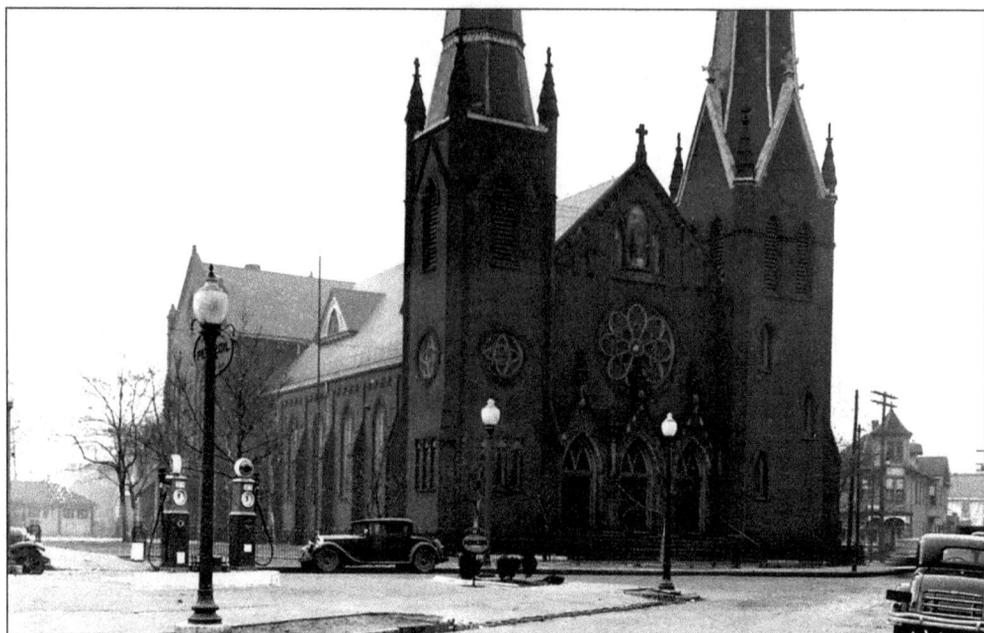

At the time Our Lady of Lourdes Parish celebrated its 50th anniversary in December 1933, the church had had only two pastors, Fr. Stefan Furdek and Fr. (later Msgr.) Oldrich Zlamal, who became pastor when Father Furdek died in 1915. Once, when Father Furdek was transferred to another parish, parishioners of Our Lady of Lourdes became so enraged that they stood at the church doors with loaded guns to prevent his successor from taking charge. The bishop relented in his decision. (Courtesy of Cleveland Press Archives—CSU Library Special Collections.)

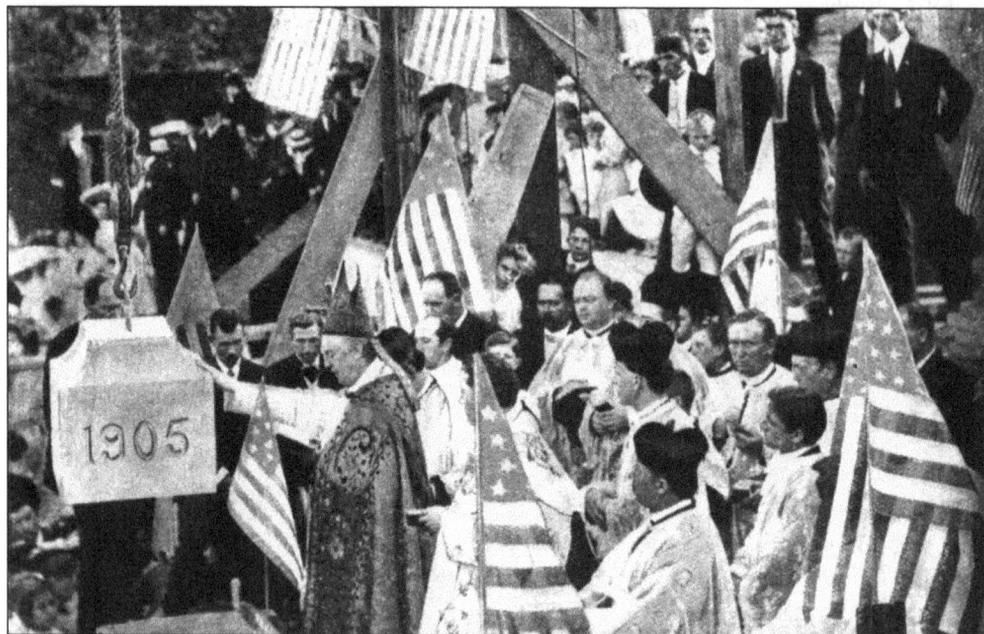

From 1902 to 1905, children at Our Lady Of Lourdes Parish went to school in the old church building, which was razed in 1905 to make way for a new school. In 1905, the cornerstone was laid for Our Lady of Lourdes School. (Courtesy of the Slovak Institute and Library.)

This is Our Lady of Lourdes Church in September 1955, a few months after the death of its second pastor, Msgr. Oldrich Zlamal. While he was pastor, the parish added a gymnasium, a convent, and a rectory. In 1939, a ninth grade was added to its school, and by 1948, Our Lady of Lourdes High School produced its first graduating class. The high school later merged into Cleveland Central Catholic High School. (Courtesy of Cleveland Press Archives—CSU Library Special Collections.)

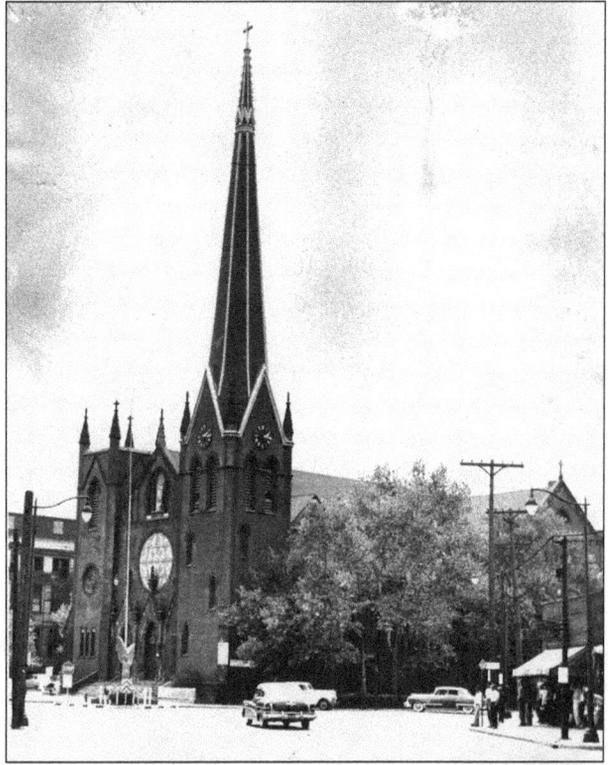

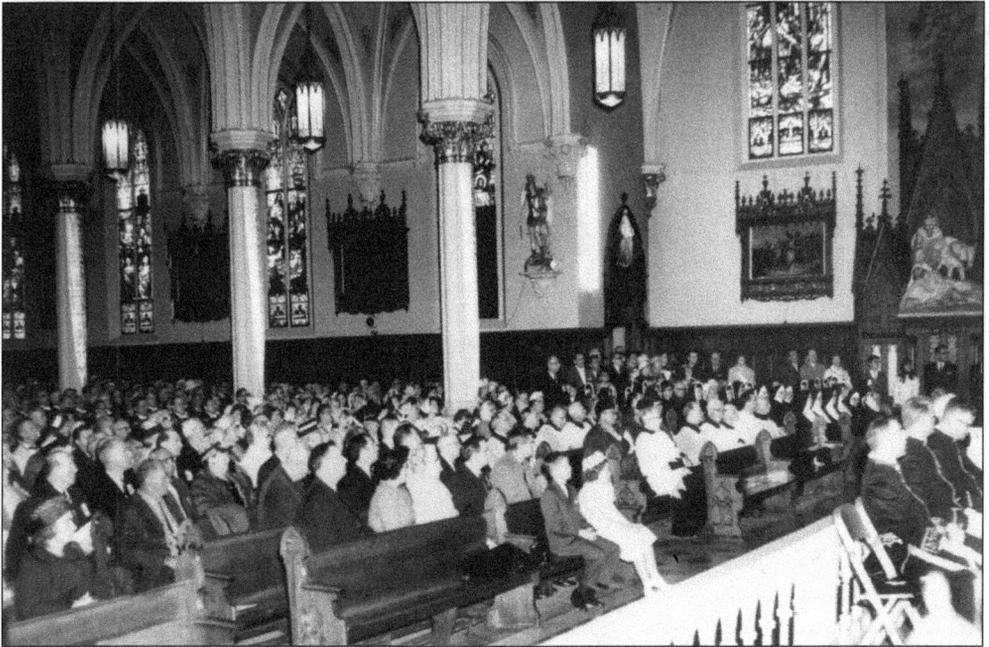

The large gothic interior at Our Lady of Lourdes Church can accommodate a large number of worshippers as shown in this photograph. The church was designed by Emile Uhlrich, who also designed the West Side Czech Catholic church St. Procop. (Courtesy of Our Lady of Lourdes Parish.)

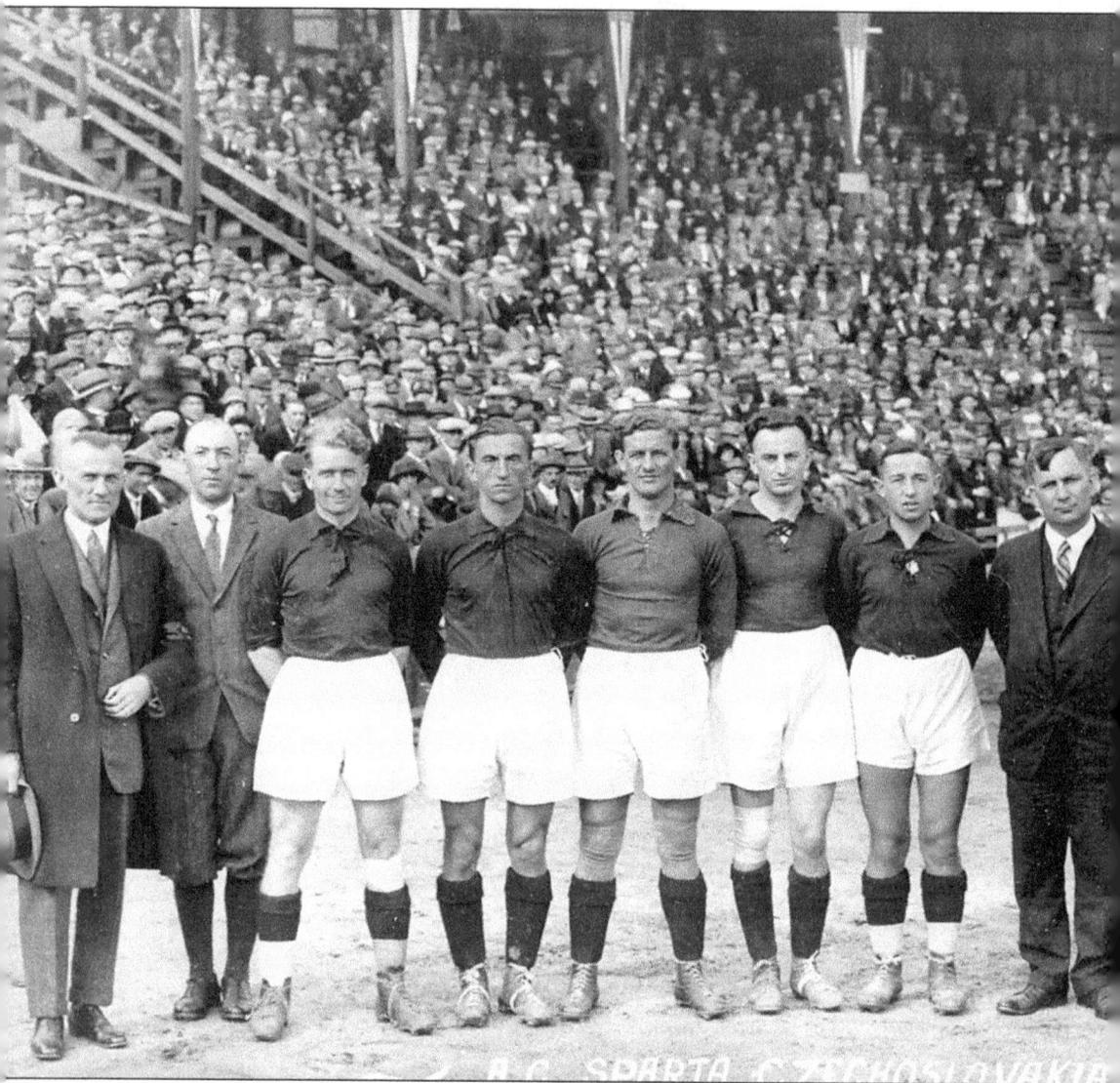

On September 26, 1926, more than 6,000 watched the Spartas soccer team from Prague beat the Ohio All-Stars 6-2 at Slavia Hooper Field on East 55th Street in the heart of Cleveland's Czech community. According to newspaper accounts, the speed of the Prague team was

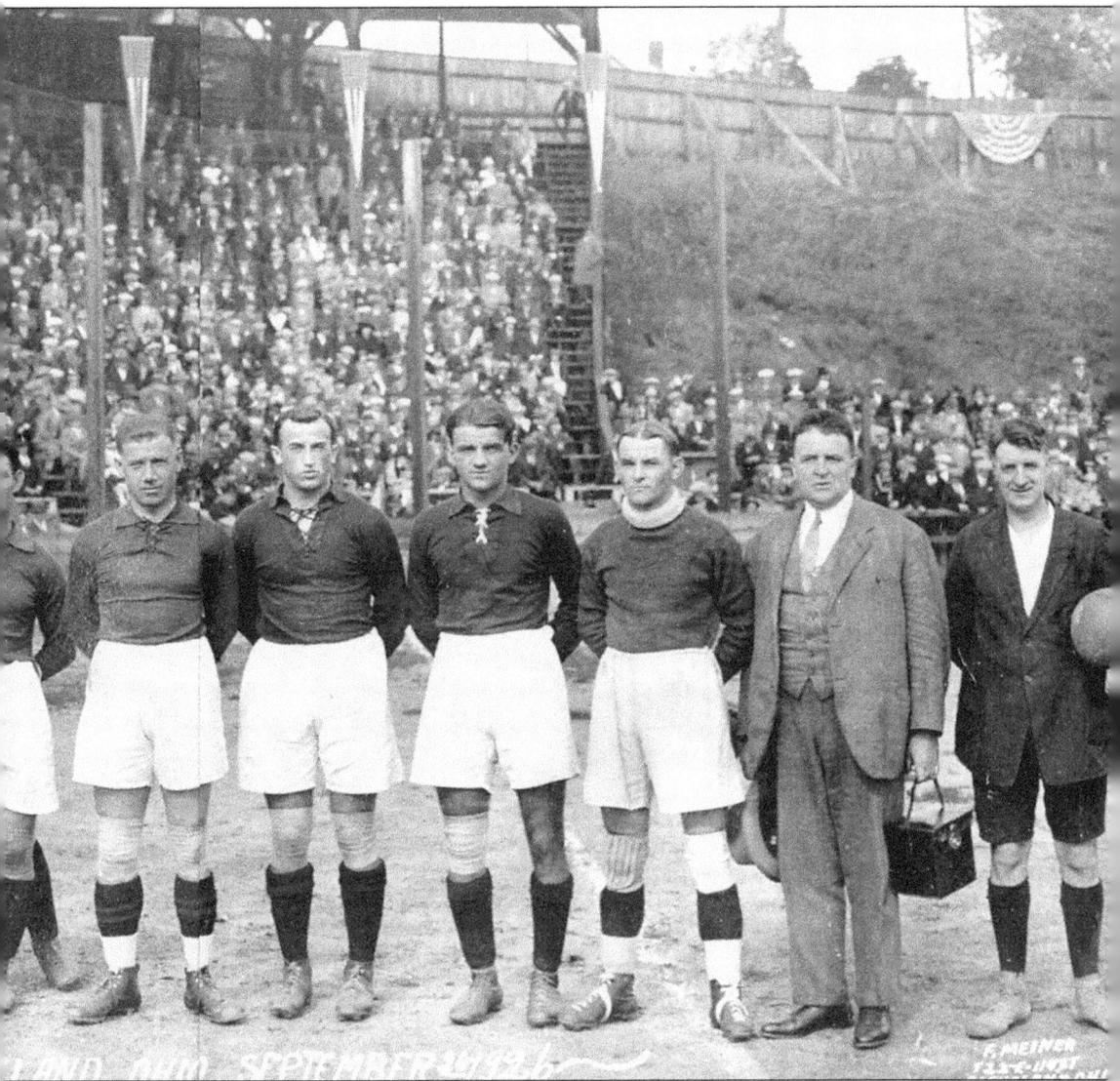

LAND AUM SEPTEMBER 1949 b

F. MEINER

too much for the handpicked Ohio squad. (Courtesy of the Czech Cultural Center of Sokol Greater Cleveland.)

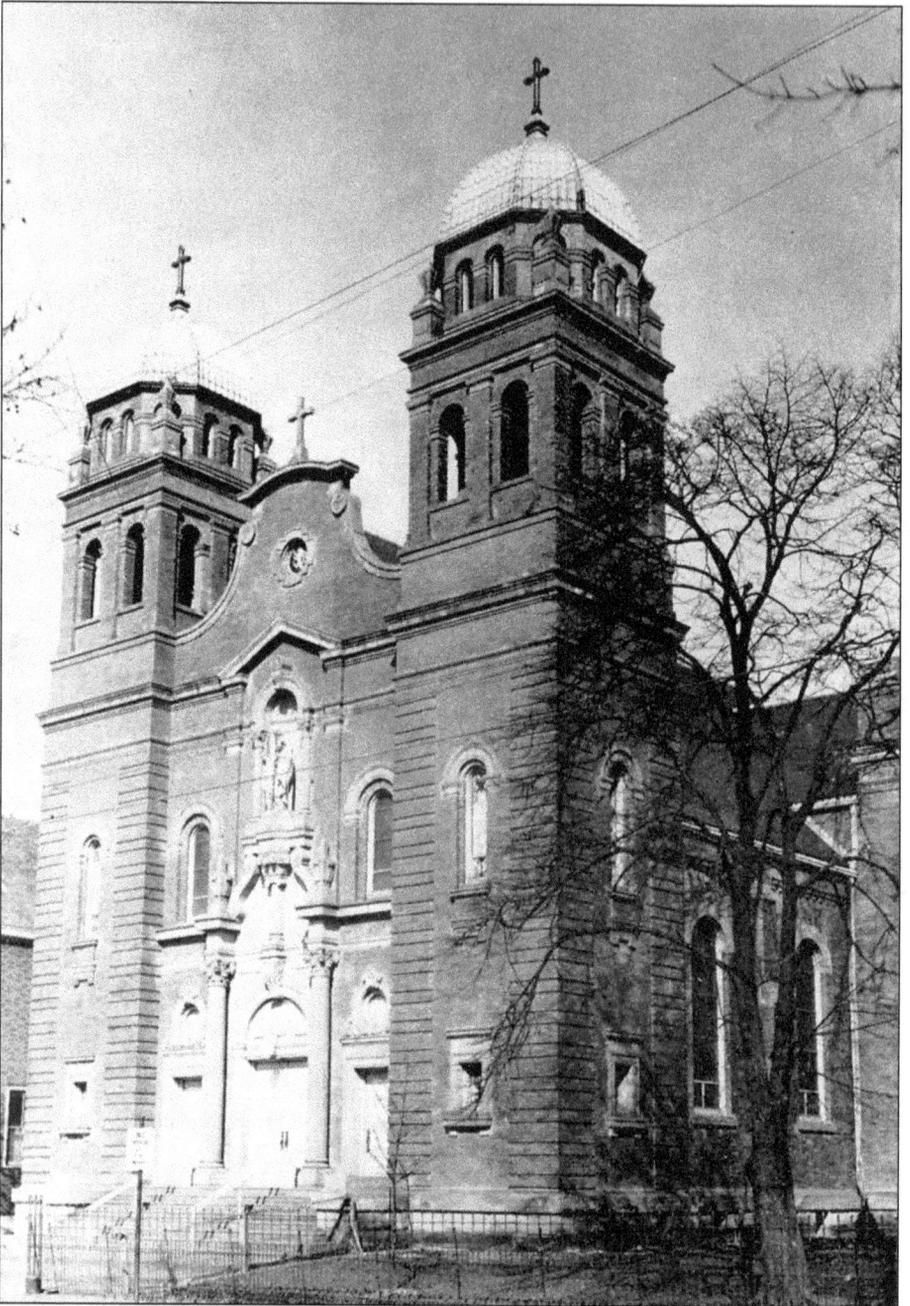

In 1912, after almost 30 years, St. Adalbert Parish, located at East 83rd Street and Central Avenue in what was earlier known as "East Cleveland," built its second church under the leadership of Fr. John Becka. The interior of the church was marked by statues of Czech saints, including St. Adalbert (moved from the parish's original church); St. Ludmila; St. Wenceslaus, grandson of St. Ludmila; and St. Cyril. A marble shrine to St. Theresa was donated by the family of Frank Vlchek, founder of Vlchek Tool, a major Czech-owned tool manufacturer in Cleveland. In 2009, the Cleveland Catholic Diocese designated St. Adalbert to be closed. This process is still continuing. (Courtesy of St. Adalbert Parish.)

24

For any young man growing up in Cleveland's Czech community, there was no lack of places providing good accordion lessons. Basta's Music, Sistek's Music, Smerda's Furniture, and the Hruby Conservatory—all on Broadway—provided accordion lessons and more. Aspiring accordionist Phil Houdin, age 18, shows his technique in this photograph taken July 4, 1931. (Courtesy of Ellen Howard.)

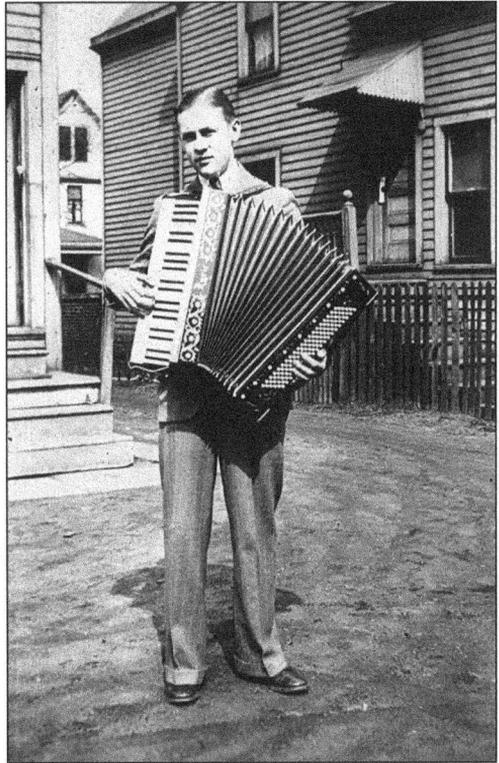

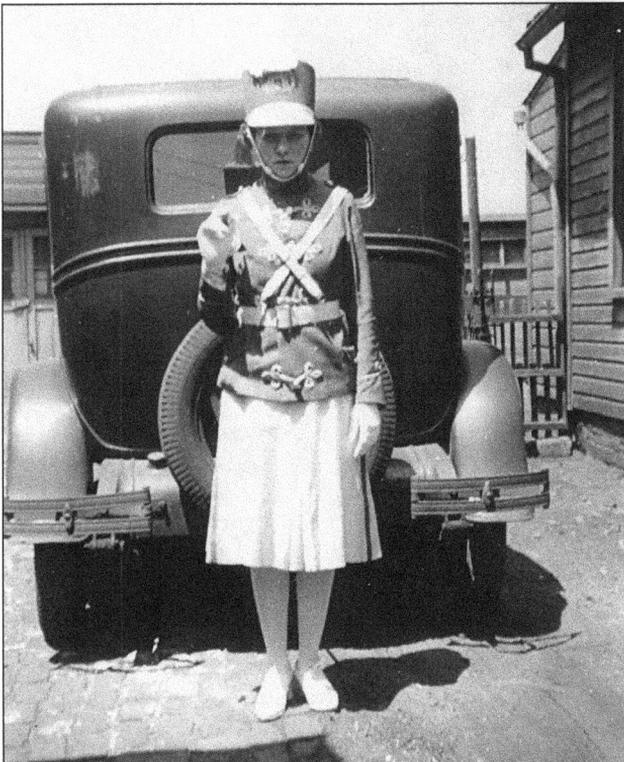

Josephine Kahoun shows off her Knights of St. John Ladies Auxiliary uniform at her home on Pershing Avenue. Each Czech parish in Cleveland had different colors for cadet uniforms, so they would be easy to spot in large parades. For solemn occasions at Our Lady of Lourdes Church, cadets would let other units march through, then close ranks and march in starting from the bottom of the steps. (Courtesy of Ellen Howard.)

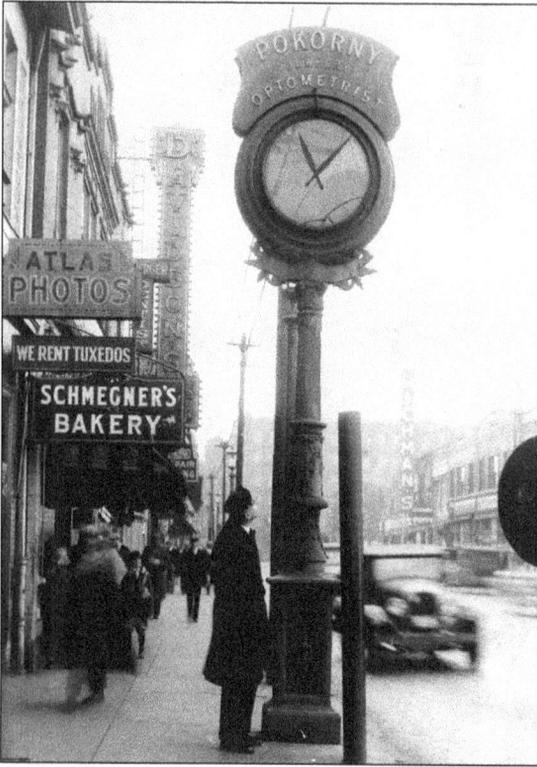

For Cleveland's Czech community and many others, Broadway from East 37th Street to the south was a second downtown, and its center was at East 55th Street. This photograph from December 1932 shows the bustling shoppers in front of Frank Pokorny Jewelers and Schmegner Bakery, as well as Atlas Photo. (Courtesy of Cleveland Press Archives—CSU Library Special Collections.)

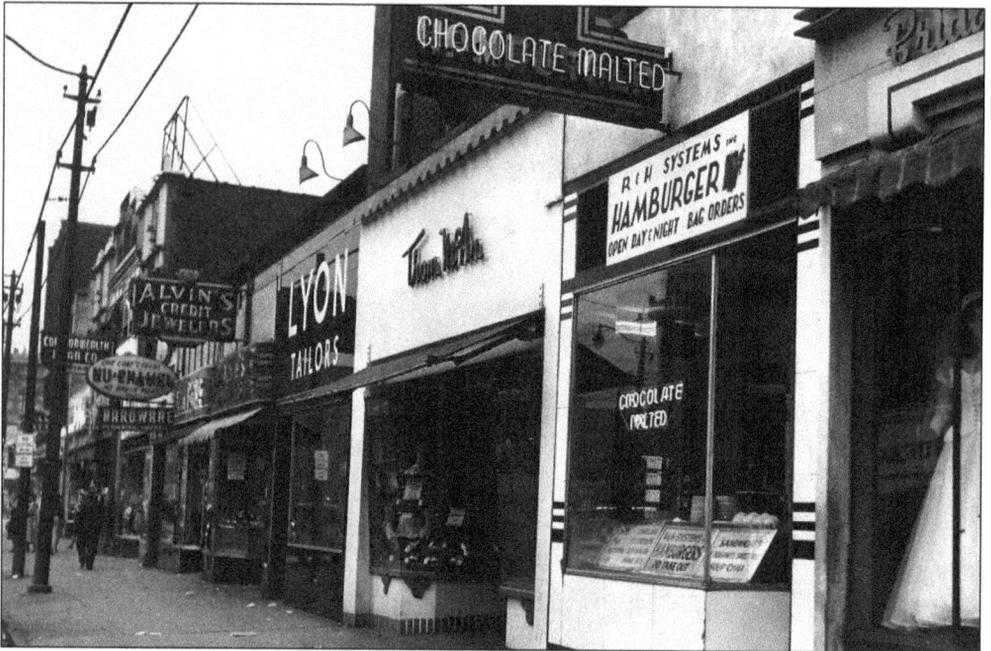

Another view of Broadway just northwest of Union Avenue in 1949 shows the array of merchants that Czech residents could choose from. There was no need to travel to downtown Cleveland, and the shopping mall had not yet made its entry into their lifestyle. (Courtesy of Cleveland Press Archives—CSU Library Special Collections.)

26

Three

WEST SIDE CZECHS
AND KUBA

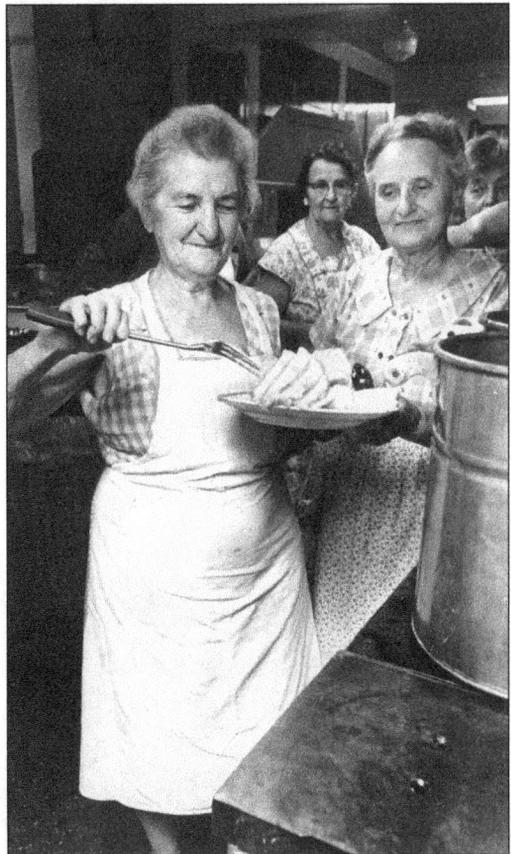

The area north and south of Clark Avenue from West 25th Street to West 65th Street was known as Kuba. St. Procop Church on West 41st Street stands as one anchor, and Ceska Sin Sokol Hall at 4314 Clark Avenue stands as another anchor in the neighborhood. Originally a Hungarian hall, the Czechs purchased it and reestablished it as their own in 1907. In 1971, Marie Hlavacek and Marie Koncal, two members of the hall's women's auxiliary, served up Czech pork, sauerkraut, and dumplings on a regular basis for diners at the hall. (Courtesy of Cleveland Press Archives—CSU Library Special Collections.)

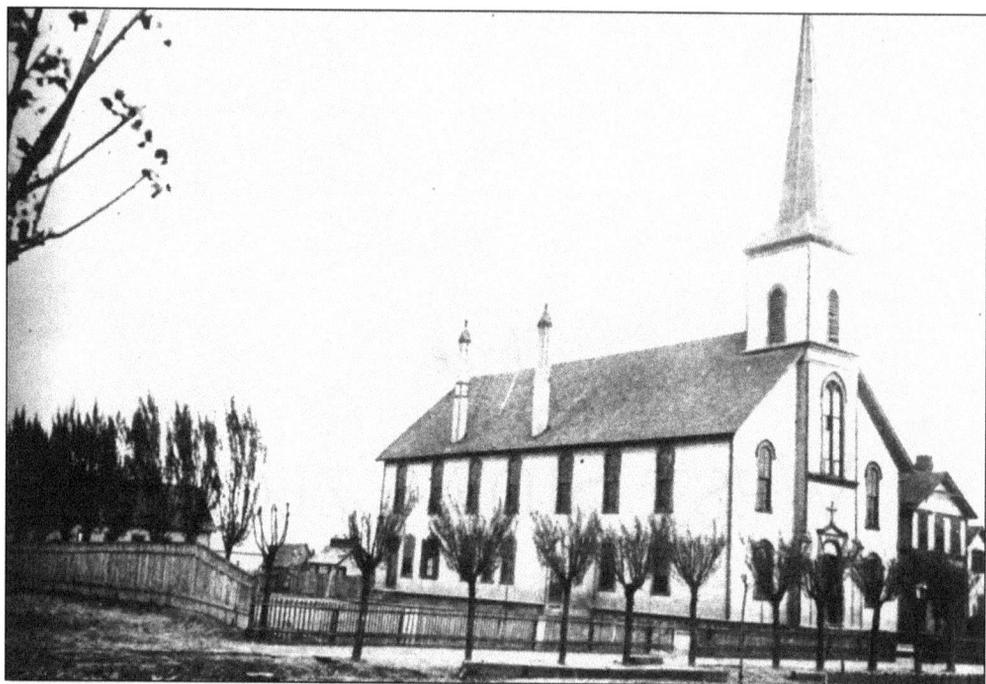

Cleveland's original Czech settlement was on the West Side in Brooklyn. However, St. Procop Parish at Burton (West 41st) and Trent Streets, is the second Czech Catholic parish to be established—in 1872, five years after St. Wenceslaus. The founding pastor was Fr. Anton Hynek, who organized the fund-raising and assisted parishioners in selecting a site for the first church halfway between Brooklyn and the Czech neighborhood Kuba. (Courtesy of St. Procop Parish.)

Rev. Anton Vlcek served as pastor of St. Procop Parish from 1885 to 1893, following a turbulent period in that parish's history. In 1882, when Fr. (later Bishop) Josef Koudelka moved to St. Louis to edit the national Czech newspaper *Hlas*, parishioners refused to accept a succession of pastors appointed by Bishop Richard Gilmour. Their recalcitrance and the fact that no Bohemian priests were available forced the bishop to close the parish for a year and a half. In 1885, Father Vlcek, recently ordained in Buffalo, was assigned as pastor and served till 1893. (Courtesy of the Czech Cultural Center of Sokol Greater Cleveland.)

Rev. Vaclav Panuska served as pastor of St. Procop Parish from 1896 to 1901. While pastor, he initiated the building of the current church building, a Romanesque structure seating 800. Before his service at St. Procop, he also served as pastor of St. Ladislas Slovak Parish and as founding pastor of St. Martin Parish, also a Slovak congregation. (Courtesy of the Czech Cultural Center of Sokol Greater Cleveland.)

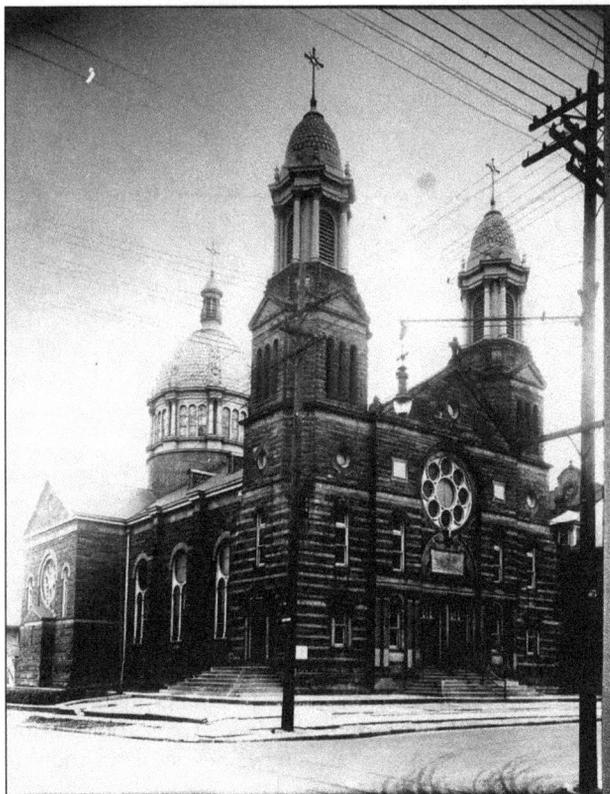

In May 1932, the two towers and central dome of St. Procop church were still intact. The parish had become debt free and the church had been consecrated three years earlier. The pastor was Fr. (later Msgr.) Peter Cerveny, who also opened a two-year commercial high school, which was expanded to a full four-year program in 1937. (Courtesy of Cleveland Press Archives—CSU Library Special Collections.)

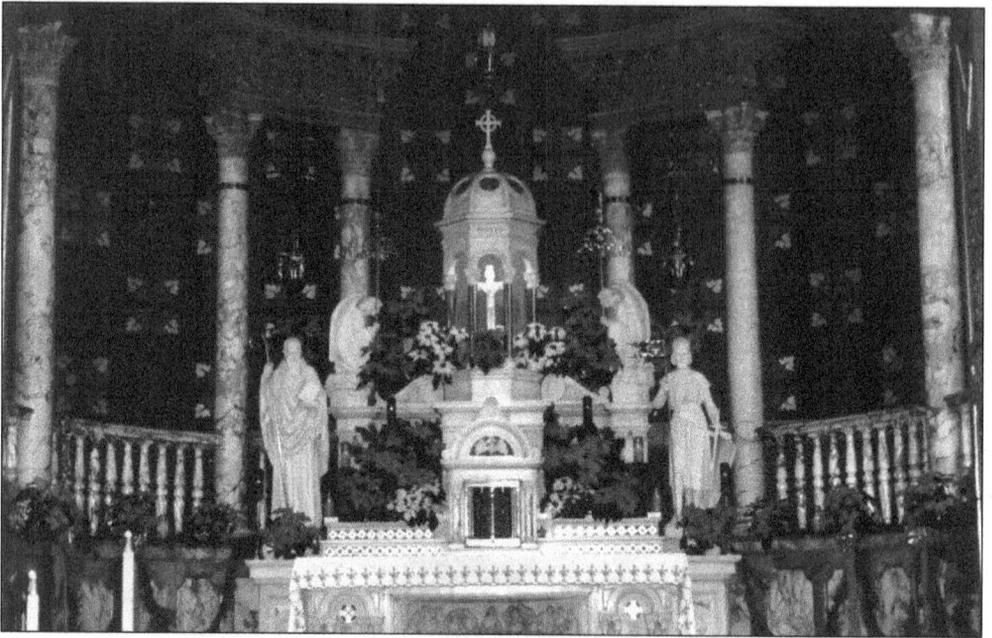

Planning for a new St. Procop church began in 1899 with an Italian Romanesque design. Construction began in 1901 and was completed shortly before Christmas 1902. This is the sanctuary of the current church in 1989. (Courtesy of St. Procop Parish.)

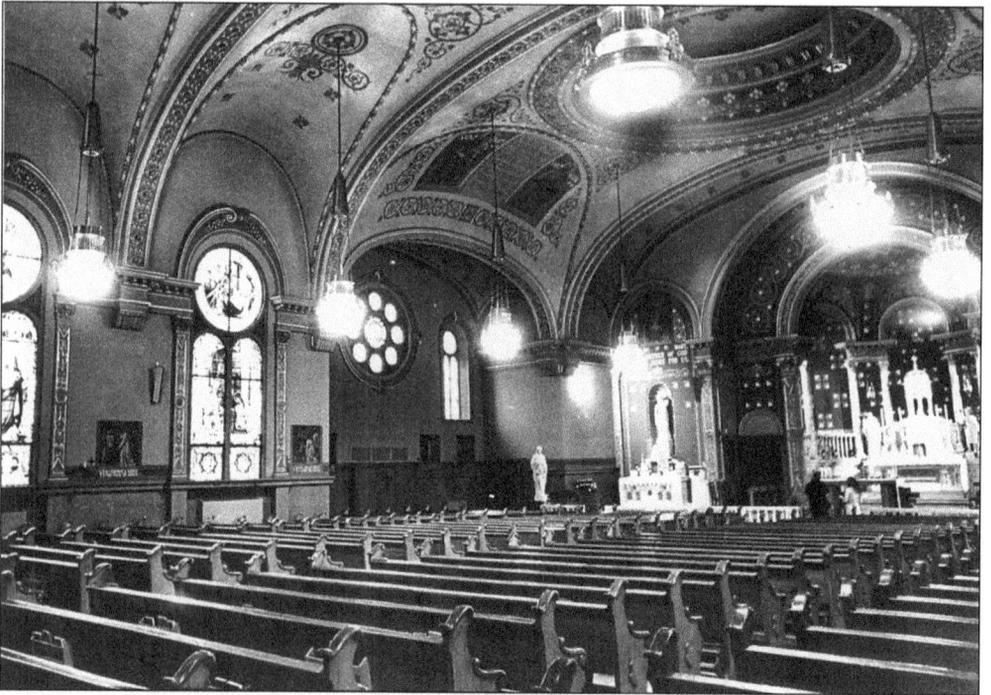

This is the interior of St. Procop church in 1974, at the time of the parish's centennial. The interior is 144 feet long, 60 feet wide in its main body, with an 88-foot-wide nave. Total seating is 1,300. The church is different from many of the gothic-style churches in Cleveland and was completed in 1902. (Courtesy of Cleveland Press Archives—CSU Library Special Collections.)

Stained-glass windows brighten the interior of St. Procop church. Besides the church, by the mid-1920s the parish also boasted a grade school with 800 pupils and a high school—originally a two-year commercial program expanded to four years in 1937. (Courtesy of St. Procop Parish.)

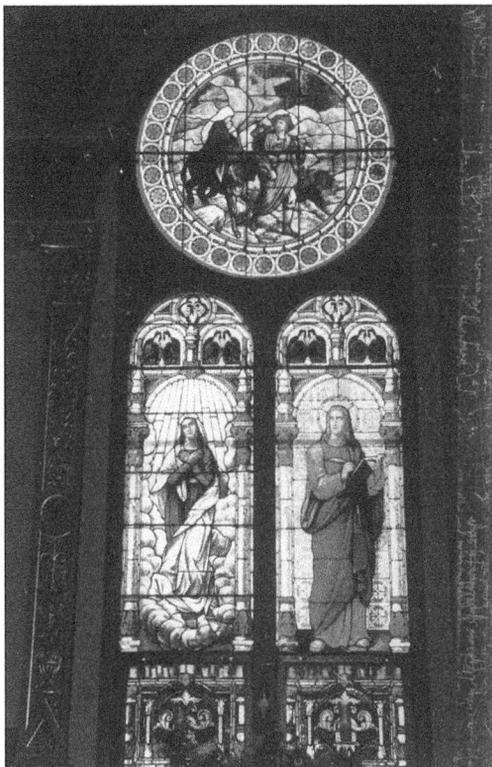

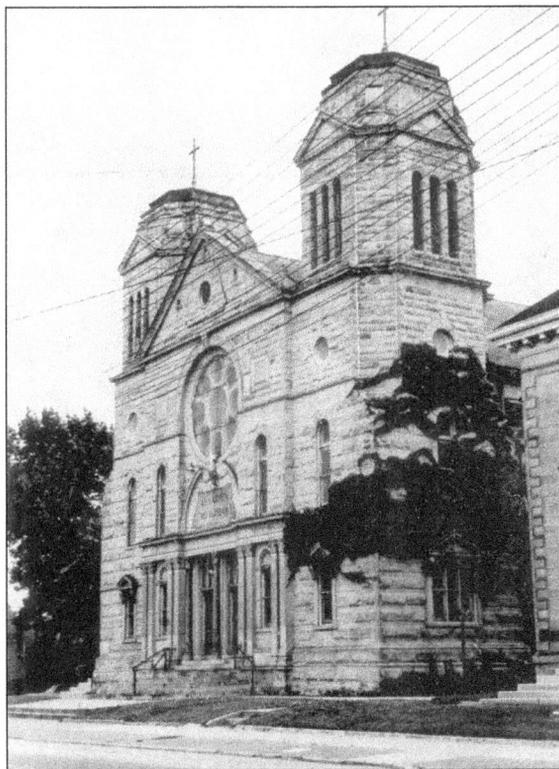

In later years, St. Procop church would take on this profile, with two truncated towers. In 2009, the Cleveland Catholic Diocese designated St. Procop to be closed. This process is still continuing. (Courtesy of Cleveland Public Library/Photograph Collection.)

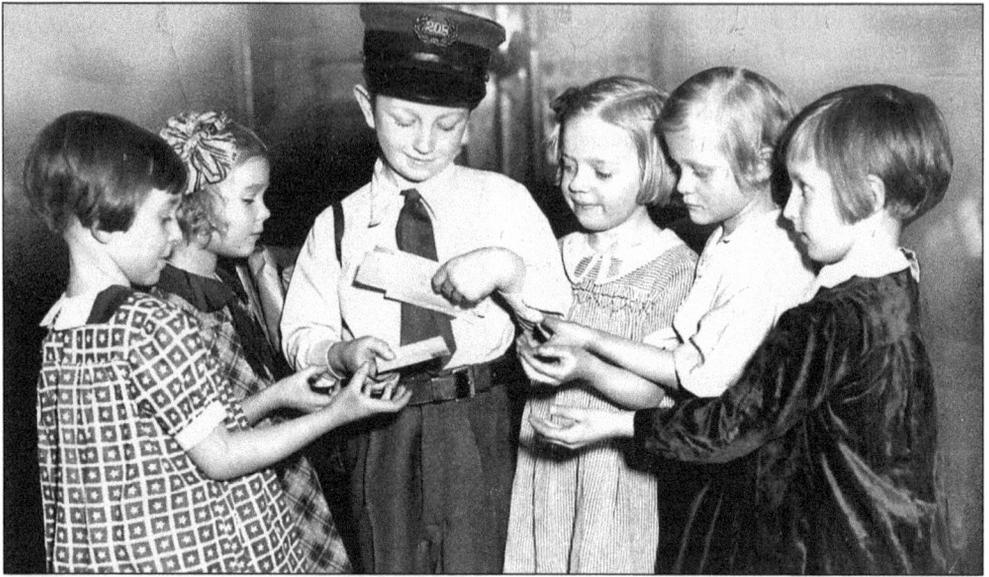

Leonard Tesar (uniformed) was probably the most popular pupil at St. Procop School on February 14, 1936. He played mailman, delivering valentines to the other pupils, who included, from left to right, Jacqueline Heus, Ruth Czinger, Ruth Slota, Virginia Donner, and Mary Catherine Kroupa. Schoolchildren and their parents built a miniature airport with mail planes and trucks, according to newspaper accounts. (Courtesy of Cleveland Press Archives—CSU Library Special Collections.)

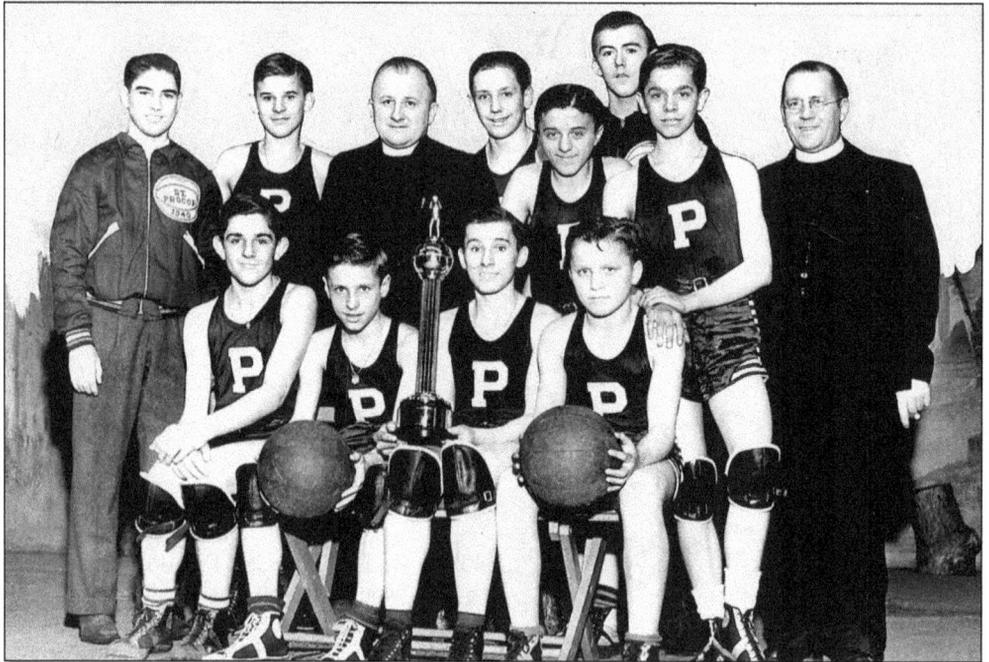

The St. Procop basketball team in 1940 included, from left to right, (first row) Rudy Surej, John Vlasko, George Sup, and Mike Palcisko; (second row) coach Bob Sindelar, Frank Koribek, Fr. J. M. Andel, Andrew Kraft, Emery Palcisko, coach Joe Cihlar, Ray Toman, and Fr. J. T. Huzl. (Courtesy of Cleveland Press Archives—CSU Library Special Collections.)

St. Wenceslaus Day (September 28) is a major event in Cleveland's Czech community, with a different Czech parish hosting the event each year. It was St. Procop's turn in 1930, as thousands took part in the ceremonies and banquet that followed. A parade through the neighborhood preceded the mass in the church. A banquet at the Regnatz Dining Hall in Lakewood followed the mass. (Courtesy of Cleveland Press Archives—CSU Library Special Collections.)

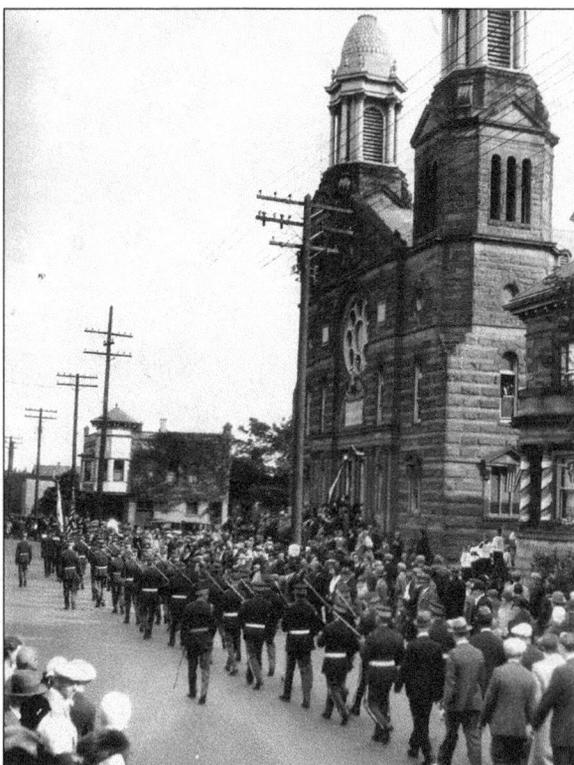

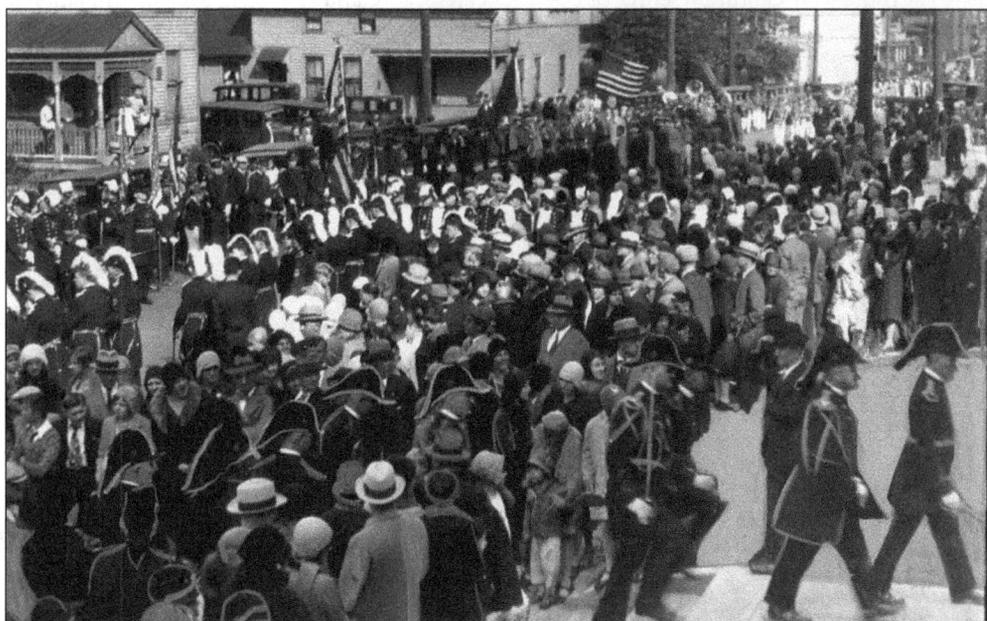

The crowd of spectators at Cleveland's St. Wenceslaus celebration in 1930 gives a good indication of the size and strength of the Czech community at that time. St. Wenceslaus (Svaty Vaclav) is regarded as the patron saint of Bohemia and lived during the 10th century. He was the duke of Bohemia and was assassinated by his brother Boleslav. (Courtesy of Cleveland Press Archives—CSU Library Special Collections.)

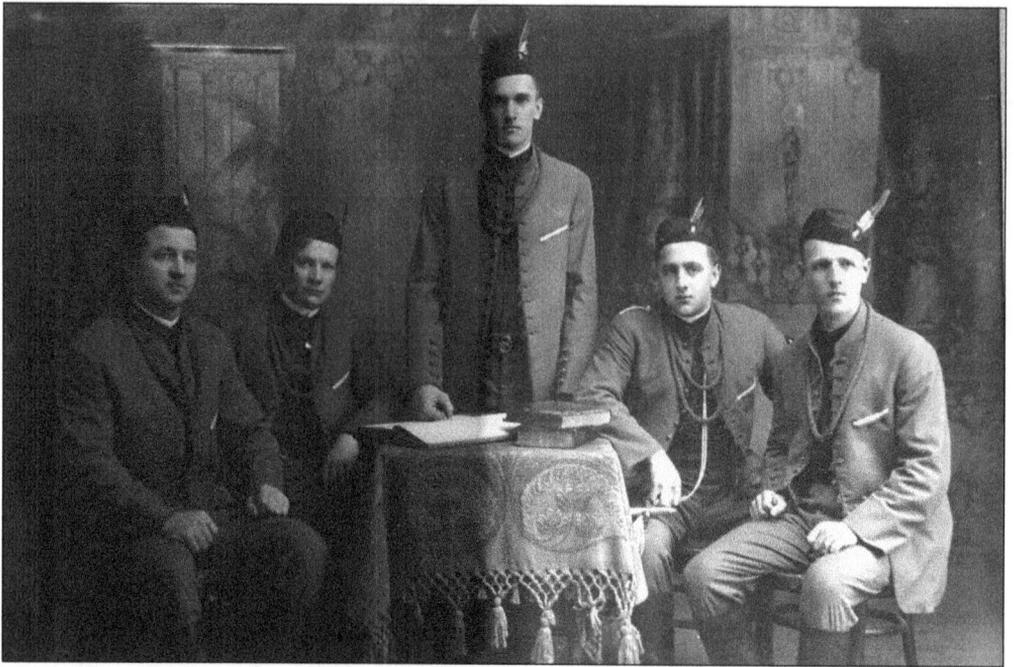

Sokol Nova Vlast was founded in 1892, meeting at Ceska Sin Sokol Hall on Clark Avenue. According to the *Encyclopedia of Cleveland History*, its membership grew to nearly 600 by 1935. In 1976, Sokol Nova Vlast merged with Sokol Tyrs to form Sokol Greater Cleveland, which now meets at the Czech Cultural Center of Sokol Greater Cleveland (formerly Bohemian National Hall). (Courtesy of the Czech Cultural Center of Sokol Greater Cleveland.)

Adding color to an old-fashioned Czech beer festival at Ceska Sin Sokol Hall on Clark Avenue are John Galik of Independence and Betty Hosticka of Seven Hills. Sokol Nova Vlast sponsored the event, which drew about 500. (Courtesy of Cleveland Public Library/Photograph Collection.)

Four

KARLIN AND CORLETT

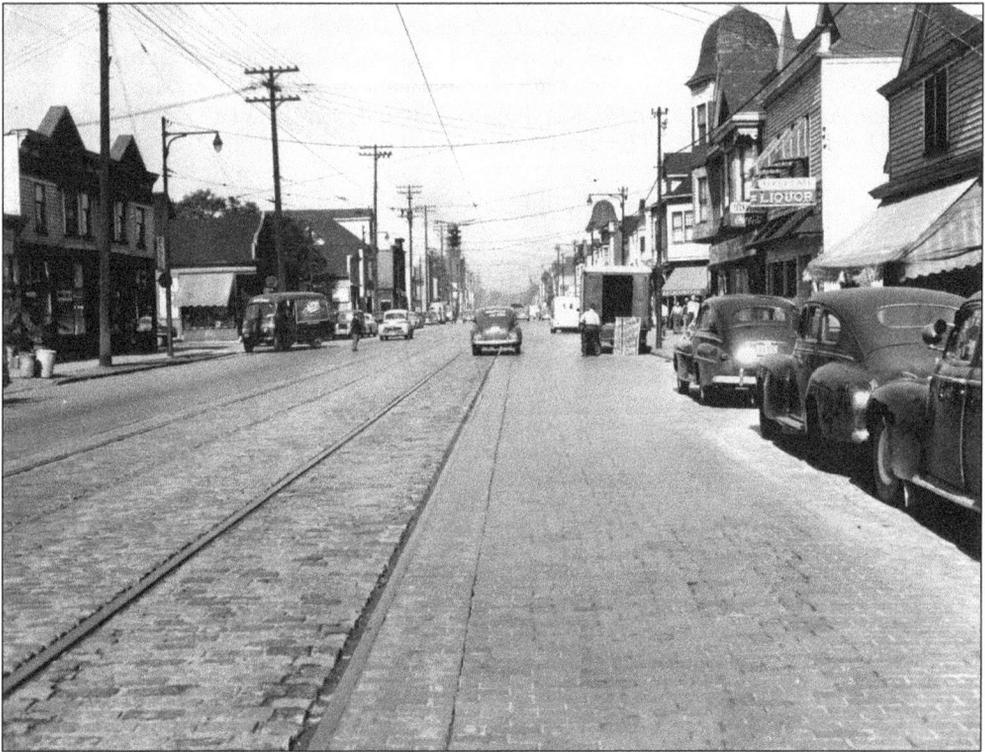

In 1935, Fleet Avenue was the heart of the area surrounding St. John Nepomucene Parish, with a variety of businesses for all the neighborhood's needs. The area, now regarded as part of Slavic Village, was called Karlin, after a suburb of Prague, by an early saloonkeeper and meat market owner in 1891. Residents originally attended Our Lady of Lourdes Parish, but in 1902 population increased to allow them to establish St. John Nepomucene Parish. (Courtesy of Cleveland Press Archives—CSU Library Special Collections.)

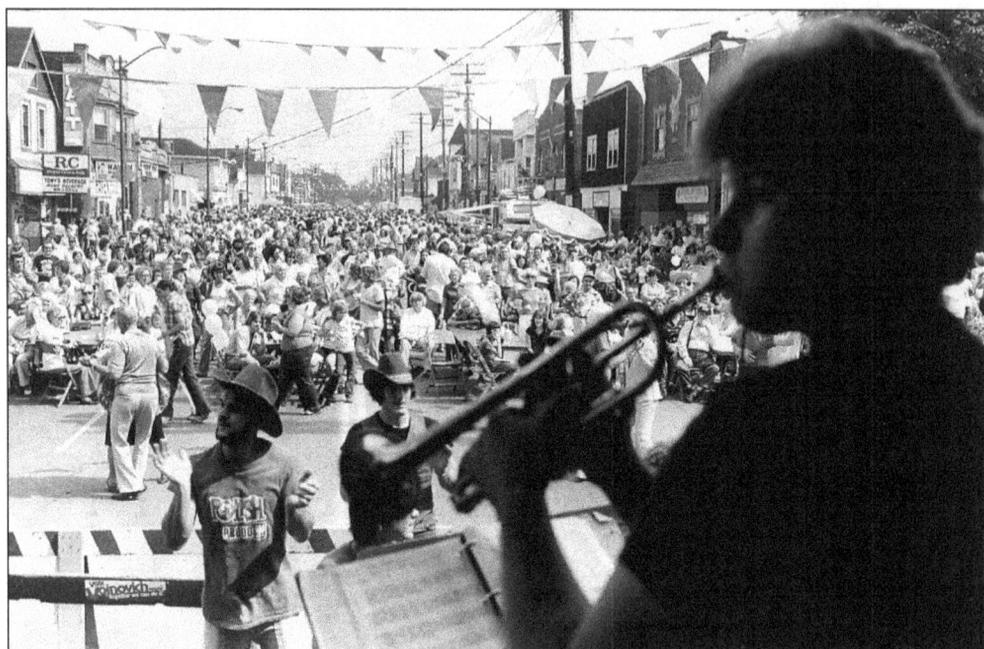

This is Fleet Avenue in 1980, site of the first Slavic Village Harvest Festival. About 15,000 people attended the event, which featured music, dancing, and ethnic food and celebrated the renaissance of the Slavic Village neighborhood. (Photograph by Van Dillard; courtesy of Cleveland Press Archives—CSU Library Special Collections.)

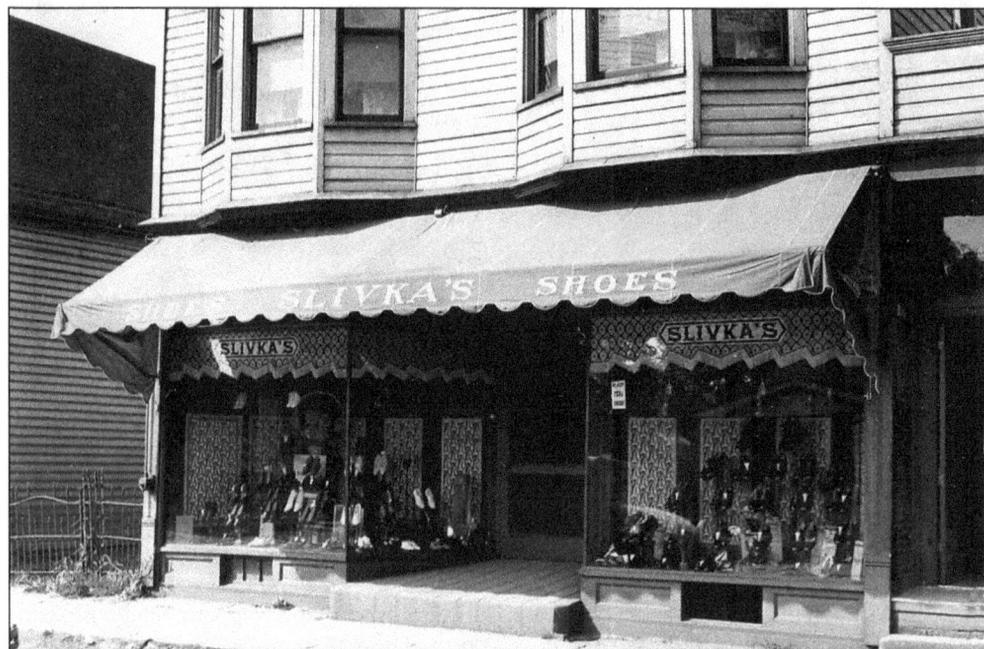

Slivka's Shoes at 5417 Fleet Avenue is shown in September 1935. The store was owned by Stanley Slivka of Washington Park Boulevard in Newburgh Heights. Members of the Slivka family were founding parishioners of St. John Nepomucene Church. (Courtesy of Cleveland Press Archives—CSU Library Special Collections.)

As Cleveland's Czech community continued its move south, they settled near Fleet Avenue. Czech Catholics founded the St. Joseph Society, which raised money to buy land at Fleet and Raus (East 50th) Street and petitioned the Cleveland Catholic Diocese to establish a parish. In 1902, Rev. Frantisek Hroch was named founding pastor of St. John Nepomucene Church. (Courtesy of the Czech Cultural Center of Sokol Greater Cleveland.)

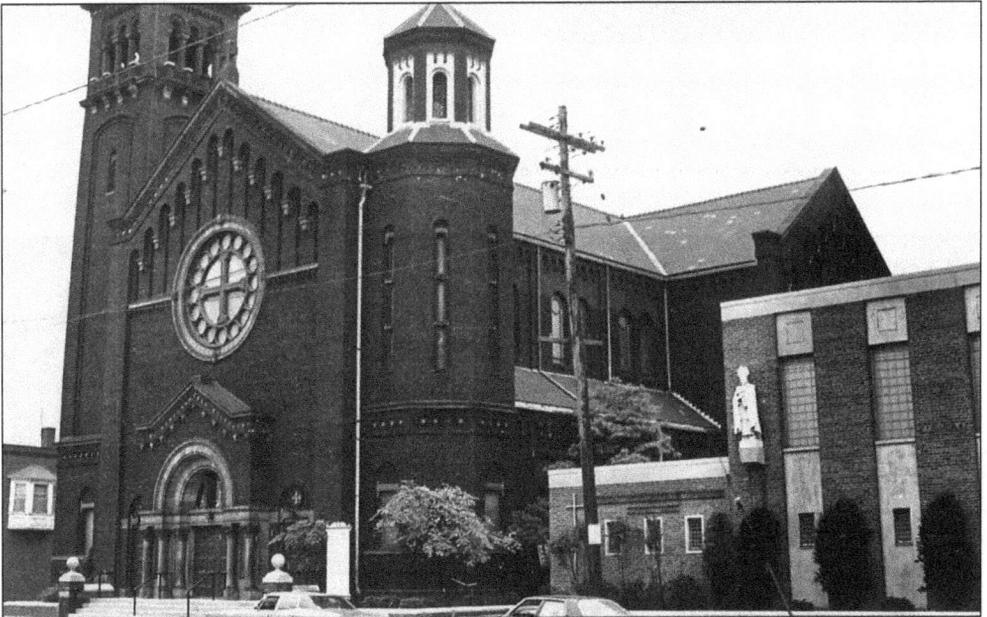

The first St. John Nepomucene Church, at East 50th Street and Fleet Avenue, was built in 1903, shortly after the parish was established. By 1917, the Czech Catholic population of the Karlin area had outgrown the original structure, and the cornerstone was laid for this structure. Three years later, the new church, shown in 1977, was dedicated. (Courtesy of Cleveland Press Archives—CSU Library Special Collections.)

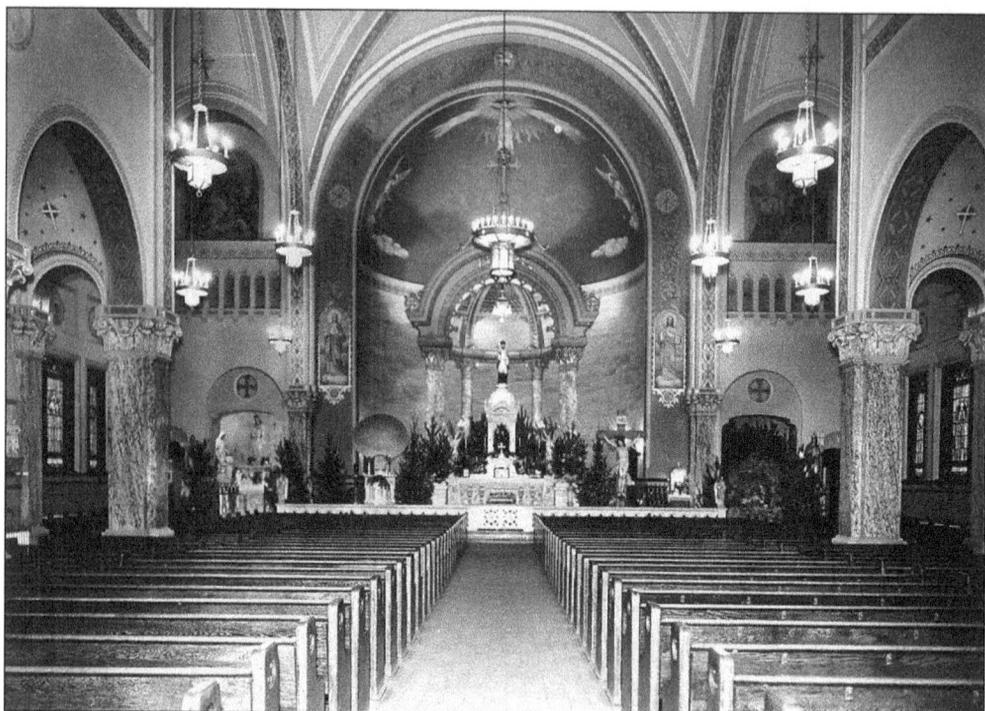

The interior of St. John Nepomucene Church, shown in 1953, contains a rich collection of stained-glass windows honoring Slavic saints and scenes from the Bible. The church is a Romanesque structure of Bokhara brick and Vermont marble. (Courtesy of Cleveland Press Archives—CSU Library Special Collections.)

This photograph of the St. John Nepomucene Altar and Rosary Society from 1963 marked the 60th anniversary of the group, which was founded shortly after the parish was established. Much of the early fund-raising and community building for the parish can be attributed to the St. John Nepomucene Altar and Rosary Society. (Courtesy of Joseph Kocab.)

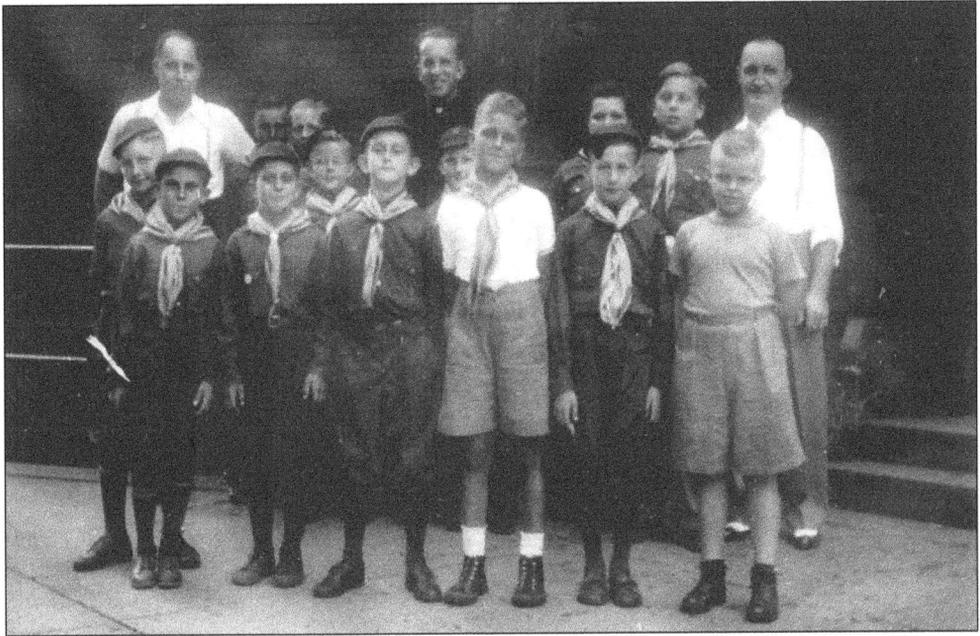

As community anchors, Cleveland's Czech parishes did not ignore American culture and, in fact, encouraged parishioners to keep their heritage and become good citizens. These Czech-American Cub Scouts from St. John Nepomucene Parish, shown in 1942, exemplify that philosophy. Adult leaders in this photograph are Ed Dvorak (left), Fr. Edward Rumplik (center), and John Tesar (right). Joseph Kocab, contributor of this photograph, is in the front right. (Courtesy of Joseph Kocab.)

The wedding of Bozena (Bertha) Masin, the oldest daughter of Frank and Frances Masin of Newburgh Heights, and Jan Tucek took place about 1915. Members of St. John Nepomucene Parish, they eventually settled on Alpha Avenue in Newburgh Heights. (Courtesy of Jane Tucek Donovan.)

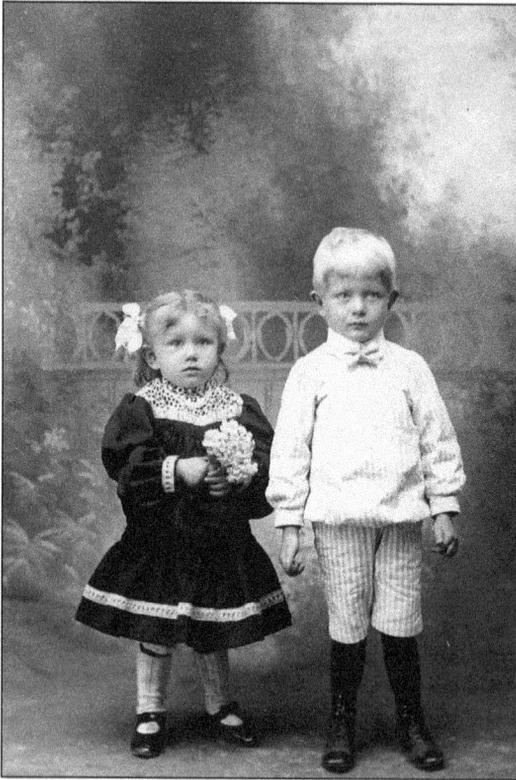

Joseph Holat Jr. and Emma Holat are shown in this 1906 photograph. They were the two oldest children of Joseph and Anna Holat. Joseph Sr., a building contractor, and his family lived at the time on East 52nd Street south of Fleet Avenue, almost in the shadow of St. John Nepomucene Church. In a few years, the family would move to Washington Park Boulevard in Newburgh Heights, where Joseph Sr. would build a number of new homes. (Courtesy of Marion Adams.)

Lillian Holat Gabriel, second-youngest daughter of Joseph Holat, poses with Newburgh Heights councilman Ed Lisy in what appears to be an early tailgate party. (Courtesy of Marion Adams.)

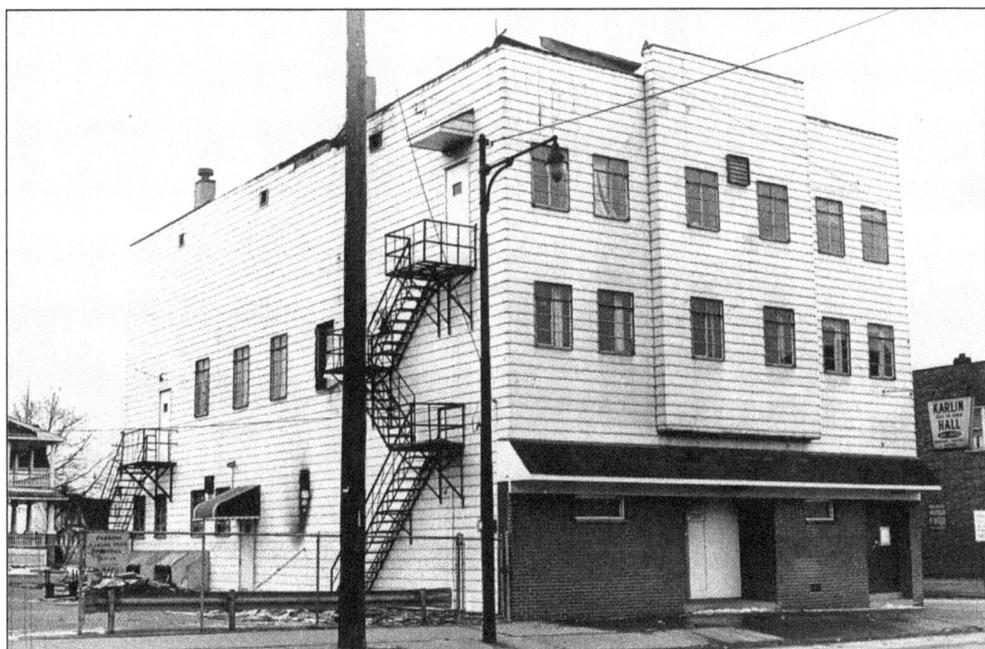

The original Karlin Hall, founded in 1935 by three lodges of the Czech fraternal insurance society the Catholic Workmen, stood near East 53rd Street and Fleet Avenue. Of the Czech halls in Cleveland, Karlin represented the Czech Catholic community. (Courtesy of Cleveland Press Archives—CSU Library Special Collections.)

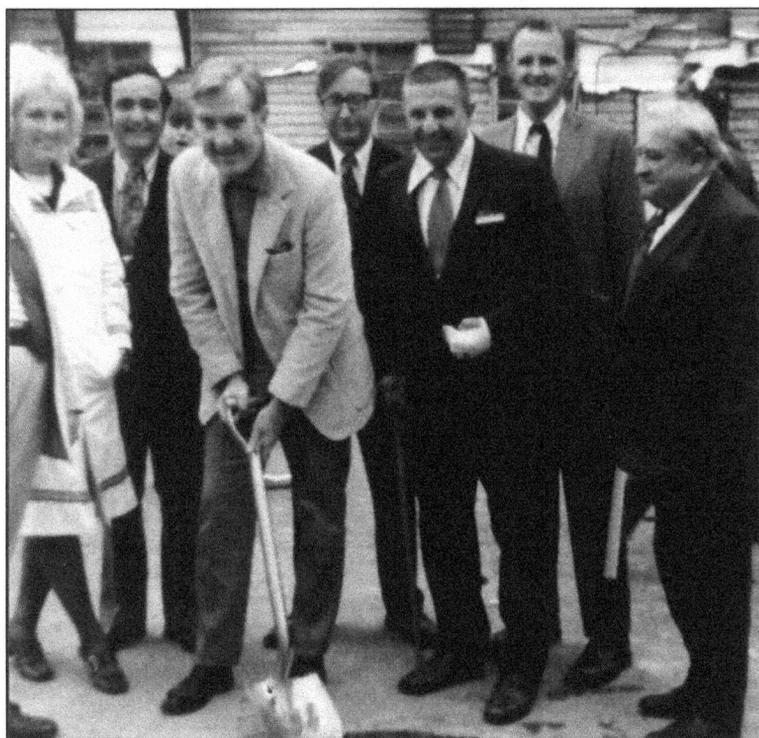

Cleveland Czechs were quick to respond to the tragic fire that destroyed the original Karlin Hall in 1972. By April 1972, ground was broken at East 53rd Street and Fleet Avenue for a new hall. Present for the groundbreaking was then Ohio governor John Gilligan. (Courtesy of Joseph Kocab.)

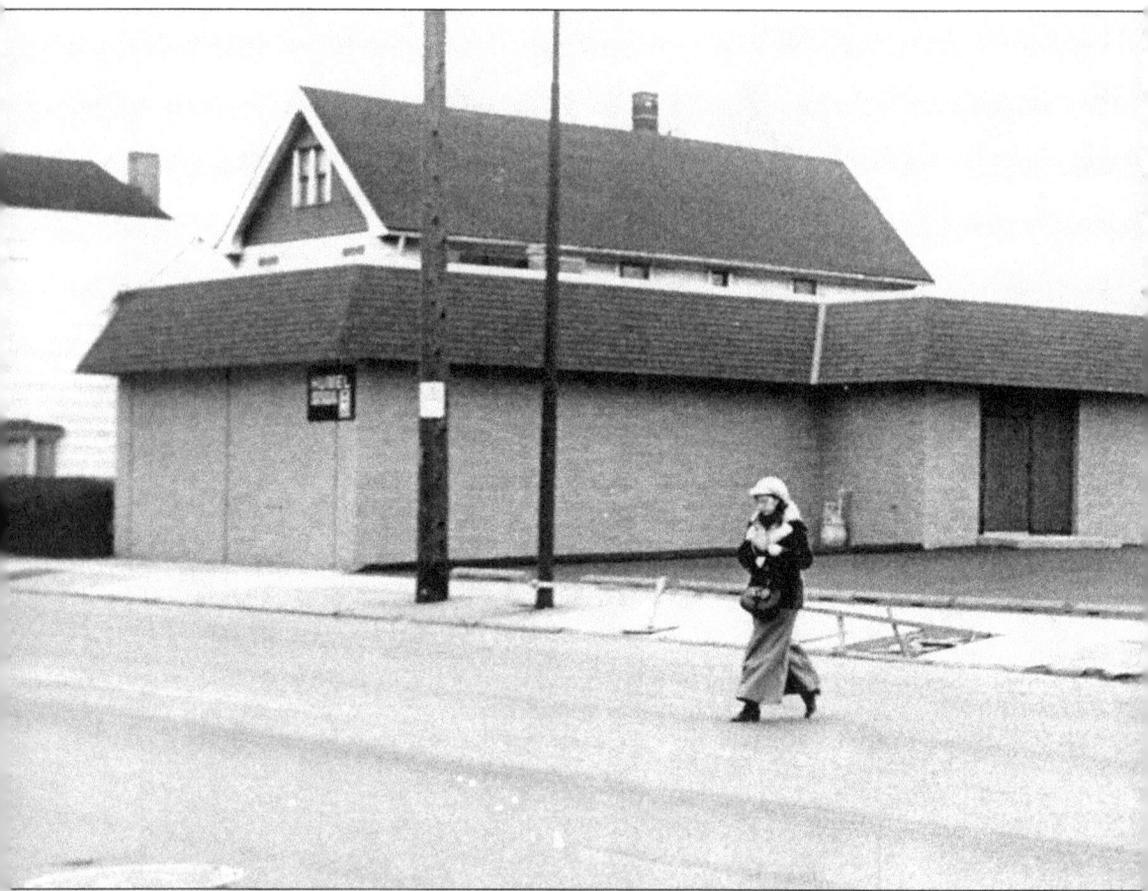

The old Karlin hall was partially destroyed by fire in 1972 and was replaced by a new, one-story building slightly larger than the old hall at a cost of $180,000. The new hall was a vast improvement over the old, where food was prepared upstairs and brought downstairs

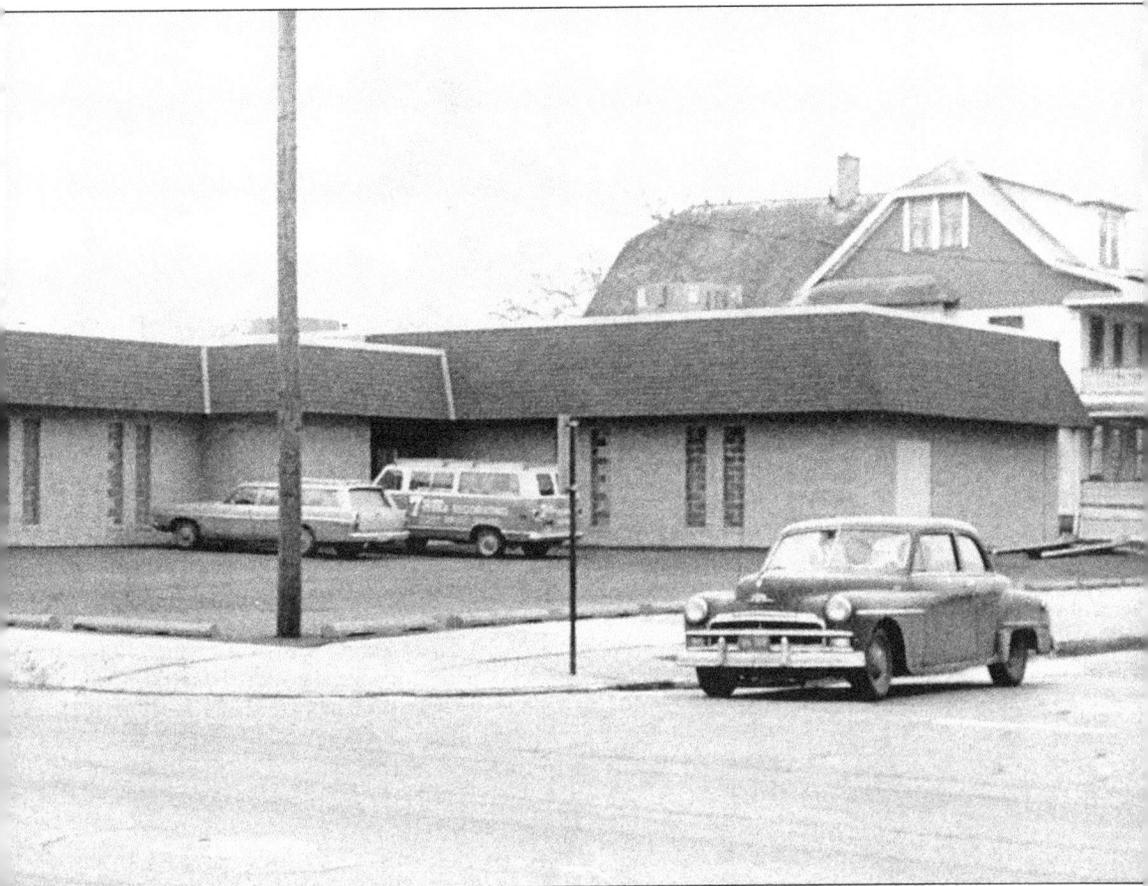

to diners at weddings and other events. (Courtesy of Cleveland Press Archives—CSU Library Special Collections.)

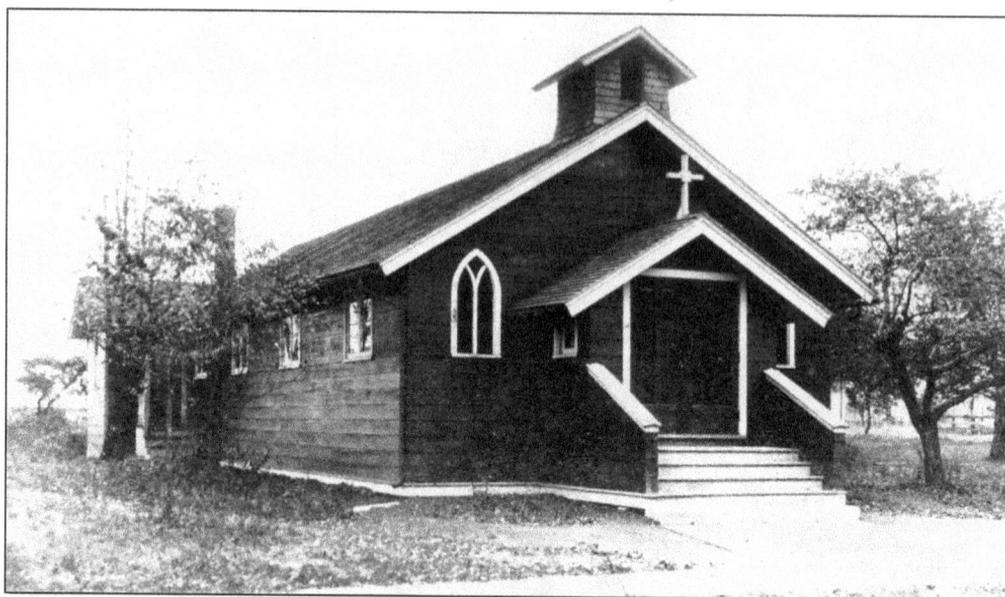

As Czechs continued their trek eastward, they settled along Kinsman and Union Avenues and into the Corlett area, along East 131st Street. Masses for Catholics in this community were first said in an orphanage run by the Notre Dame Sisters of Cleveland on Buckeye Road. By November 1911, this chapel on East 131st Street was built and named "Holy Family" at the request of Fr. Stefan Furdek. (Courtesy of Archives, Diocese of Cleveland [ADC].)

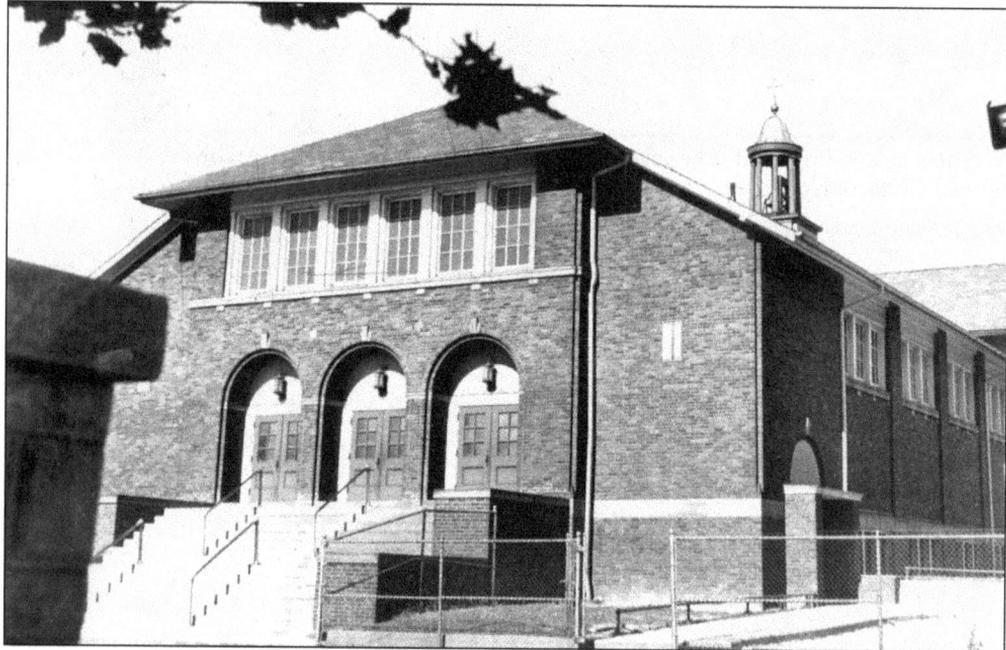

By 1920, the Corlett/Mt. Pleasant Czech settlement had grown, and Holy Family parish expanded into this combination church-school building at East 131st Street and Chapelside Avenue. The parish thrived before and after World War II, but as families of parishioners dispersed to the suburbs, Holy Family lost population. Finally in June 1988, parishioners voted to close the parish. (Courtesy of Cleveland Public Library/Photograph Collection.)

Five

DTJ'S PARADISE ON EARTH

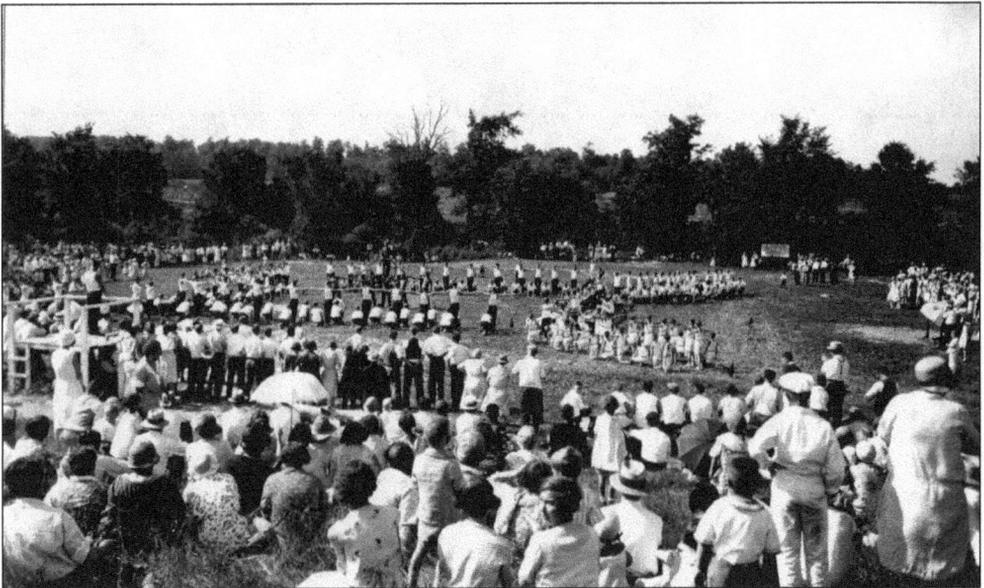

Shortly after World War I, bucolic Geauga County to the east of Cleveland became a destination for some Czech families seeking more space. Among those who made a home there was the Delnicka Telocvicna Jednota (DTJ) or Workers' Gymnastic Union. Shown here is the crowd at a July 4, 1929, gymnastics exhibition. (Courtesy of DTJ Historical Archives.)

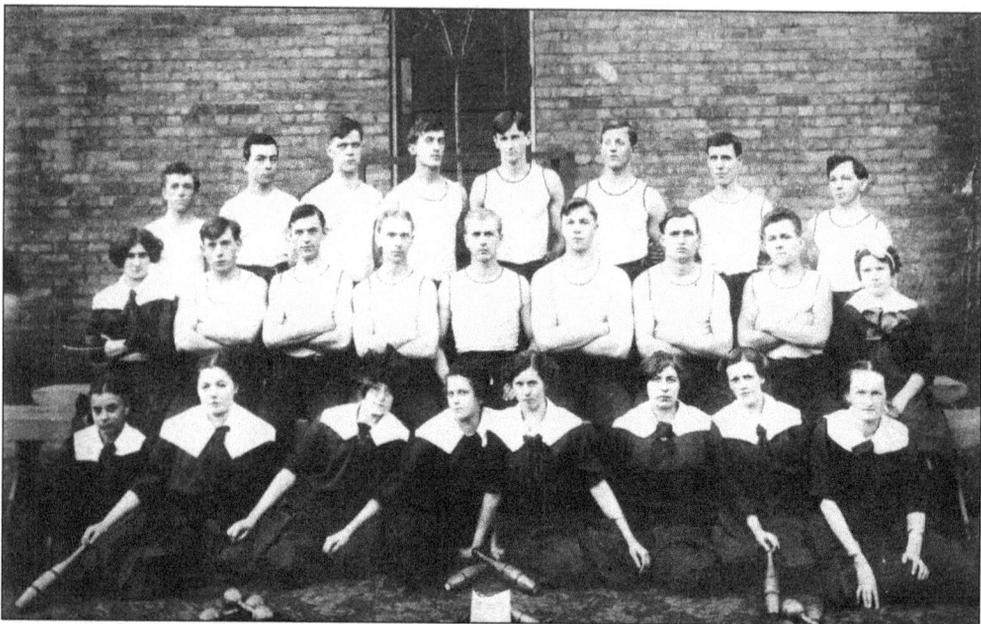

When DTJ was originally established at a hall on Quincy Avenue in Cleveland in 1909, it was known as the DTJ Lassalle Unit, shown here in 1929. DTJ's program consists of enabling the youth of the world to take part in the great movement for a better and more just organization of society. (Courtesy of DTJ Historical Archives.)

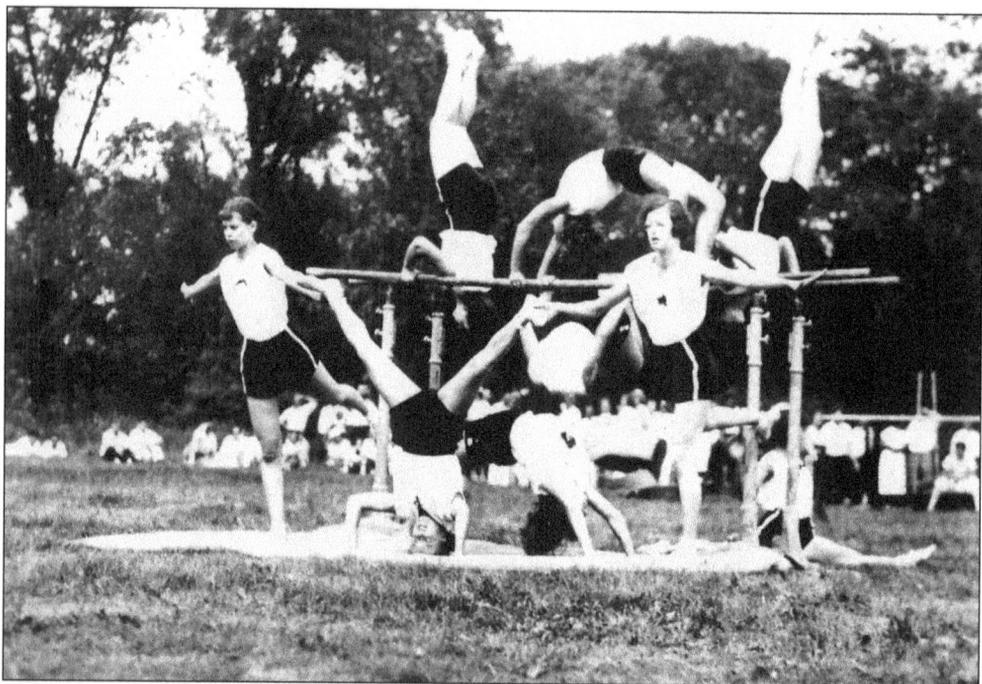

DTJ, as it is generally known, was formed in Prague in 1897, and established a branch in Cleveland in 1909—the first DTJ group in the United States. Members regarded themselves as a part of the great labor movement. Shown here is a July 4 exhibition in the late 1940s or early 1950s. (Courtesy of DTJ Historical Archives.)

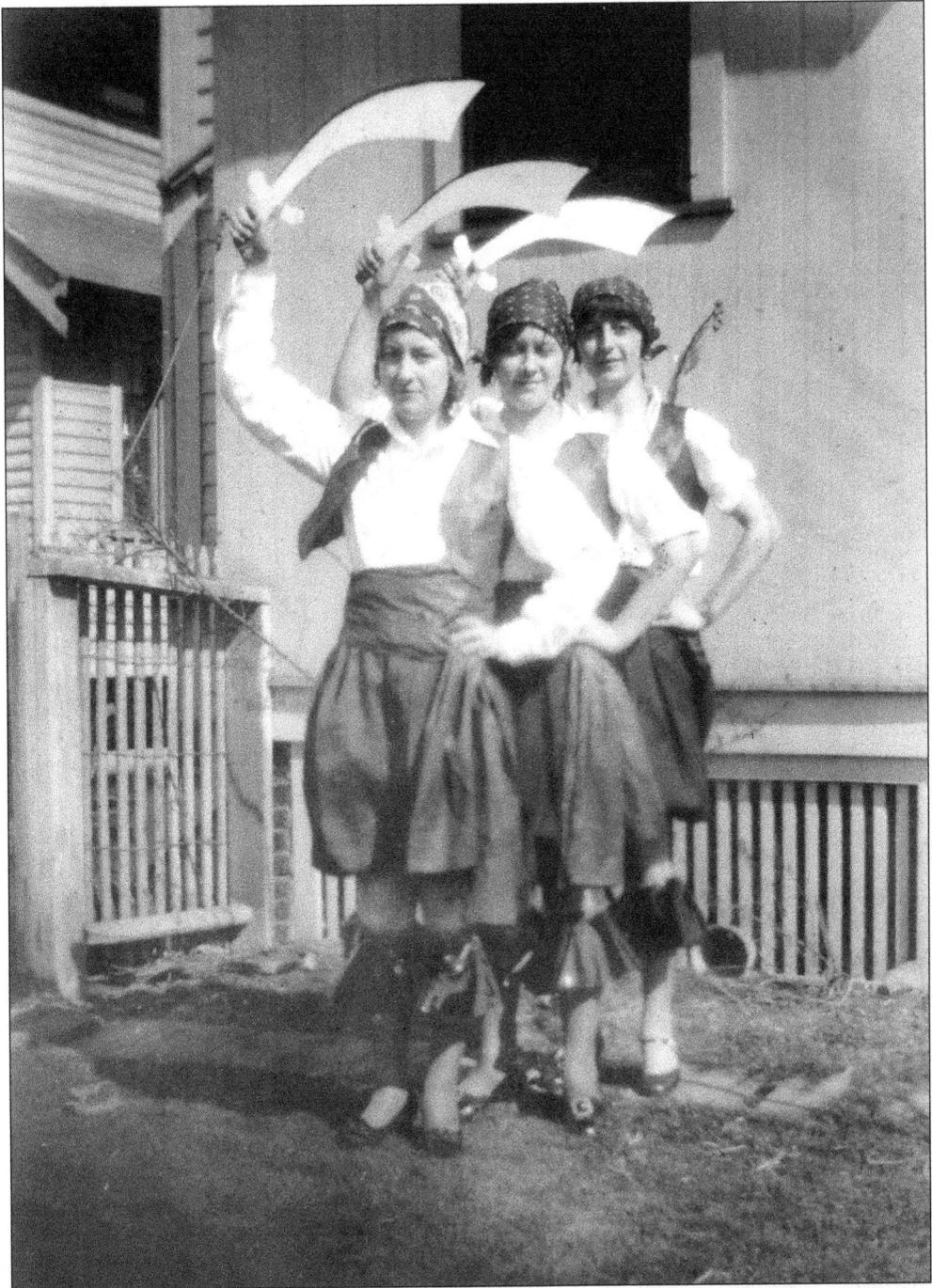

Participating in an exhibition March 11, 1929, four years after the DTJ farm (Taborville) was established in Geauga County, are, from left to right, Antoinette Krabec, Alby Cerny, and Vlasta Cerny. The 100 acres of farms and woodlands were divided into one-third-acre lots and a public area comprising a social hall, parking lots, a gymnastic/athletic field, and a 2.5-acre swimming lake. (Courtesy of DTJ Historical Archives.)

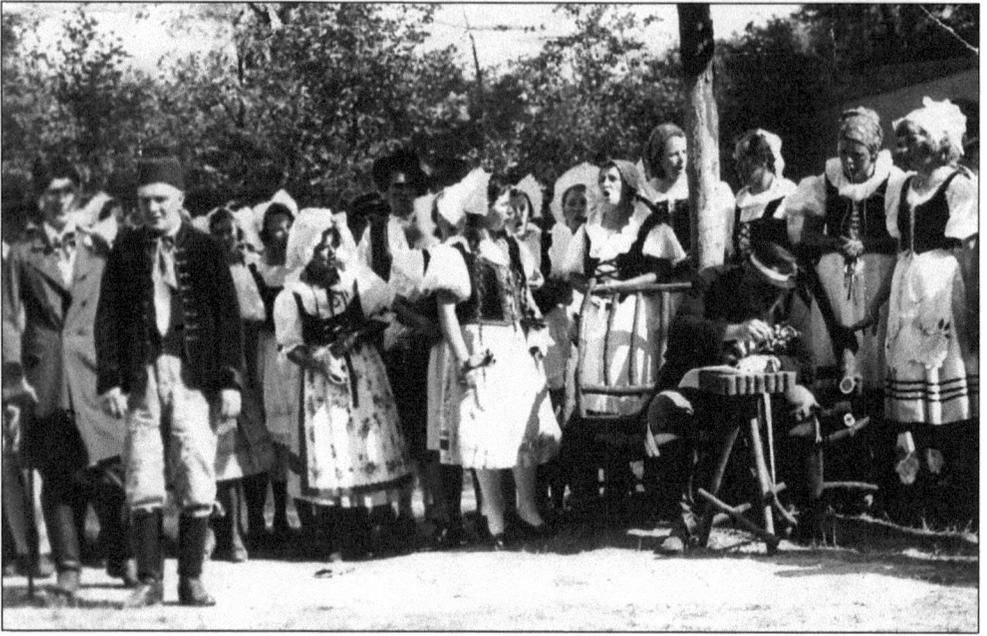

The Vojan Singing Society was formed in 1924 as part of DTJ and named for Czech character actor Eduard Vojan, well known for his portrayals of the actual lives of the peasants in Central Europe. The society's noteworthy presentations include numerous performances of the Czech opera *The Bartered Bride* by Bedrich Smetana, shown here at its first performance in 1934 at the DTJ Woodland Theater. (Courtesy of DTJ Historical Archives.)

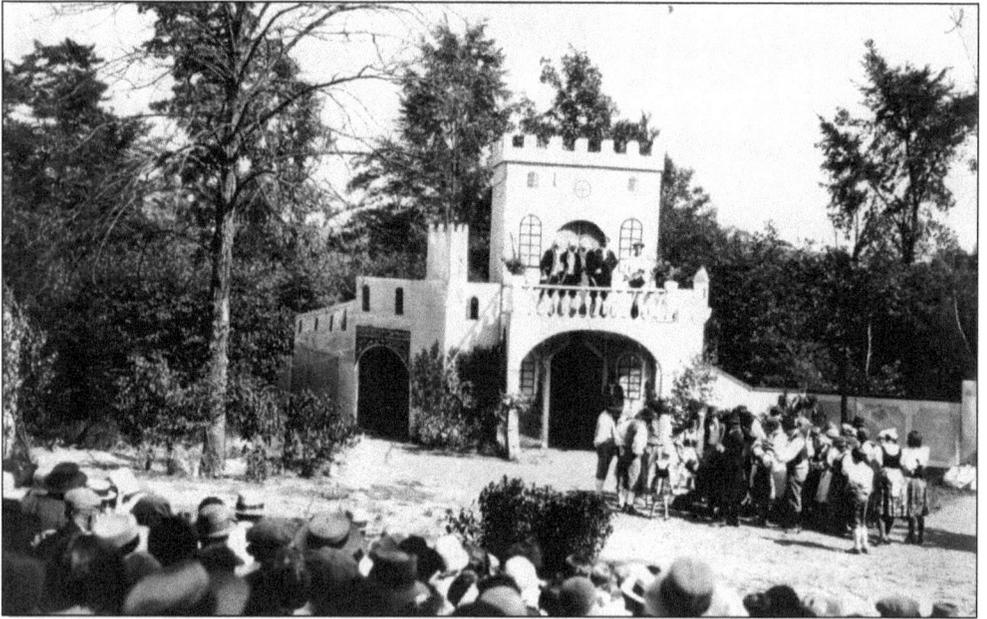

For a nonprofessional group, Vojan's performances were nothing less than spectacular as evidenced by this 1929 performance of the operetta Jan Vyrada, performed in the DTJ outdoor Woodland Theater. Vojan member James Pokorny built the scenery. (Courtesy of DTJ Historical Archives.)

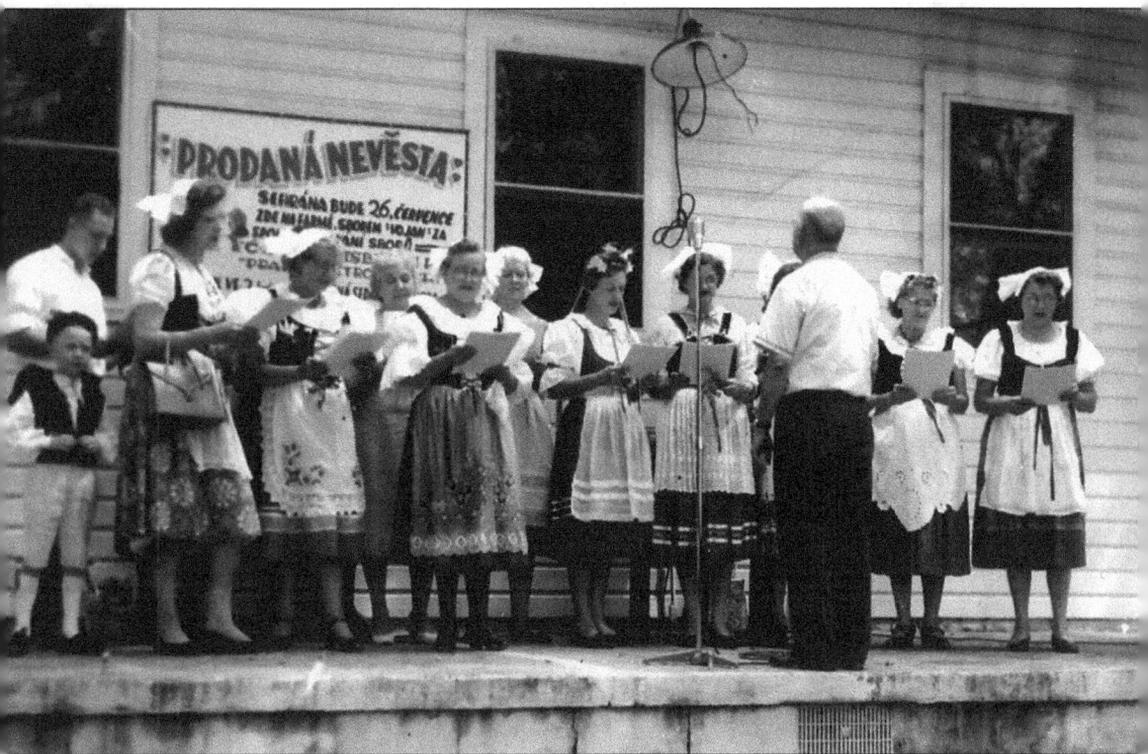

In its later years, Vojan concentrated more on concerts rather than full-blown operatic and theatrical productions. Shown here is the Vojan Singing Society performing on the porch platform at DTJ Taborville. The music director is J. V. Krabec, who directed 95 percent of Vojan's performances from the time the group was founded until his death in 1960. (Courtesy of DTJ Historical Archives.)

The Vojan Singing Society's most often-performed production was Bedrich Smetana's opera *The Bartered Bride*. Vojan ceased presenting plays in the 1960s, but it continues to make annual appearances at DTJ's Taborville settlement at Auburn Township in Geauga County. Shown here are Lu Hromadka and Ludmila Hyvnar, who appeared in an operetta presented in March 1962 at Komensky Hall on East 131st Street. (Courtesy of Cleveland Press Archives—CSU Library Special Collections.)

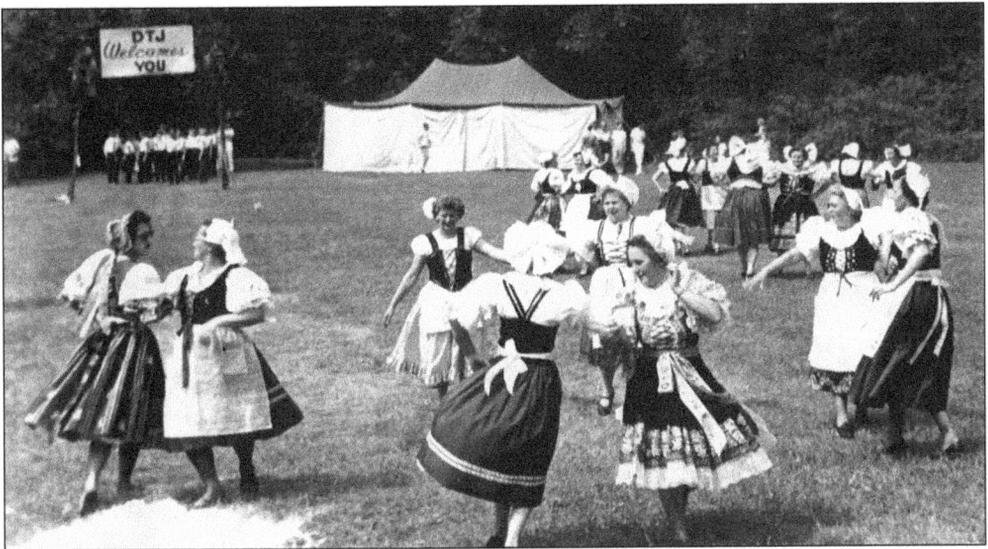

Part of the annual exhibitions at DTJ has been the ladies program, which features women in old-country costumes re-creating the dancing traditions that their parents brought to the United States. (Courtesy of DTJ Historical Archives.)

An annual event at DTJ's Taborville settlement in Auburn Township is the Obzinky, or Harvest Festival, the re-creation of a folk festival held to celebrate the completion of the harvest and to honor landowners, who in turn treated their farm servants to a feast. Participants in this DTJ Harvest Festival parade include, from left to right, (first row) Dick Mottl, Alice Prudek, Beverly Krofta, and Phyllis Plesmid; (second row) Brian Plesmid and Margie Svoboda. (Courtesy of DTJ Historical Archives.)

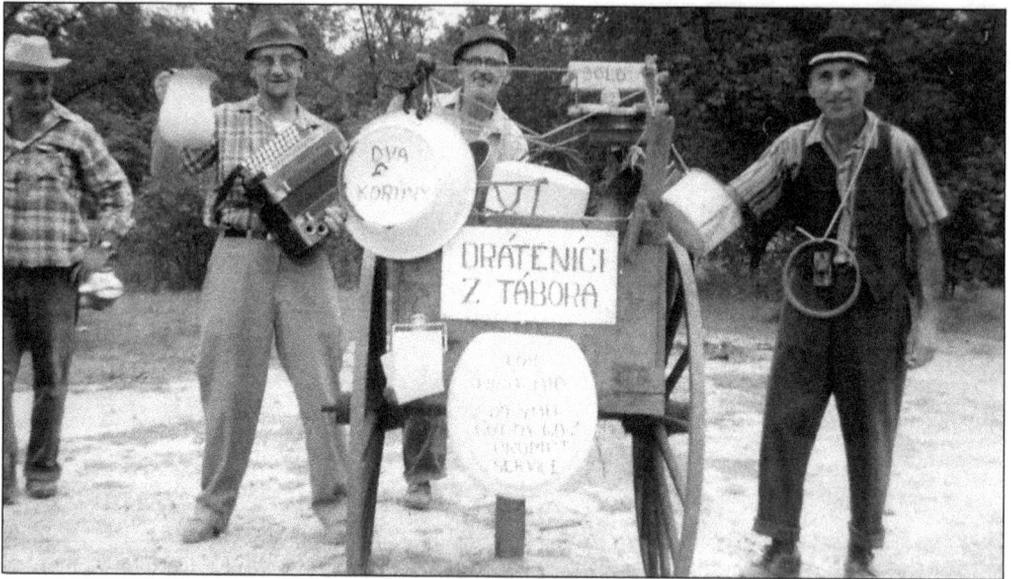

For the DTJ Harvest Festival in 1948, this group came as tinkers, reminiscent of the itinerant kettle-menders who traveled from village to village in old Bohemia. With festivals such as this, Taborville became a link to their native land for many Czech immigrants and their children. Holding the accordion is Lad Prudek, accompanied by Tony Ekl and John Plesmid. The man on the far left is unidentified. (Courtesy of DTJ Historical Archives.)

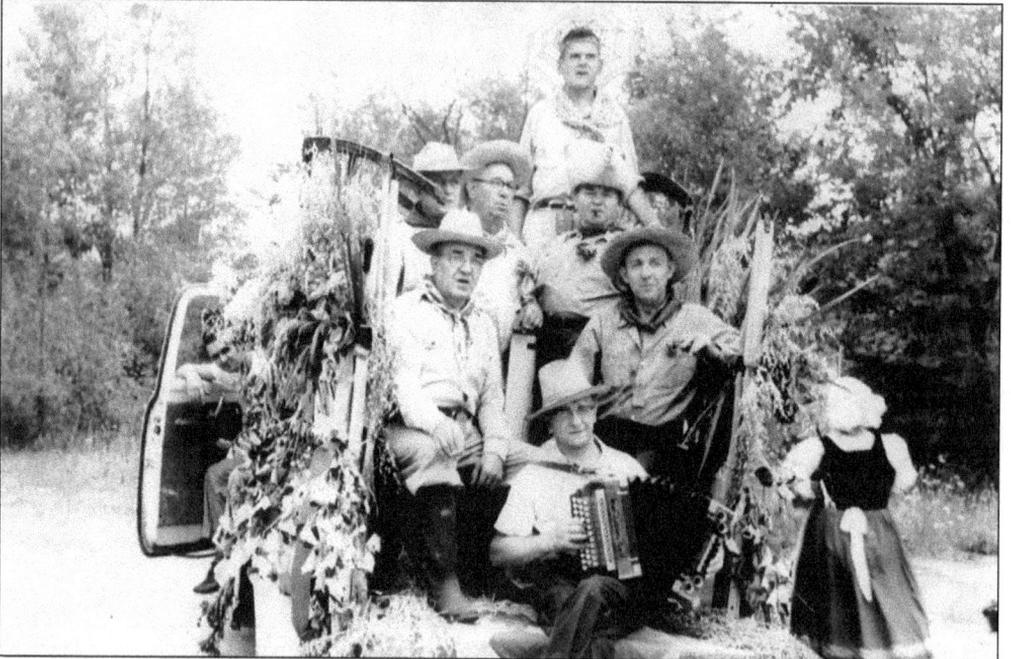

This float in the DTJ Harvest Festival parade dates to 1950–1956. Shown here are, from left to right, (first row) Lad Prudek; (second row) Joe Cech and Henry Svoboda; (third row) Nates Vild, John Svoboda, and James Stros; (fourth row) Henry Jirousek. Czechs often reenacted rituals and customs associated with these traditional festivals during folk festivals at home and in other countries. (Courtesy of DTJ Historical Archives.)

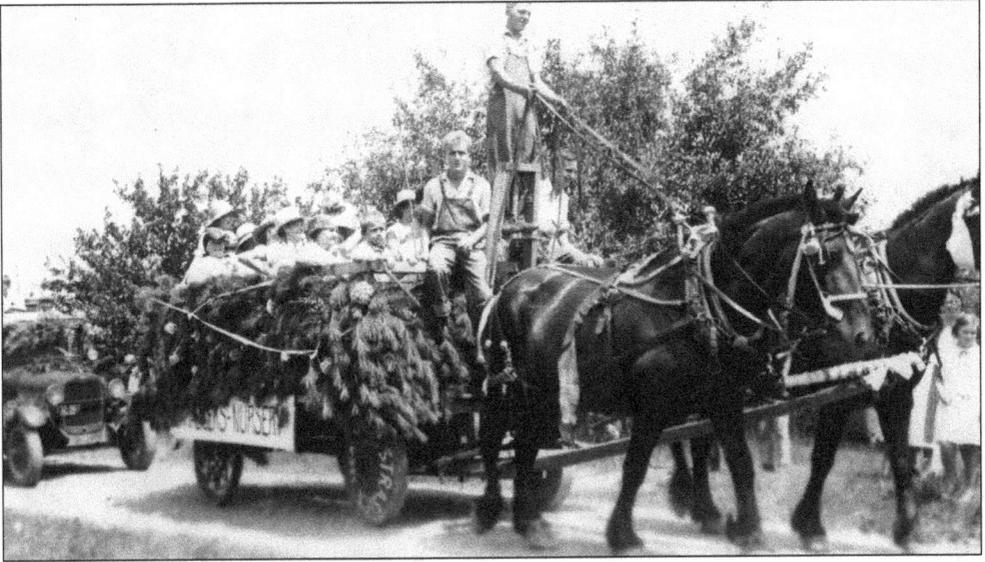

This float was part of the DTJ Harvest Festival parade in the 1950s or earlier. (Courtesy of DTJ Historical Archives.)

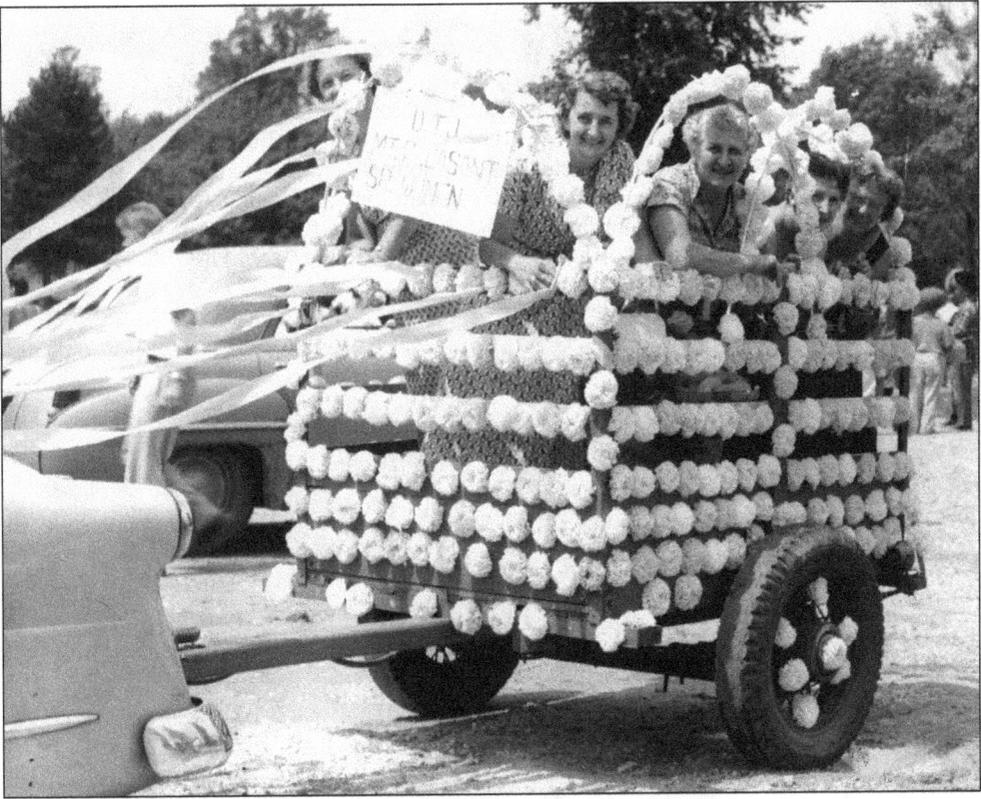

Participating in the 1956 DTJ Harvest Festival parade are, from left to right, Alby Plesmid, Vlasta Mottl, Mae Kerner, and Viola Prudek. (Courtesy of DTJ Historical Archives.)

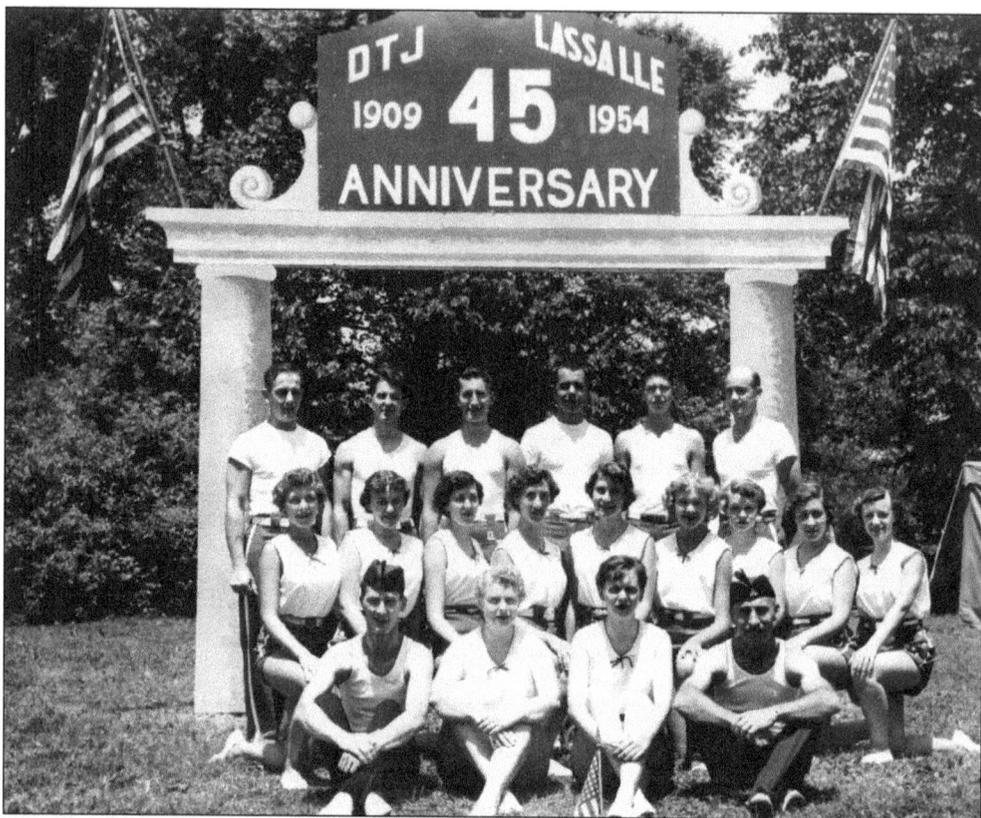

In 1954, DTJ Lassalle celebrated its 45th anniversary. From left to right are (first row) instructor Bob Krobusek, Dory Novotny, Lori Ekl, and instructor John Plesmid; (second row) Beverly Gorek, Jean Slater, G. Maurer, Barbara Stipek, Gayle Grossman, Beverly Bysura, Alice Prudek, Marge Svoboda, and Shirley Onefrey. Identifiable in the third row are George Senft, Dick Brichacek, Brian Plesmid, Bob Gorek, Dick Mottl, and Carl Fath. (Courtesy of DTJ Historical Archives.)

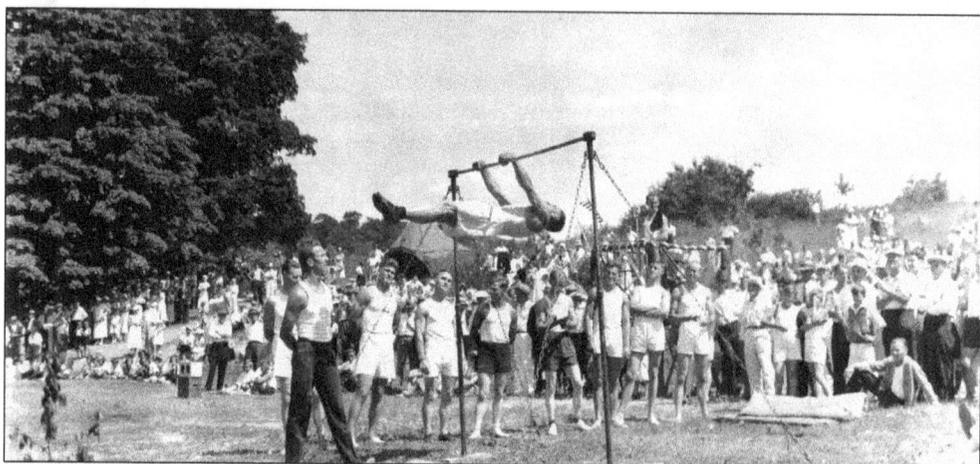

From its very beginnings in Europe and the United States, one of DTJ's focuses has been gymnastics. Gymnastics classes are conducted by DTJ to the present day. Shown here is an early DTJ gymnastics exhibition. (Courtesy of DTJ Historical Archives.)

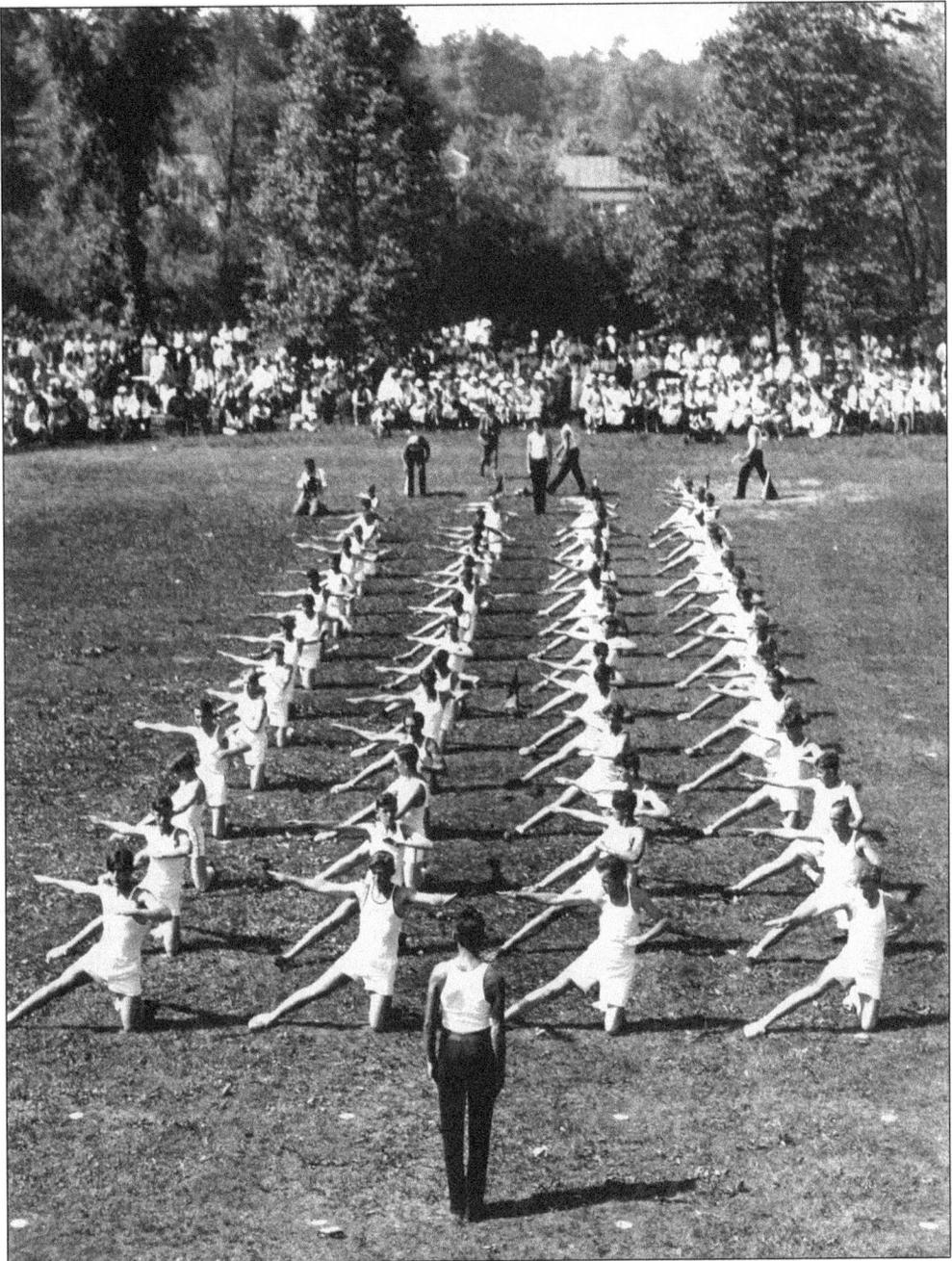

One of the major events of the DTJ was the Olympiad, which took place at the group's headquarters at Taborville, in Auburn Township in Geauga County. At the July 1936 presentation, this group of gymnasts was part of a massed array of 1,000 athletes who presented gymnastic demonstrations and massed drills to an audience of 10,000. Shown here are members of the junior boys division of the Cleveland DTJ. (Courtesy of Cleveland Press Archives—CSU Library Special Collections.)

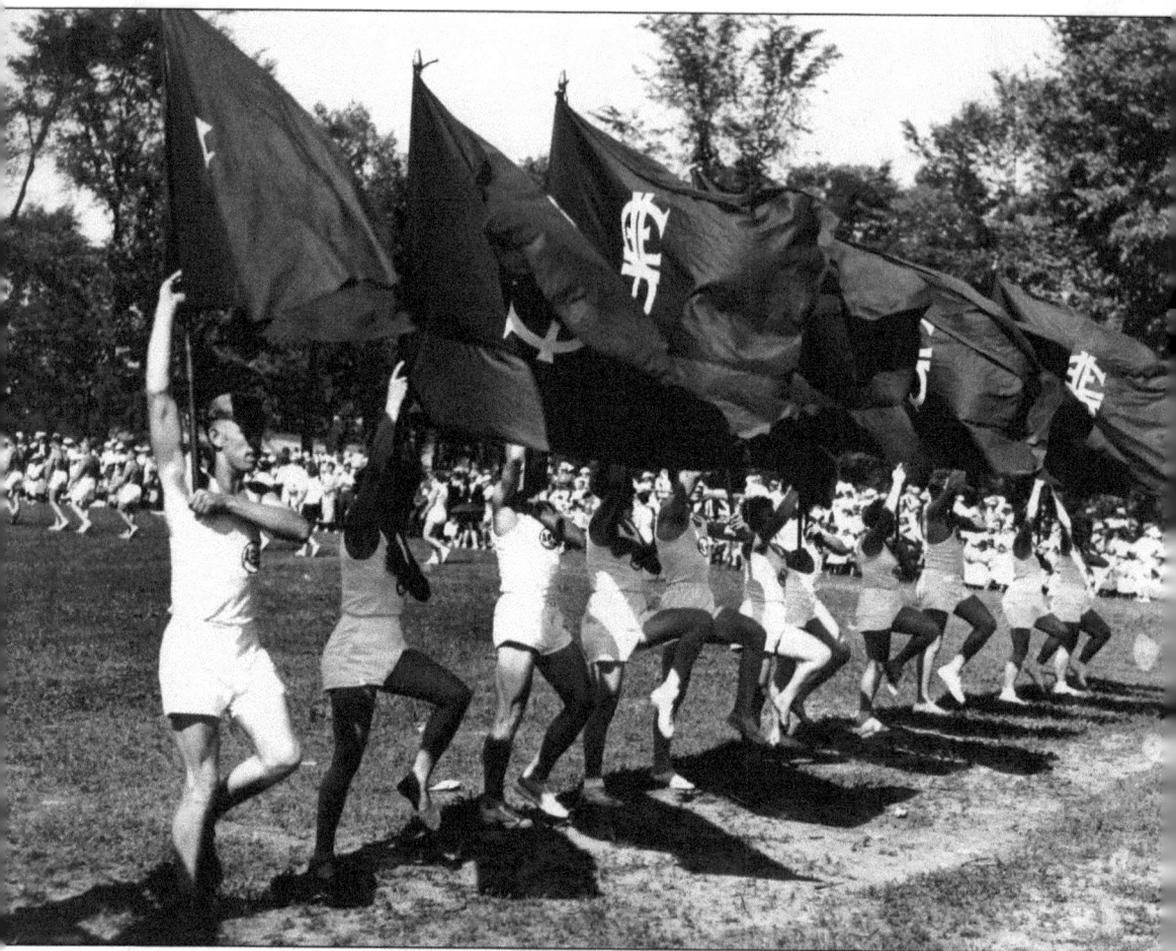

Also appearing at the 1936 DTJ Olympiad was this flag drill team. Besides the local DTJ, groups also came from Detroit, New York, Chicago, St. Louis, and Pittsburgh, as well as from Czechoslovakia. (Courtesy of Cleveland Press Archives—CSU Library Special Collections.)

Six

CZECH NATIONALISM/
AMERICAN PATRIOTISM

MASARYKOVY
přednášky.
24. a 25. srpna, 1907

V SOBOTU V 8 HOD. VEČ.

přednáší v Čes. Národní Síni
PROFESSOR
T. G. MASARYK

——————na větu:——————

"Jakých vědomostí a znalostí je nám
tu nejvíc zapotřebí".

Při tom vytkne poměr Sokolstva k svobodomyslnosti.

V neděli ve 2 hodiny odpol.

......přednáší......

v Sokolovně Sokola Cleveland.

"O utváření se této republiky
v budoucnosti."

Sokolovna ta stojí na rohu
Plymouth a Central Avenue.

Vstup do obou přednášek je volný.

Čechové, přijďte v nejvalnějším počtu pozdravit a poslechnout
velkého krajana.

On August 24 and 25, 1907, Tomas G. Masaryk, who would become the first president of the Czechoslovak Republic, spoke in Cleveland 11 years before the founding of that country. Masaryk was on a speaking tour of the United States. The speech took place at a hall at Plymouth (East 74th) Street and Central Avenue. He also lectured twice at Bohemian National Hall, including one appearance in 1911. (Courtesy of the Czech Cultural Center of Sokol Greater Cleveland.)

Even before World War I, a number of Cleveland Czechs—most of them first-generation Americans—volunteered to serve in the U.S. armed forces. Charles F. Kahoun enlisted and served in the U.S. Army 102nd Cavalry in 1908. (Courtesy of Ellen Howard.)

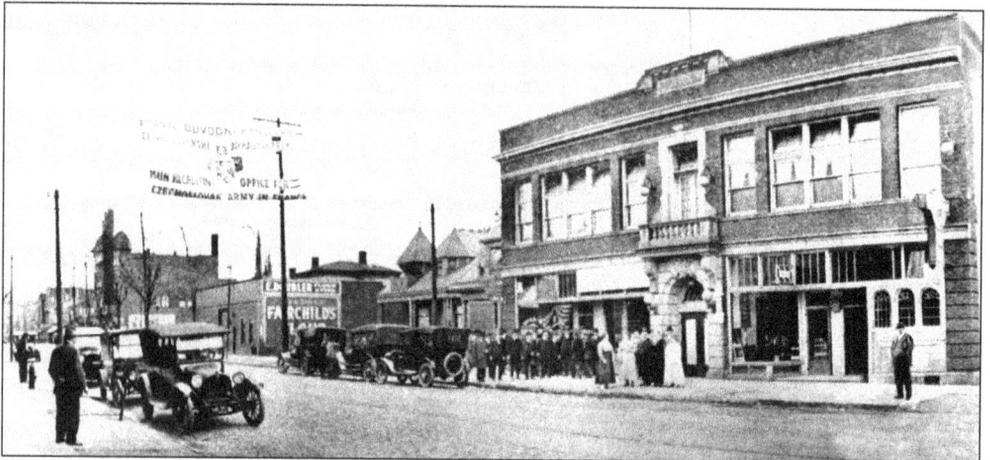

Probulov Hall stood near Broadway and East 55th Street and was the recruiting office where Czech and Slovak young men signed up to serve in the Czechoslovak Legion in France before the United States entered World War I. Almost 400 Clevelanders volunteered to serve to liberate their homeland. (Courtesy of Cleveland Press Archives—CSU Library Special Collections.)

58

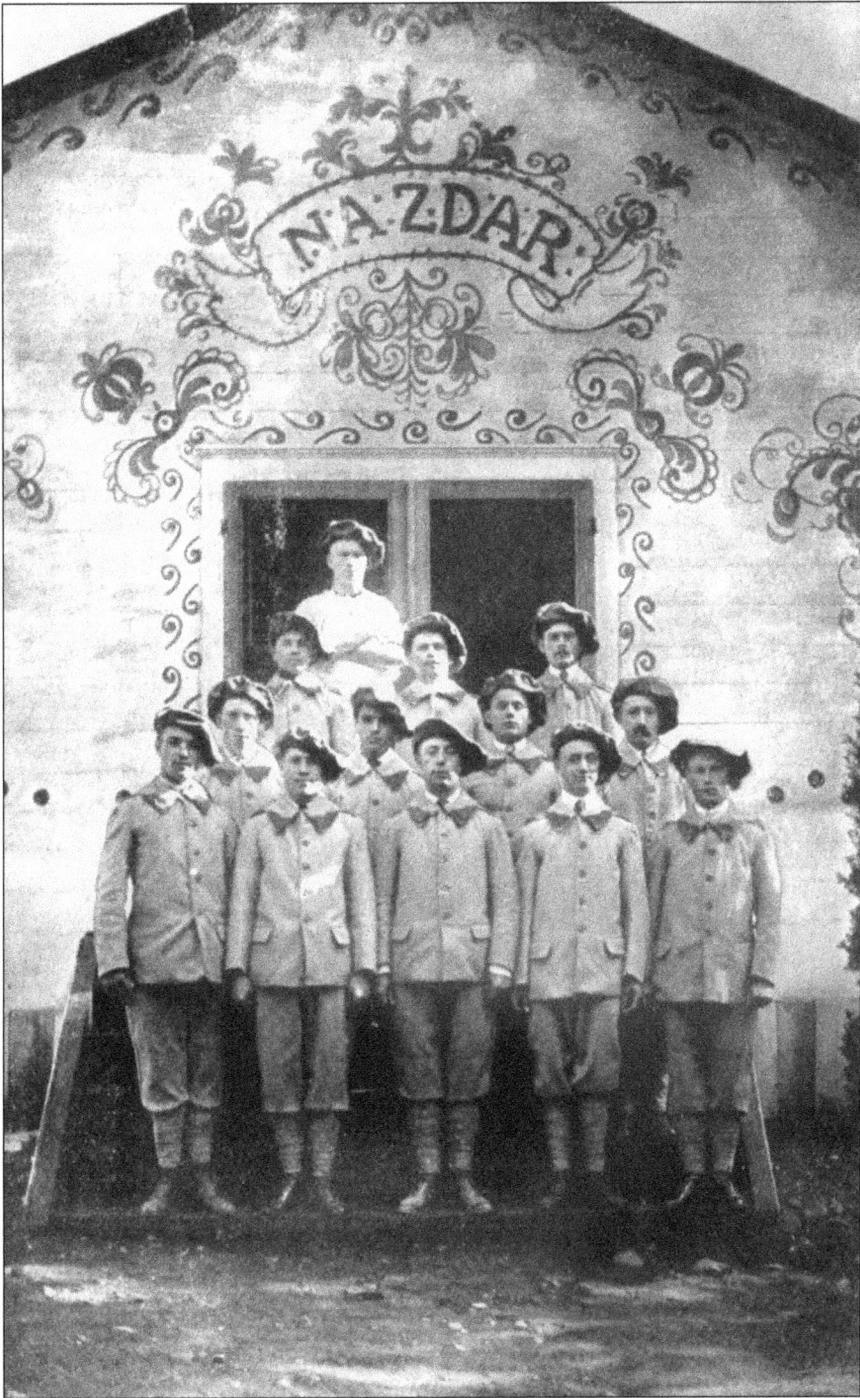

This photograph of Cleveland's Czech and Slovak legionnaires was taken at an unknown location sometime before America's entry into World War I. A total of 360 Czech and Slovak volunteers from Cleveland joined other Czechs and Slovaks from the United States and abroad to create the Czechoslovak Legion in Europe, fighting against the Austro-Hungarian Empire for the ultimate independence of Czechoslovakia. (Courtesy of the Slovak Institute and Library.)

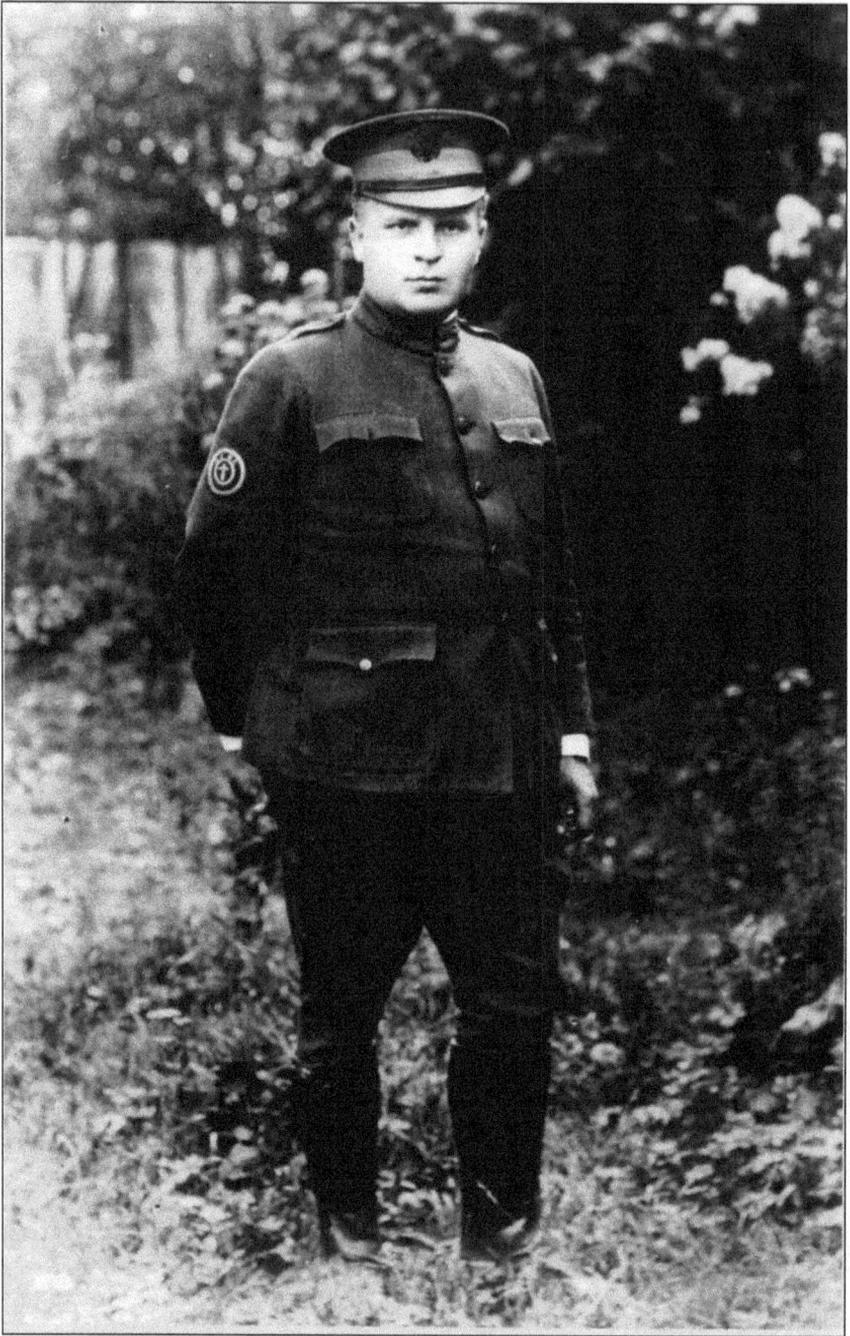

With the outbreak of World War I, Fr. Oldrich Zlamal took on the task of ensuring political freedom for Czechs and Slovaks in Europe, who had been under the Habsburg yoke as part of the Austro-Hungarian Empire. During the war he became an officer in the U.S. Army. In 1919, Monsignor Zlamal and Msgr. Emanuel Bouska of South Dakota appealed to Pope Benedict XV to approve their mission to secure political independence for Czechs and Slovaks. Monsignor Zlamal made 48 public speeches for this cause across the United States. (Courtesy of Joseph Kocab.)

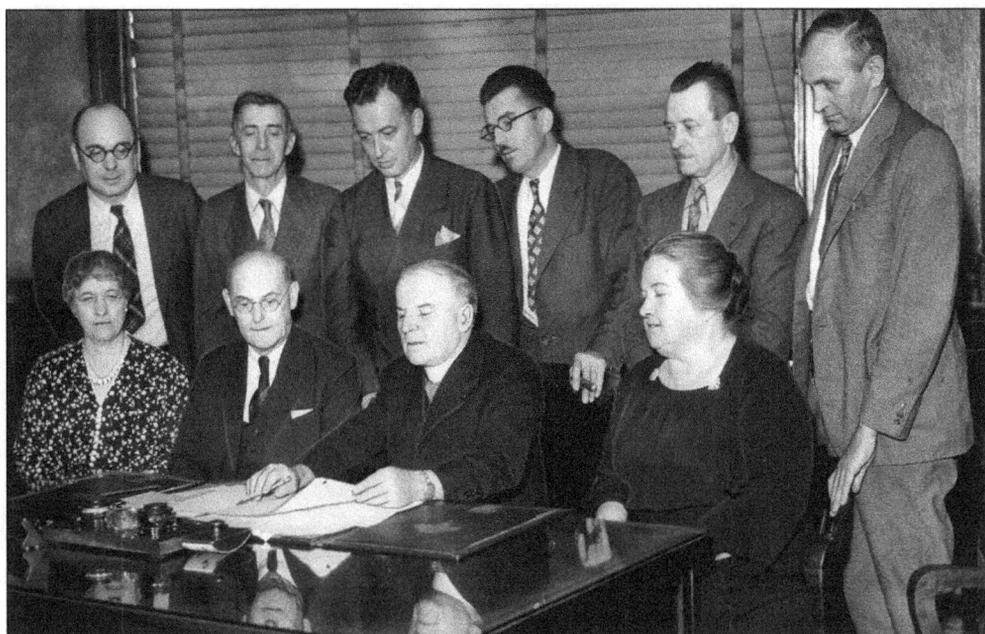

In 1938, as events in Europe threatened the existence of Czechoslovakia, Cleveland Czechs formed the Joint Committee for Defense of Czechoslovak Democracy. Headquartered in the Atlas Building on Broadway, the committee included, from left to right, (first row) Marie Ruzicka; Frank Manak Sr.; Msgr. Oldrich Zlamal, chairman; and Anna Simerka; (second row) Anton Svoboda; Frank J. Svoboda; Frederick Wolf; Lada Krizek; John Keleciny; and John L. Payer. (Courtesy of Cleveland Public Library/Photograph Collection.)

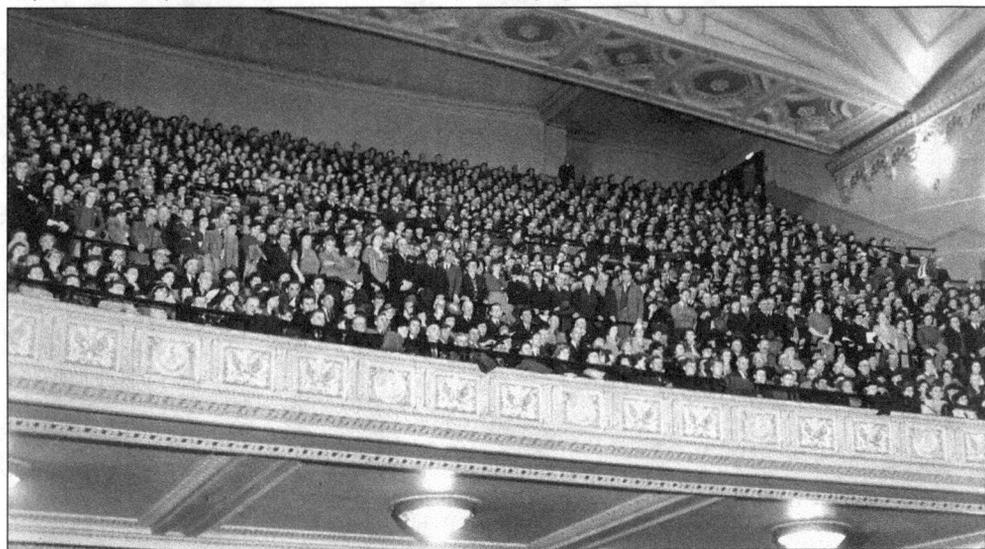

This is part of the crowd of Cleveland Czechs and Slovaks who gathered at the Cleveland Music Hall on October 11, 1938, about a week and a half following the German invasion of Czechoslovakia. Both the Czech and Slovak communities were concerned about the invasion, which would eventually result in the Nazi occupation of Bohemia and the establishment of the Slovak Republic in 1939. (Courtesy of Cleveland Press Archives—CSU Library Special Collections.)

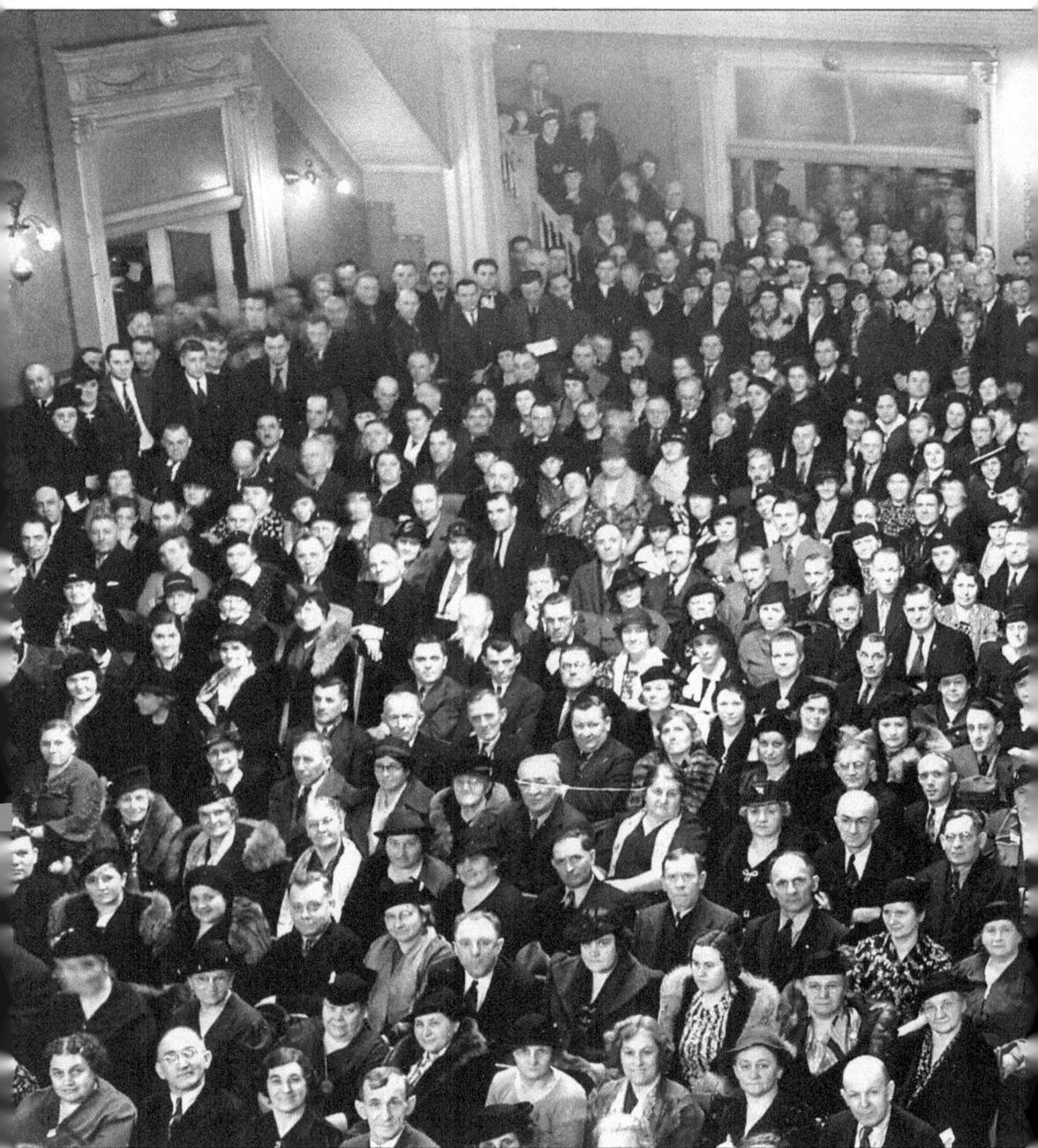

With their native land and the land of their ancestors torn apart and occupied by the German Army, more than 2,500 Czechs and Slovaks jammed Bohemian National Hall on March 23, 1939,

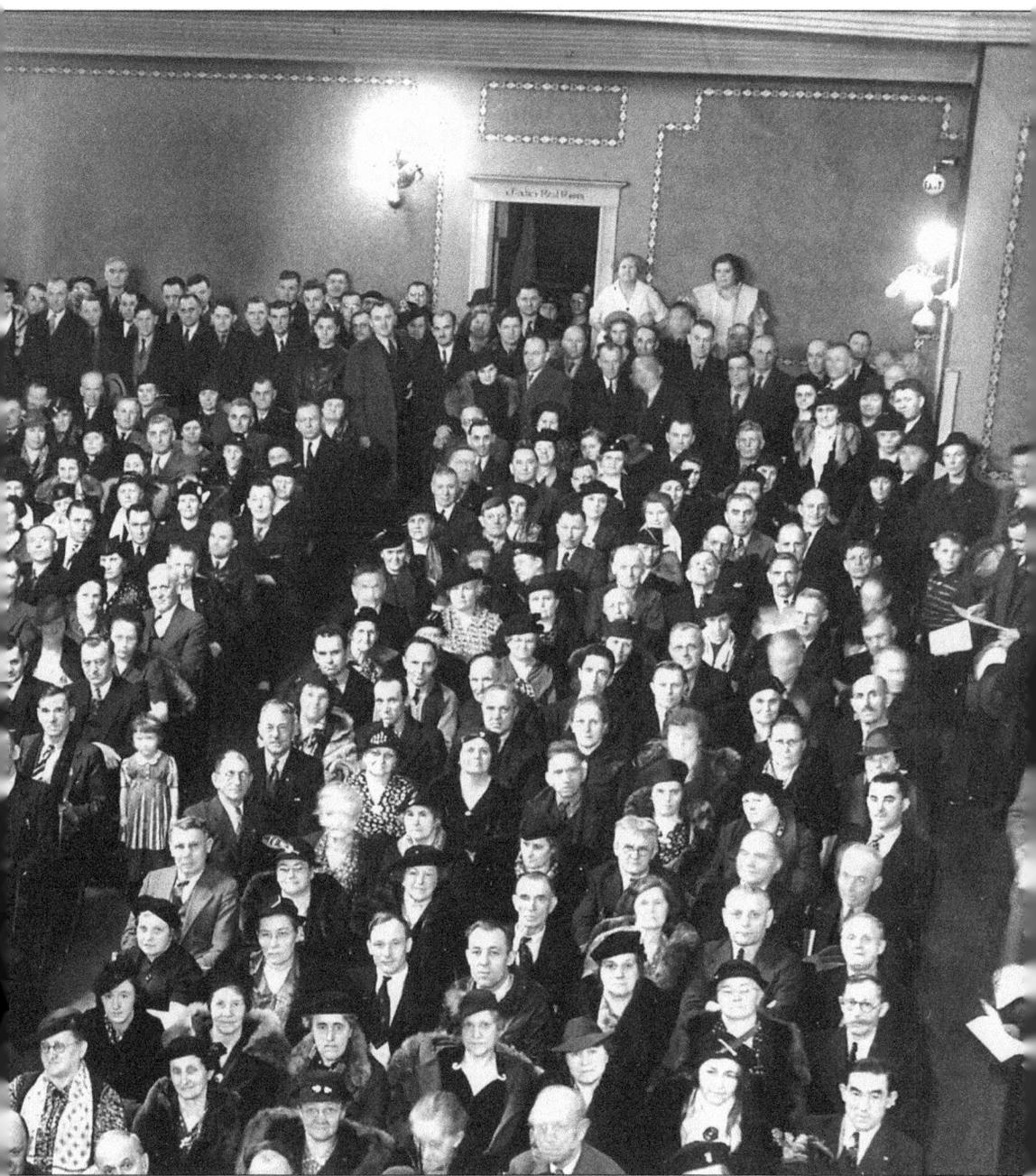

to pledge their efforts to work for the resurrection of Czechoslovakia. (Courtesy of Cleveland Press Archives—CSU Library Special Collections.)

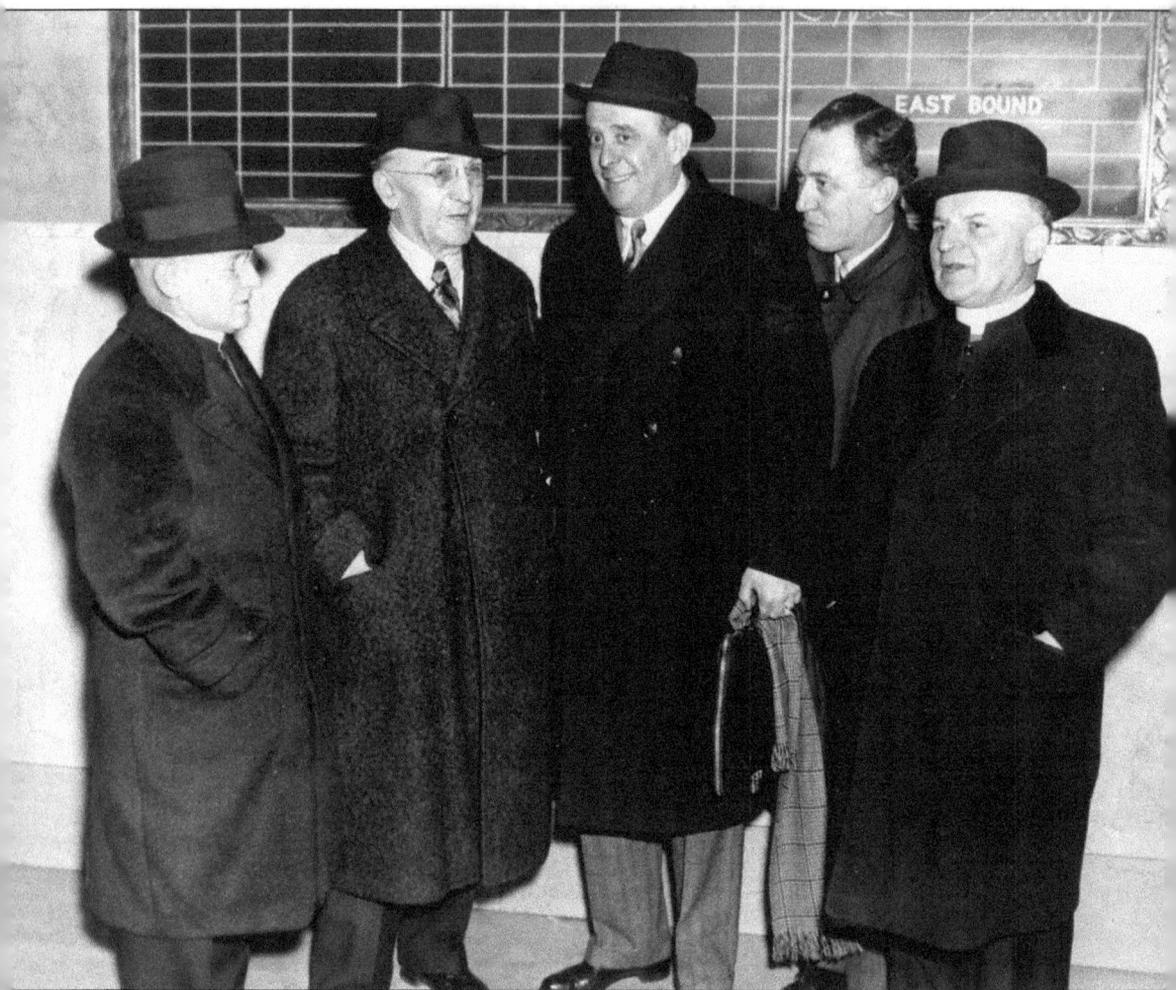

On February 8, 1939, about four months after the signing of the Munich Pact, Jan Masaryk, son of Tomas Masaryk, who was the first president of Czechoslovakia, spoke about the appeasement offered by British prime minister Neville Chamberlain to Nazi Germany. In a speech at the temple, Masaryk said that Chamberlain "could have saved himself much embarrassment by simply sending the dictators assembled in Munich a telegram: 'Help yourself, boys and let me know the results.'" Shown greeting Jan (center) are some of the leaders of the Czech and Slovak communities. They are, from left to right, Fr. Augustin Tomasek, pastor of St. Wendelin Church; Frank Vlchek, founder of Vlchek Tool; Czech radio personality and announcer Fred Wolf; and Msgr. Oldrich Zlamal, pastor of Our Lady of Lourdes Church. (Courtesy of Cleveland Press Archives—CSU Library Special Collections.)

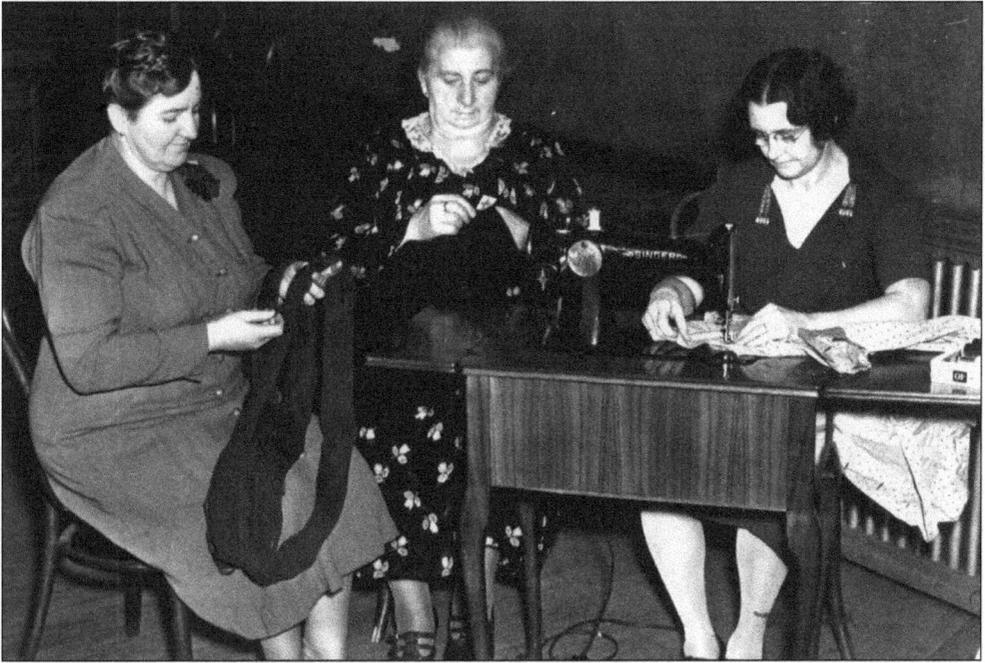

Following the German invasion of Czechoslovakia, Cleveland Czechs poured out their support in many ways. Shown here in February 1940 sewing articles for Czech refugees are, from left to right, Marie Vondra, Marie Tomsik, and Christine Kunasek. (Courtesy of Cleveland Press Archives—CSU Library Special Collections.)

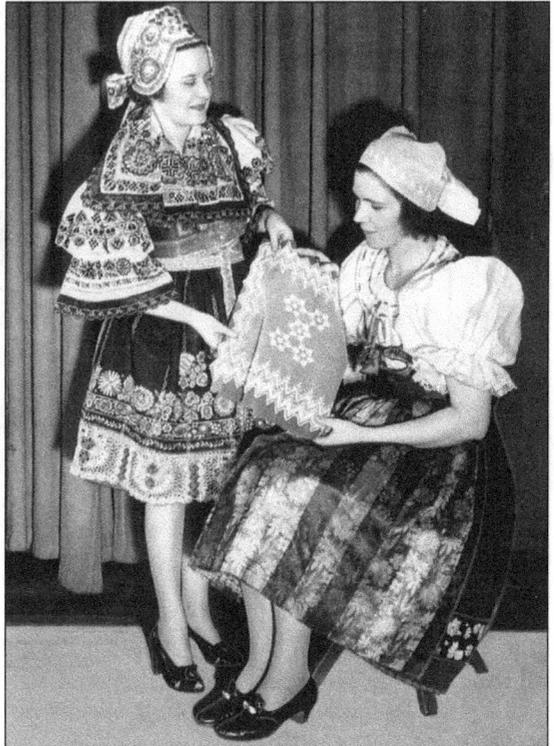

During World War II, Cleveland Czechs rallied their forces to raise funds for Czechs in Europe after the Nazi invasion of Czechoslovakia. The Czech-American National Alliance, which comprised 10 organizations from throughout Ohio, sponsored an eight-day event at the Bohemian National Hall in April 1940. The event drew Czechs from throughout the region and national leaders of the Czecho-Slovak National Council. Shown here are Helen Sorm (left) and Mildred Houdek, who greeted visitors to the eight-day bazaar. (Courtesy of Cleveland Public Library/Photograph Collection.)

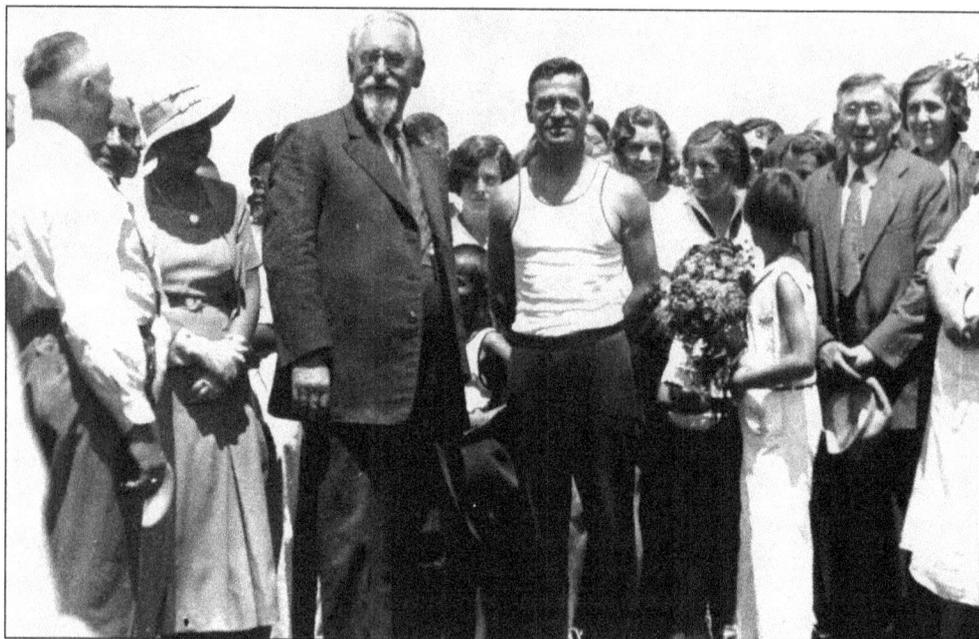

DTJ, like many other Czech organizations, took a special interest in the affairs of Czechoslovakia, particularly during the turbulent 1930s. Shown here is the 1936 welcome of Dr. Frantisek Soukup, president of the Czechoslovak Senate. Shown here are, from left to right, Joseph Skalnik, Mrs. Soukup, Frantisek Soukup, and Joseph Martinek, who founded DTJ in Cleveland and started Taborville. Presenting flowers is Eleanor Peterka. (Courtesy of DTJ Historical Archives.)

Military units parade along Clark Avenue, marking Czechoslovak Independence Day in September 1940. The celebration had special significance for Czechs because of the Nazi invasion of Czechoslovakia in 1938. (Courtesy of Cleveland Press Archives—CSU Library Special Collections.)

A central event in the history of Cleveland's Czech community was the visit on May 1, 1966, of Cardinal Joseph Beran, primate-in-exile of Czechoslovakia. Nationality groups lined the intersection of Broadway and East 55th Street for Cardinal Beran's arrival at Our Lady of Lourdes Church, where he celebrated mass. At the mass, he spoke of the overriding need for Slavic unity and religious liberty. (Courtesy of Cleveland Press Archives—CSU Library Special Collections.)

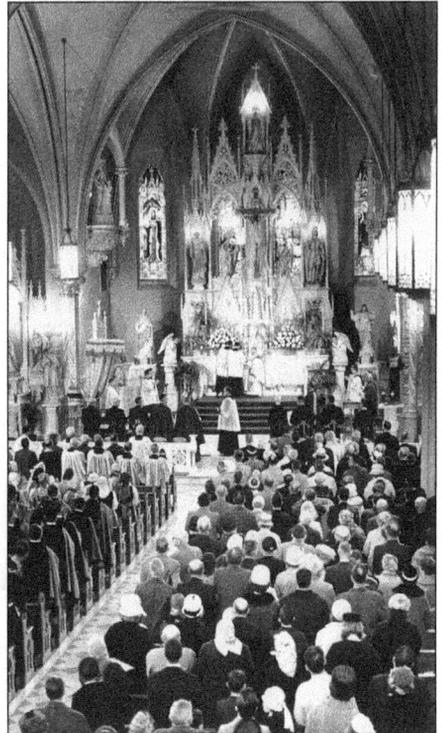

Cardinal Beran symbolized not only the leadership of Czech and Slovak Catholics, he also symbolized Czech nationalism at a time when the Czechs' native land was part of the Communist bloc. Shown here is the crowd that packed Our Lady of Lourdes Church for the mass celebrated by Cardinal Beran. (Courtesy of Cleveland Press Archives—CSU Library Special Collections.)

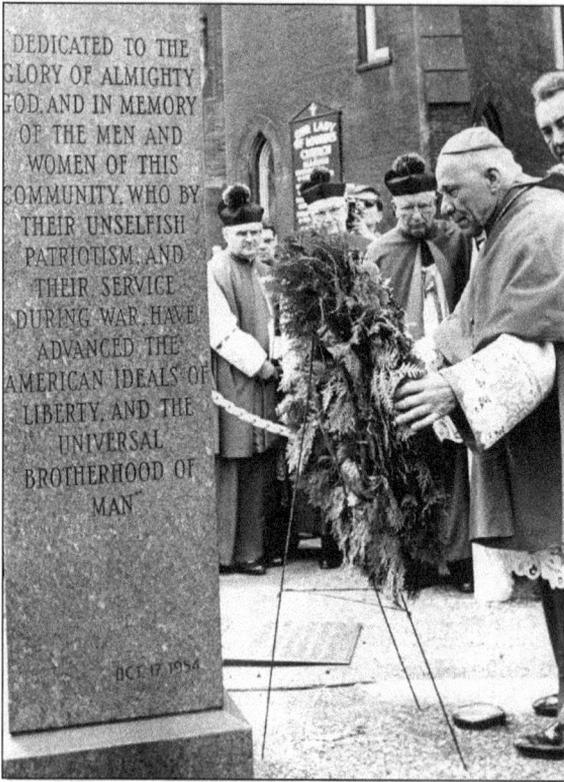

Cardinal Joseph Beran of Czechoslovakia places a wreath at the veteran's monument near the intersection of East 55th Street and Broadway during his visit to Cleveland in May 1966. He was the overnight guest of Our Lady of Lourdes pastor Fr. John Andel. (Courtesy of Cleveland Press Archives—CSU Library Special Collections.)

DEDICATED TO THE GLORY OF ALMIGHTY GOD, AND IN MEMORY OF THE MEN AND WOMEN OF THIS COMMUNITY, WHO BY THEIR UNSELFISH PATRIOTISM, AND THEIR SERVICE DURING WAR, HAVE ADVANCED THE AMERICAN IDEALS OF LIBERTY, AND THE UNIVERSAL BROTHERHOOD OF MAN

OCT 17 1954

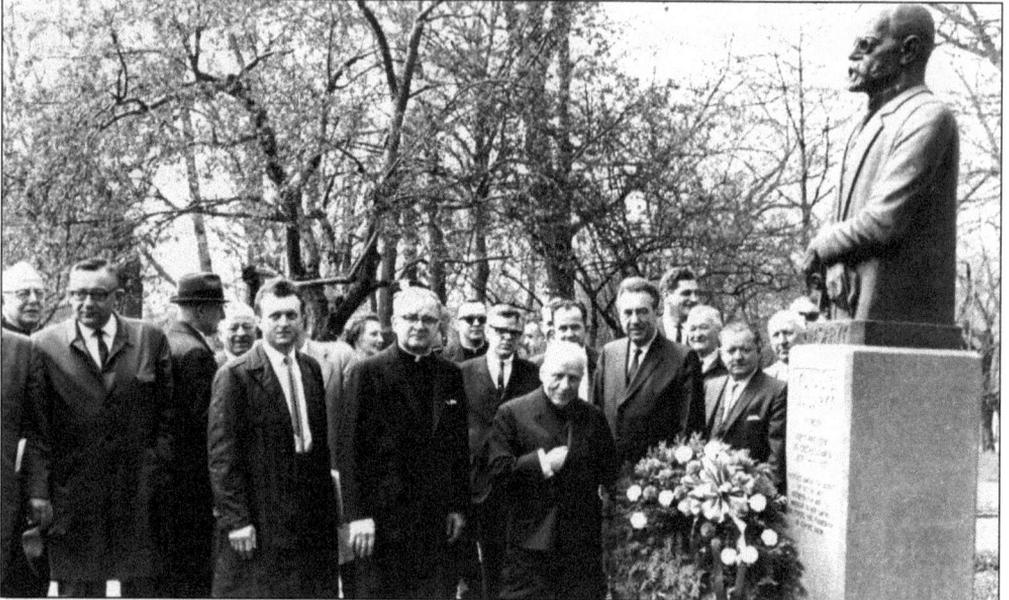

During his Cleveland visit, Cardinal Beran laid a wreath at the statue of Tomas G. Masaryk at the Czech Cultural Garden. According to one observer, it was a unifying event for Cleveland Czechs because the cardinal brought together the Catholic and non-Catholic (the freethinkers) Czechs as a symbol of religious and national freedom. (Courtesy of Cleveland Press Archives at Cleveland State University.)

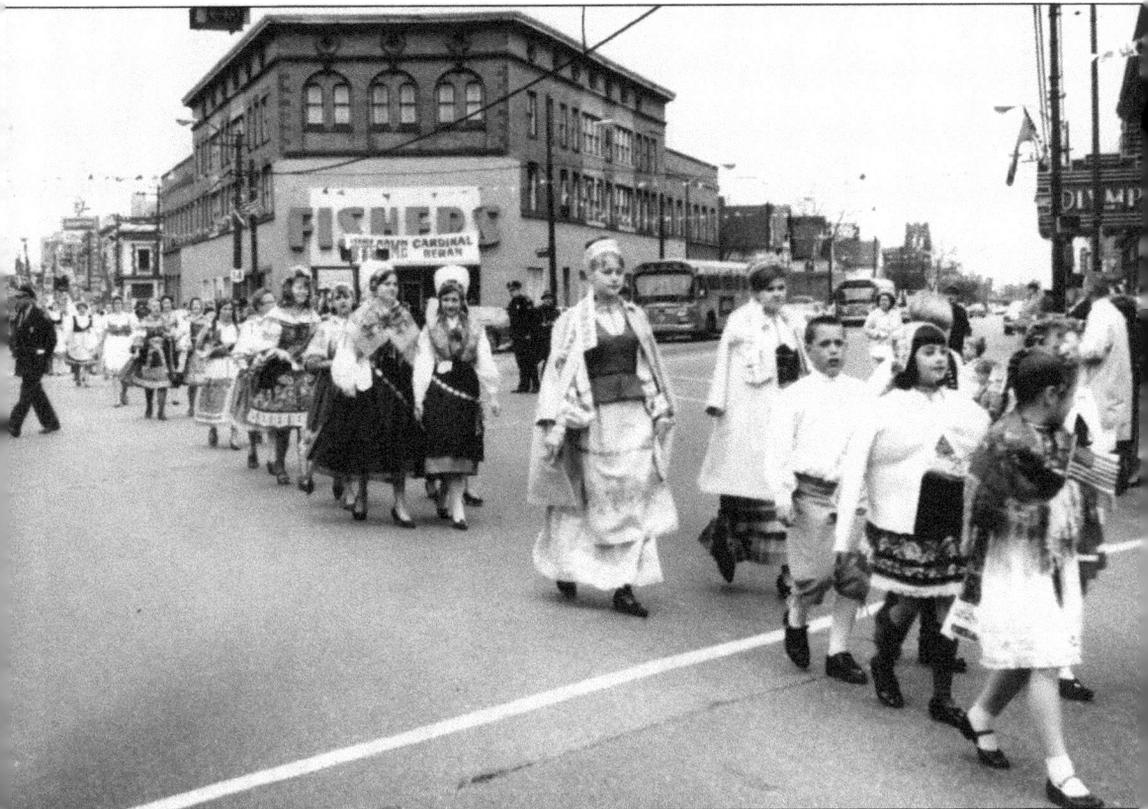

Dressed in colorful Czech costumes, members of the welcoming procession for Cardinal Beran cross through the intersection of Broadway and East 55th Street. (Courtesy of Judge Ralph Perk Jr.)

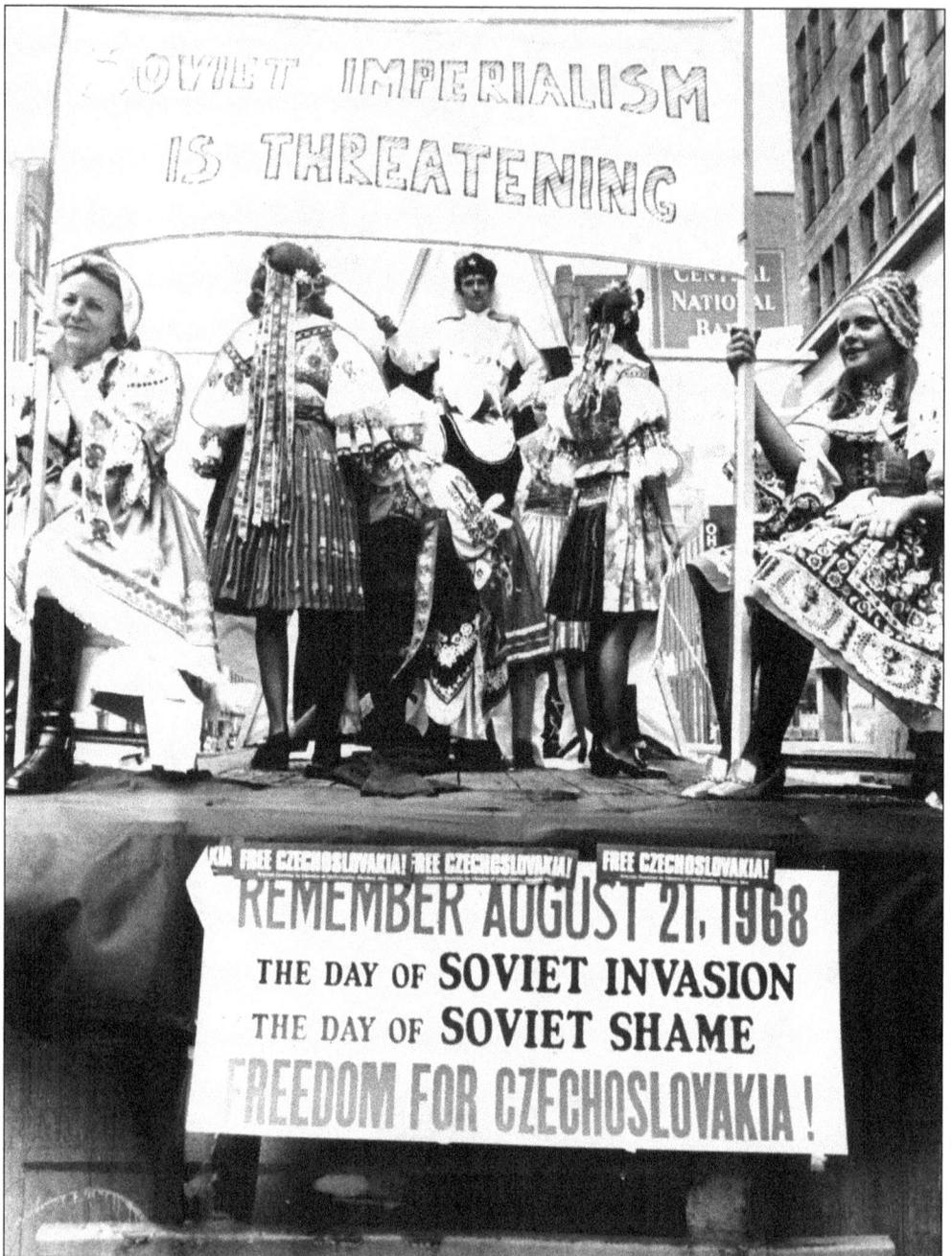

For many years, Cleveland Czechs and Slovaks carried bitter memories of the Russian invasion of their country on August 21, 1968. This demonstration on August 27, 1971, protested the tragic events of 1968. (Courtesy of Cleveland Press Archives—CSU Library Special Collections.)

Seven

SOUND MIND, SOUND BODY

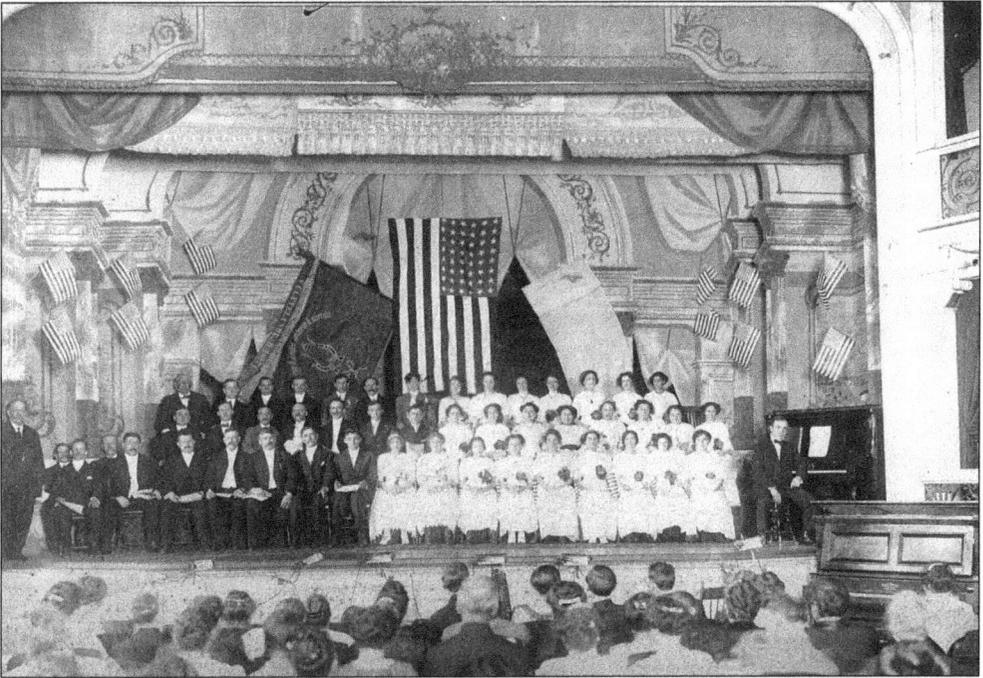

Roots of the Lumir-Hlahol-Tyl Singing Society date to the founding of the Lumir Singing Society in Cleveland's original Czech neighborhood in 1867. The Hlahol Singing Society, founded in 1896, merged with Lumir in 1918 to form the Lumir Hlahol Singing Society. Meanwhile, the Tyl Dramatic Society, founded in 1881 and named for Czech playwright Josef Tyl, joined the other two groups in 1940. Sadly, an aging membership caused the group to dissolve in the 1980s. The group is shown here performing at Bohemian National Hall. (Courtesy of Joseph Kocab.)

The women of the Lumir-Hlahol-Tyl Singing Society shown here at Bohemian National Hall are, from left to right, (first row) Slavie Hanket, Alma Ziegelheim, Jeanette Hanket, Mildred Seidel, Alice Pesek, Jane Novak, Mae Novak, and Lillian Gross; (second row) Blanche Knobloch, Emma Kubelik, Mildred Belsan, Blanche Knobloch Jr., Mildred Kolar, Zdenka Dohnal, and Margaret Bakalar; (third row) Thelma Votypka, Marie Simerka, and Lillian Simerka. (Courtesy of Cleveland Public Library/Photograph Collection.)

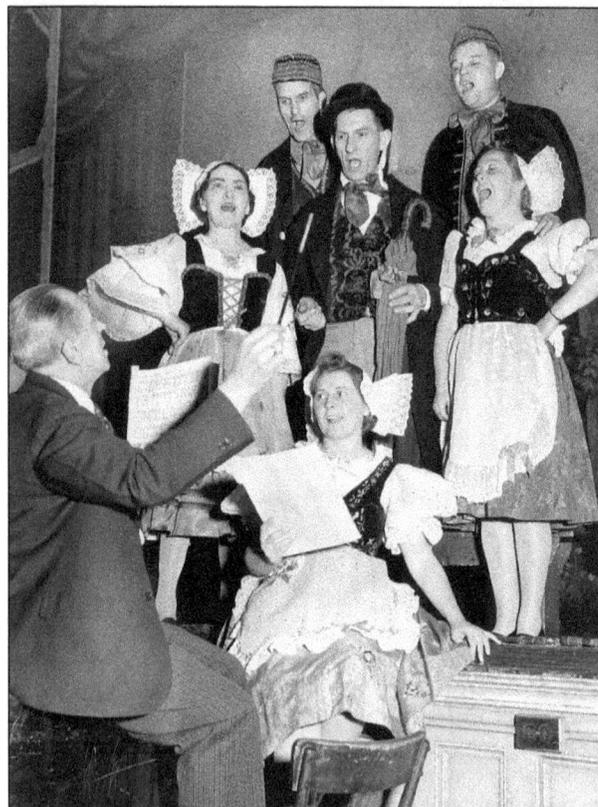

Director Edward Krejsa prepares the principals in 1942 for Lumir-Hlahol-Tyl Singing Society's diamond anniversary presentation of The Bartered Bride by Bedrich Smetana. The men include, from left to right, Jerry Knobloch, John Hanket, and Charles Belsan. The women include, from left to right, Anna Votykpa, Emma Kubelik, and Slavie Hanket. (Courtesy of Cleveland Press Archives—CSU Library Special Collections.)

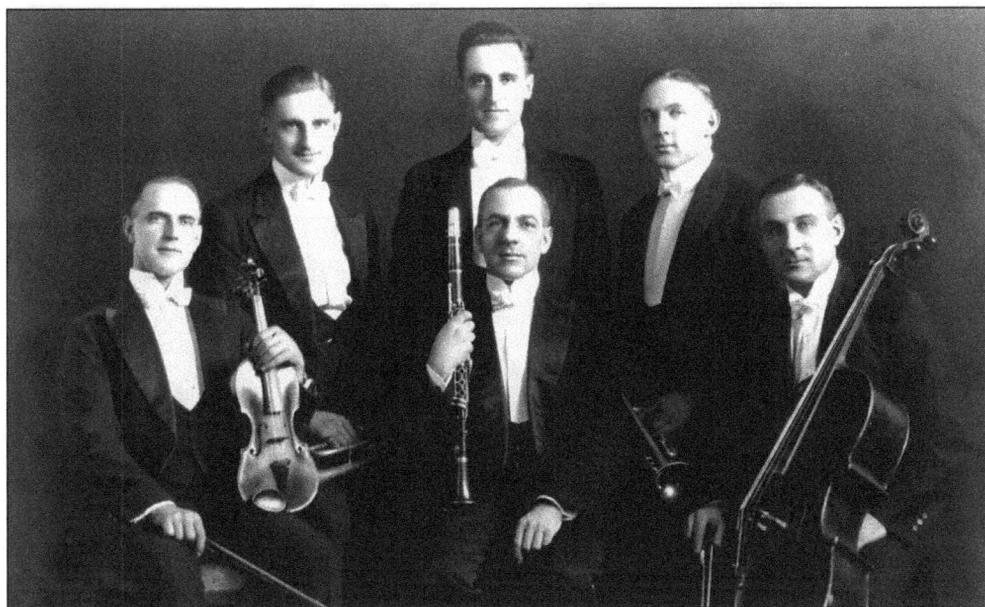

The Hruby family played a big role in the Cleveland Orchestra when it was founded in 1918. Shown from left to right are the brothers who were on the original orchestra roster: (first row) John, Frank, and Alois; (second row) Charles, Fred, and William. (Courtesy of Dr. Ferdinand Hruby.)

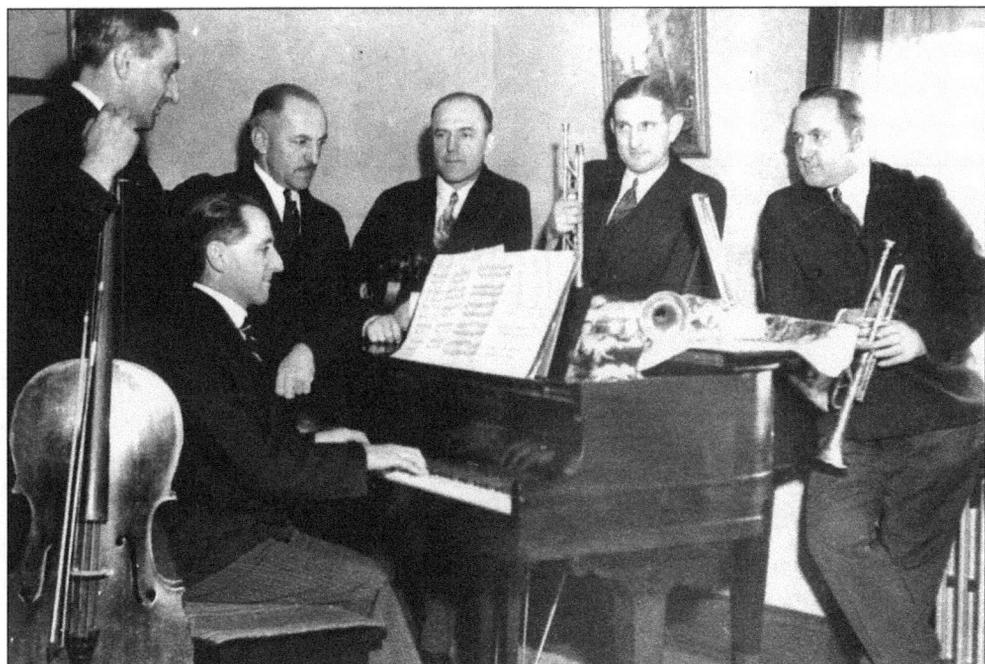

Shown in this photograph from the 1940s are members of the Hruby family. They are, from left to right, Alois, cello; Fred, piano; Frank, clarinet; John, violin; and Charles and William, trumpet. Not shown is a sister Mayme Kolda. Another sister, Celia Mazanec, died in 1937. The brothers and their sister Mayme were members of the Cleveland Orchestra when it was founded in 1918. (Courtesy of Dr. Ferdinand Hruby.)

Born in Music. — Raised in Music. — Live in Music.

HRUBY BROTHERS.

Charley. Fred. John. Alois. Frank.

FAREWELL SURPRISE RECEPTION.

In 1907, five of the Hruby brothers made one of their early tours. In their honor, a surprise reception was held for the young musicians. They eventually traveled from coast to coast, playing the Chatauqua and Lyceum Circuits. As early as 1893, John and Alois Hruby played at the inauguration of William McKinley. (Courtesy of Dr. Ferdinand Hruby.)

Yourself and Friend are cordially invited to attend a

FAREWELL SURPRISE RECEPTION

to be given

IN HONOR OF THE HRUBY BROTHERS,

who leave on an extended Concert tour,

to be held

at Hruby's Garden, cor. E. 65th and Francis St.

Sunday Eve., September 22. at 8 P. M. '07.

COMMITTEE:

Anthony L. MareshFred. W. Gillette
Walter S. Raeder.........................Robt. L. White.

As shown on page two of the invitation, the surprise party was held at the Hruby family beer garden. (Courtesy of Dr. Ferdinand Hruby.)

74

As accomplished musicians, the Hruby brothers toured United States and European cities often, making a concert tour of Europe in 1912. The family embarked on April 14, 1912, the same date the *Titanic* sank in the North Atlantic. During their extended tour abroad, the political winds began to change in Europe, and they were advised to return to the United States. Soon after, World War I broke out. (Courtesy of Dr. Ferdinand Hruby.)

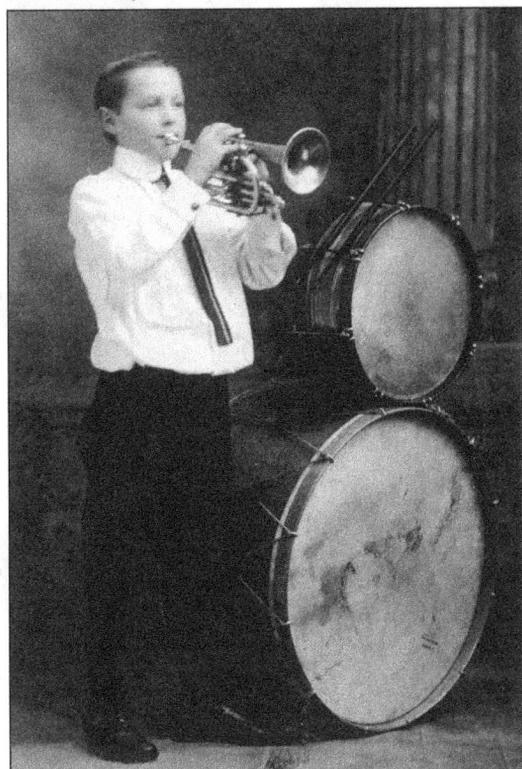

Ferdinand (Fred) Hruby, son of Fred Hruby, carried on the family musical tradition as a young man, becoming proficient on trumpet and drums. In his adult life, he became a physician. (Courtesy of Dr. Ferdinand Hruby.)

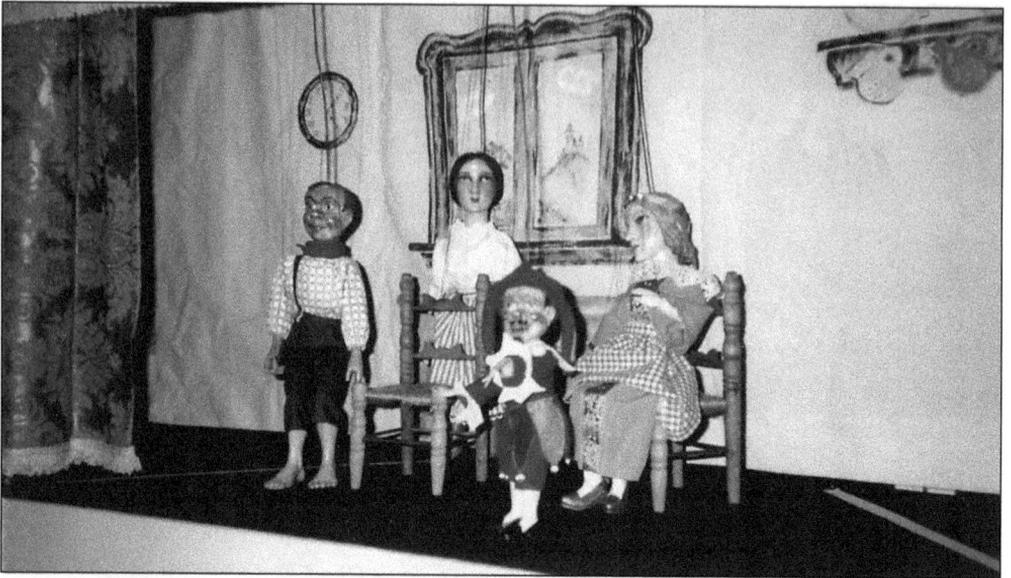

At the beginning of the 20th century, many Czech halls being established in Cleveland included a set of marionettes, part of a long-time tradition in the Czech Republic (Bohemia). These puppets, known as Sokol Puppets, originally resided at Bohemian National Hall and were returned to the hall in 1975, when Sokol Greater Cleveland purchased the building. (Courtesy of the Czech Cultural Center of Sokol Greater Cleveland.)

Five years after the puppets became "resident" in the hall, the Sokols formed the Vcelka (bee) Puppeteers to present their first show, *Hloupy Honza se Zeny* (Simple Honza Gets Married). Shown from left to right is the play's cast and their production crew: Marjorie Juba, John Darovec, Val Kralik, Jarmila Hyncik, Elsie Kralik, Joe Bachna, Viola Perina, Rudy Perina, and Millie Darovec. (Courtesy of the Czech Cultural Center of Sokol Greater Cleveland.)

The play, originally written in Czech, was translated to English for this presentation. The puppets required three months of restoration work by several women members under the direction of Betty Hosticka. Shown here is Joe Bachna, who manipulated the title character in the play *Hloupy Honza se Zeny.* (Courtesy of the Czech Cultural Center of Sokol Greater Cleveland.)

Puppeteers work behind the scenes at the Bohemian National Hall production of *Simple Honza Gets Married* in 1980. (Courtesy of the Czech Cultural Center of Sokol Greater Cleveland.)

The Vcelka Dramatic Society was founded in 1872 and today has 80 members performing at Bohemian National Hall. Shown here are Jarmila Humpal and Mary Frijouf in a production dating from March 1947. (Courtesy of Cleveland Press Archives—CSU Library Special Collections.)

The Vcelka Czech Dramatic Society, now the Vcelka Dramatic Society of Sokol Greater Cleveland, rehearses for a performance in November 1957. (Courtesy of Cleveland Public Library/ Photograph Collection.)

In June 1933, members of Cleveland's Sokol organizations traveled to Chicago to take part in the second annual Sokol Olympic Games, sponsored by the American Sokol Union. More than 20,000 participated, including this group, part of a 500-person contingent from Cleveland, including Sokol Cech-Havlicek and Sokol Tyrs. (Courtesy of Cleveland Press Archives—CSU Library Special Collections.)

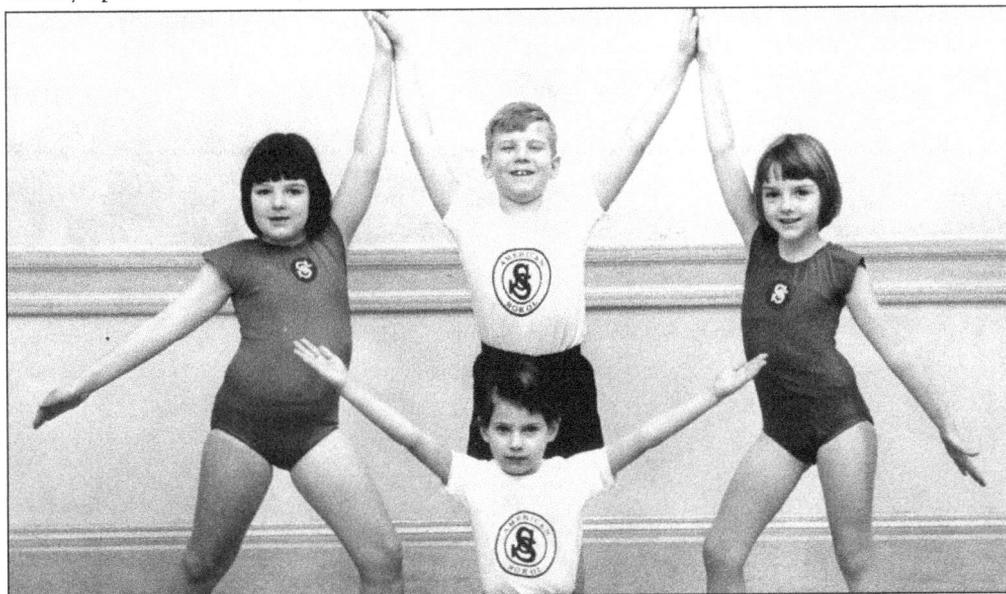

An annual event for Sokol Greater Cleveland is the group's winter exhibition. Warming up for calisthenics drills in 1979 are, from left to right, Linda Martanovic, Jack Drobny, and Barbie Martanovic. Squatting in front is Steven Friend. Gymnasts from ages 3 to 75 took part in the program, which was held at Cleveland State University. (Photograph by Larry Nighswander; courtesy of Cleveland Press Archives—CSU Library Special Collections.)

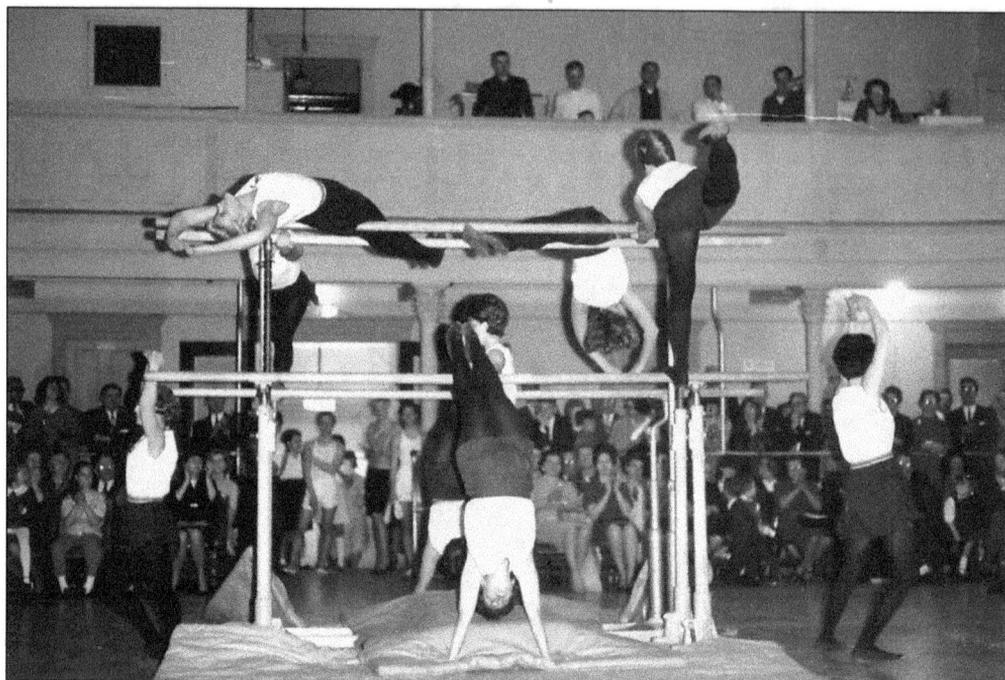

These photographs from 1965 show the gymnastic skill of some of the members of Sokol Nova Vlast during an exhibition at Ceska Sin Sokol on Clark Avenue. The Sokol movement in the United States is more than 140 years old and has helped to shape the lives of many individuals. Sokol Nova Vlast was formed in Cleveland in 1892. Besides gymnastics, the Sokols also offered dramatic and musical training, lectures, and libraries. In addition, they fostered a spirit of Czech brotherhood. (Courtesy of the Czech Cultural Center of Sokol Greater Cleveland.)

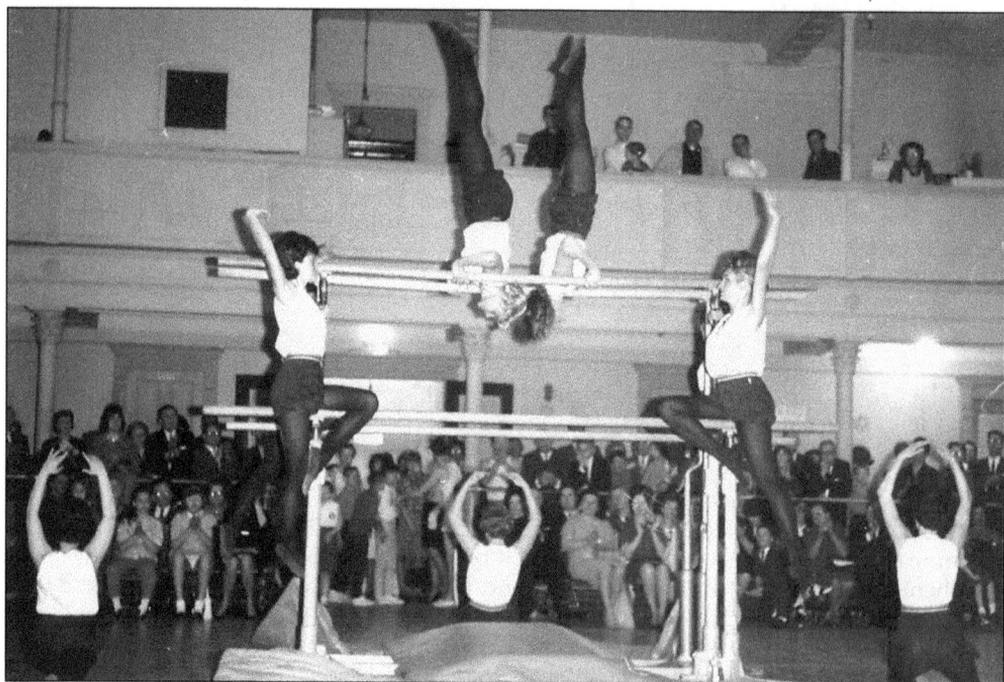

Eight

PERSONALITIES
AND LEADERS

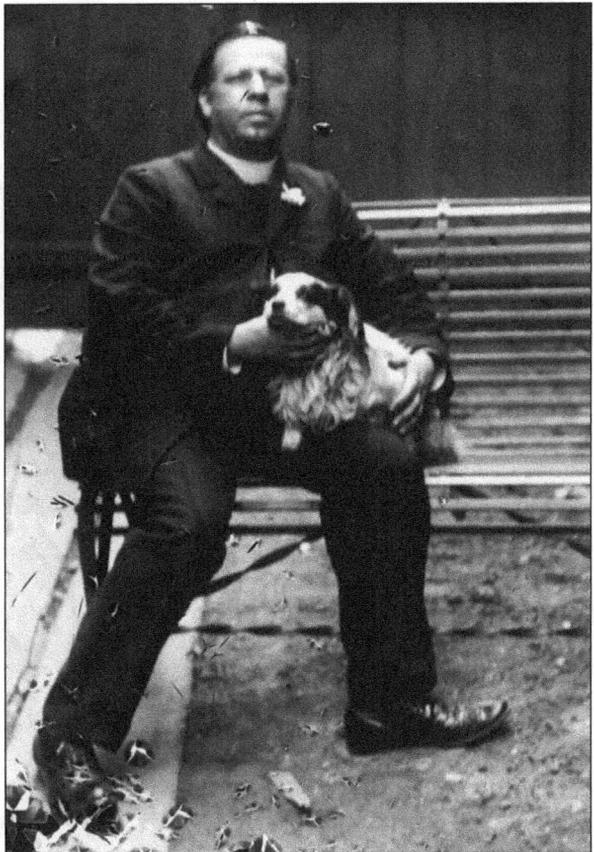

Fr. Stefan Furdek is considered a prime mover and organizer among Czechs and Slovaks in the United States. Following his arrival in Cleveland to be pastor of Our Lady of Lourdes Church, he also established St. Ladislas Church and the First Catholic Slovak Union and assisted in founding the first Catholic Slovak Ladies Association. A tireless worker for Czech and Slovak causes, he died in 1915. (Courtesy of the Slovak Institute and Library.)

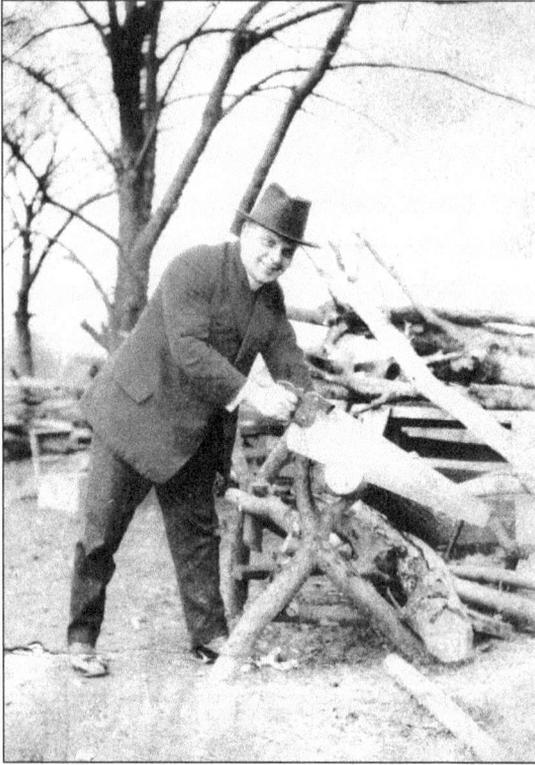

A man of great energy and leadership, Fr. (later Msgr.) Oldrich Zlamal went on to serve most of his life as pastor of the Czech parish Our Lady of Lourdes. He was also instrumental in establishing two Slovak parishes—St. Wendelin and SS. Cyril and Methodius. Father Zlamal, a Moravian, was recruited while still in the seminary in Europe and was ordained in Cleveland. (Courtesy of St. Wendelin Church.)

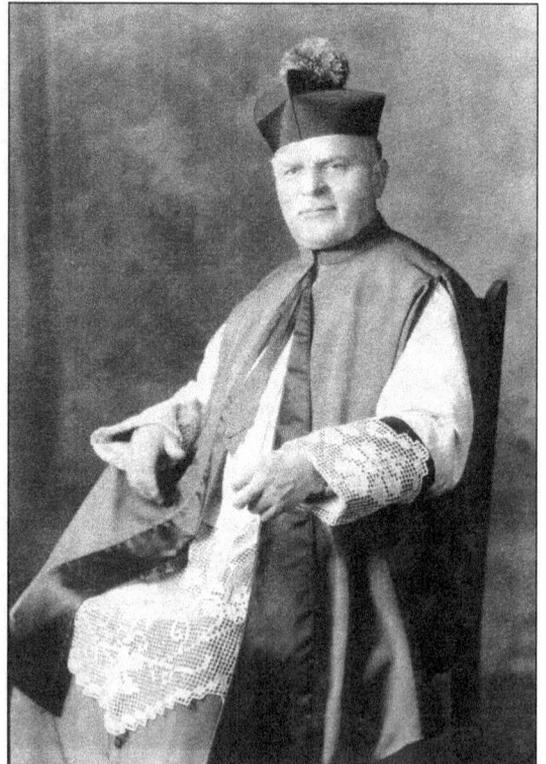

Following service in Youngstown from 1908 to 1915, Father Zlamal was assigned to Our Lady of Lourdes to succeed Fr. Stefan Furdek. In addition to his parish work, he was equally active in Czech political affairs, advocating self-government for Czechs and Slovaks following World War I. (Courtesy of Our Lady of Lourdes Parish.)

On March 24, 1955, six months after celebrating his 50th anniversary as a Catholic priest, Msgr. Oldrich Zlamal died. His sister Rose, shown here at his casket at Rumplik Funeral Home, was an almost lifelong companion to Monsignor Zlamal, leaving their native Moravia with him when he answered the invitation to serve as a priest in the Cleveland Diocese. (Courtesy of Joseph Kocab.)

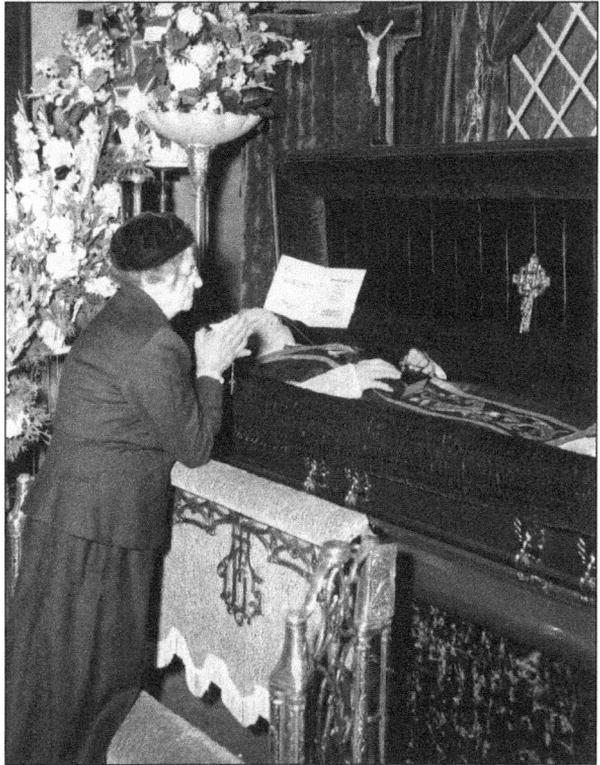

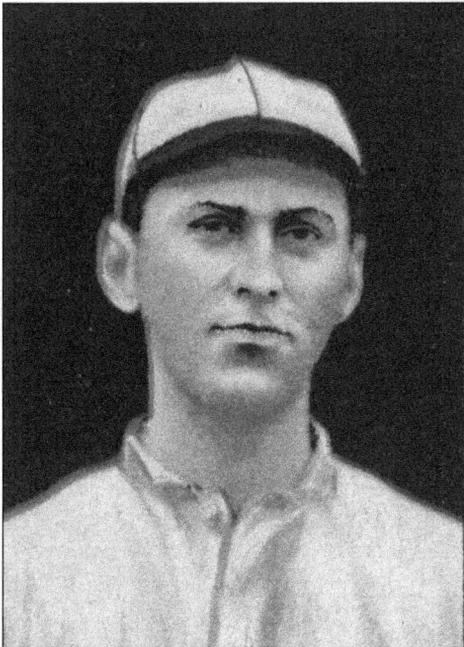

Red Nelson

Red Nelson, one of the Brown's promising young southpaws, is a product of the O. & P. League, where from 1908 to 1910 he did effective work. In 1910 he was nipped by the Browns and brought on for a trial where his fast breaking curve ball won him a home. Nelson's winning record was of course far below par, as the Browns finished last. In 12 games through 1911 he won 3 and lost 9 for an average of .250. His batting average was exactly .125.

Red Nelson pitched mainly for the St. Louis Browns in a major league career that spanned four seasons (1910–1913). He was born Albert Horazdovsky in Cleveland's Zizkov Czech district. After leaving baseball, he pursued a career in law enforcement, eventually becoming marshal of Newburgh Heights. (Courtesy of Library of Congress.)

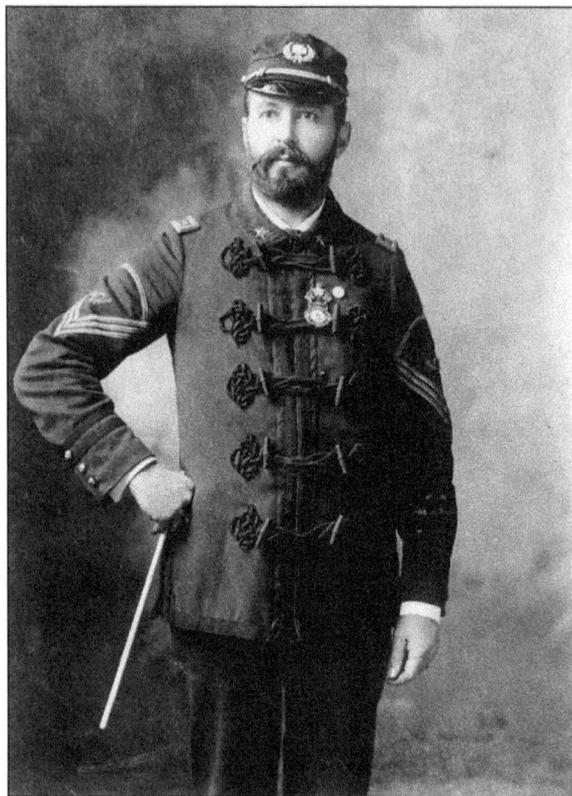

Frantisek (Frank) Hruby, the head of the musical Hruby family, was born in Bohemia. At age 21 he directed three bands in Europe. Upon arriving in Cleveland, he played at the Opera House at Euclid Avenue and Sheriff (East Fourth) Street. He later organized the Great Western Band, which won awards from Baltimore to St. Louis. (Courtesy of Dr. Ferdinand Hruby.)

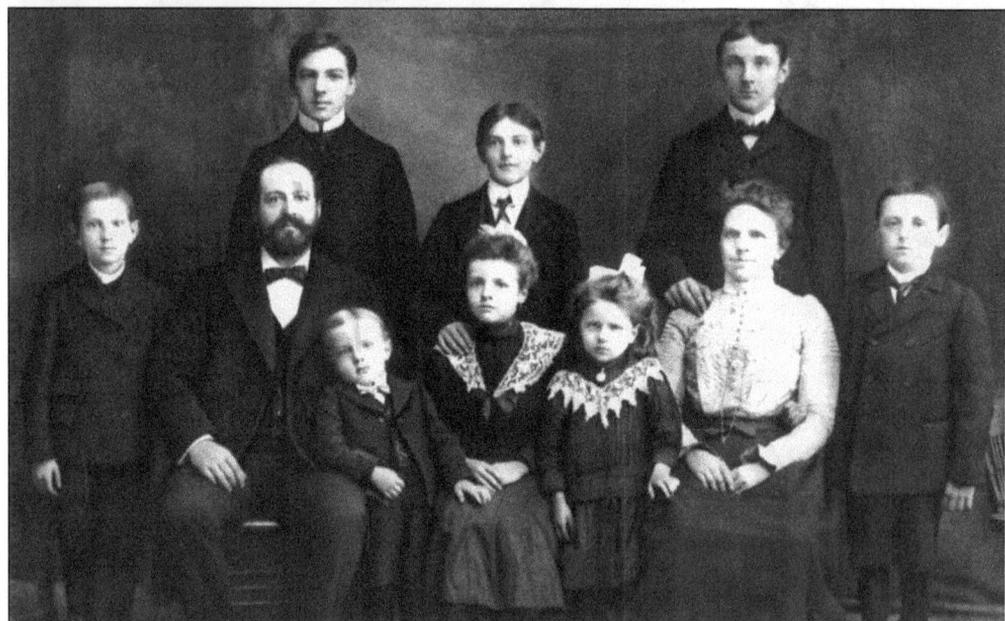

Members of the Hruby family in 1910 are, from left to right, (first row) Charles, Frank Hruby IV, Bill, Celia (Mazanec), Mayme (Kolda), Katerina Narovec Hruby, and Fred; (second row) Frank Hruby V, John Hruby, and Alois Hruby. In 1912, the family made a concert tour of Europe. The senior Hruby died shortly after they returned from the tour. (Courtesy of Mary Kay Wisnieski.)

After her husband's death, Katerina Hruby purchased a home on Miles Avenue in Cleveland. The home's backyard adjoined Calvary Cemetery, where her husband was buried. It is said that she visited the grave often. (Courtesy of Mary Kay Wisnieski.)

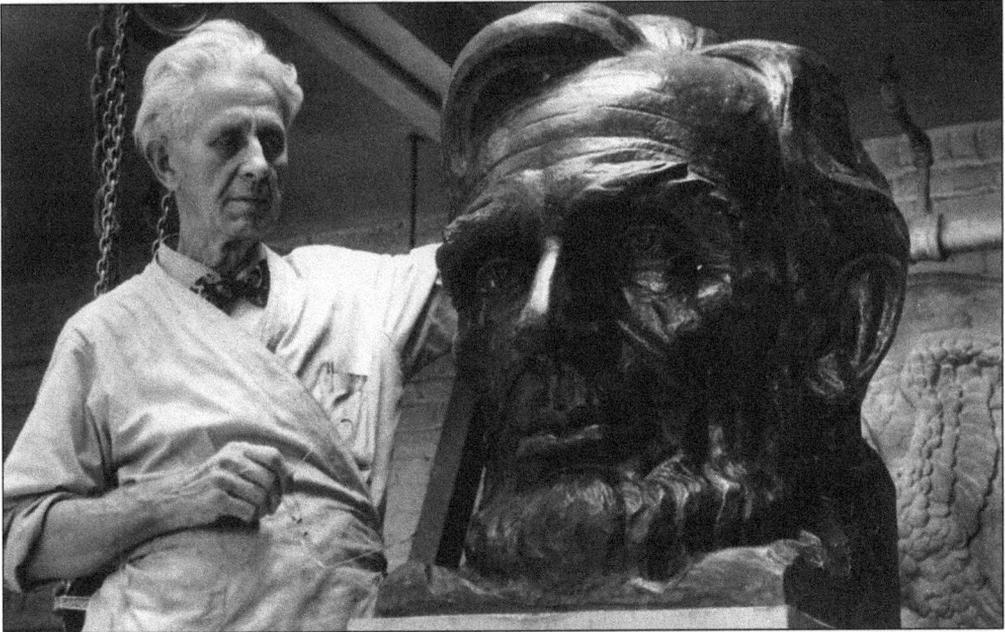

Frank Jirouch was a noted Cleveland sculptor of Czech descent whose work appears in Wade Park and in the Cleveland Cultural Gardens. Jirouch was born near Case Avenue (East 40th Street) and Orange Avenue in 1878. According to the *Encyclopedia of Cleveland History*, it is thought he created as many as 25 sculptures and busts for the cultural gardens. (Courtesy of Cleveland Press Archives—CSU Library Special Collections.)

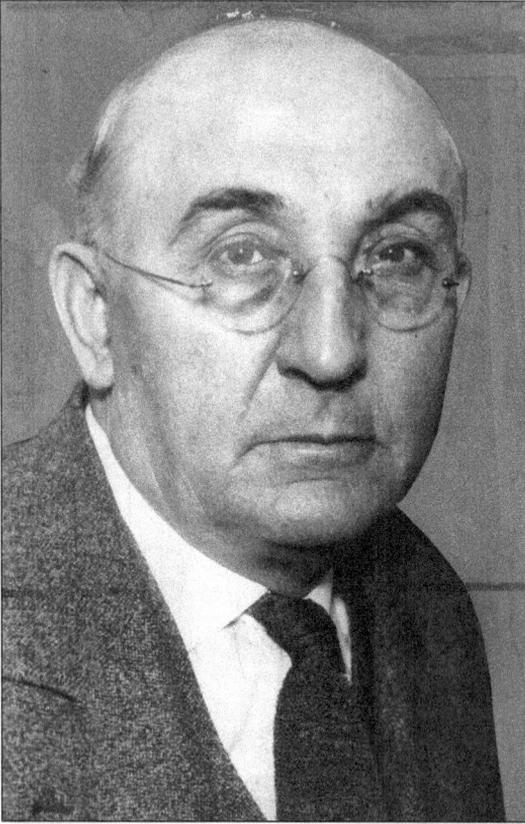

Starting from a blacksmith shop in 1895, Frank J. Vlchek built his enterprise into the Vlchek Tool Company, which became the principal supplier of tools to repair early Ford automobiles. During World War I the company was the exclusive producer of a 40-piece toolkit and other parts for the Liberty airplane. (Courtesy of Cleveland Press Archives—CSU Library Special Collections.)

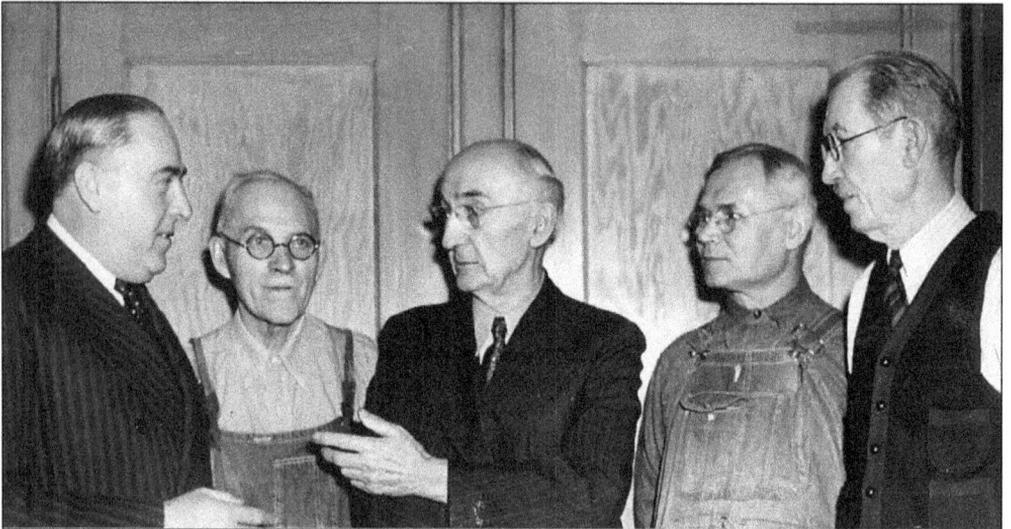

In 1945, Vlchek Tool celebrated its 50th anniversary. Celebrating with the company's founder, Frank Vlchek (center) are, from left to right, long-time employees Frank J. Prochaska, John Kokta, Anton Werkner, and John Soukup. The company started business at Lincoln Avenue (East 83rd Street) and Garden (Central) Avenue, then moved to Quincy Avenue and Woodhill Road—situated between two Czech neighborhoods—and later to East 87th Street. (Courtesy of Cleveland Press Archives—CSU Library Special Collections.)

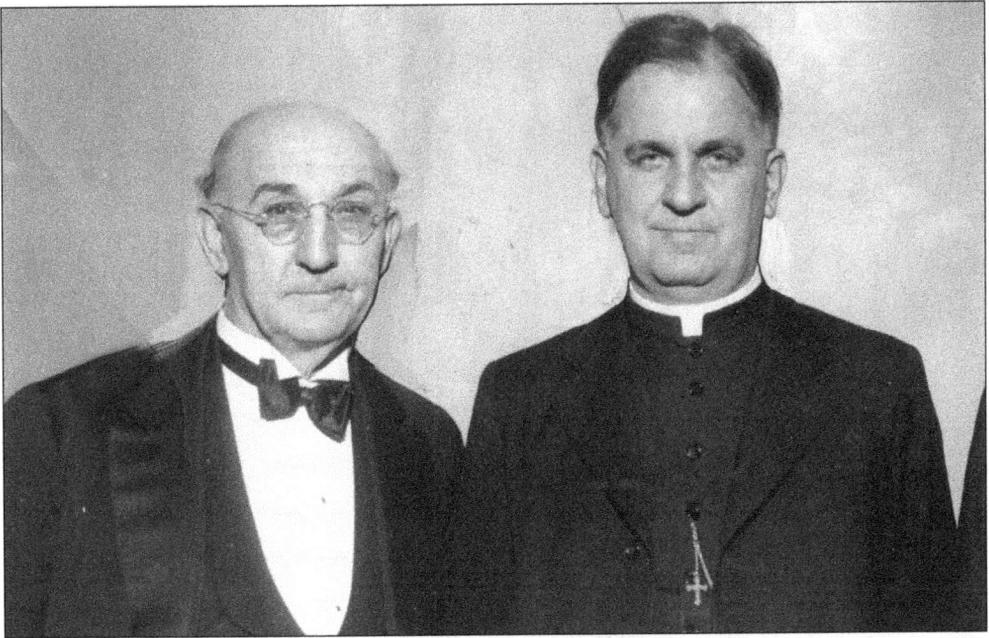

Frank Vlchek, founder and president of Vlchek Tool Company, is shown with long-time friend Fr. Vaclav A. Chaloupka, a Czech who was pastor of Nativity of the Blessed Virgin Mary Slovak Catholic Church. (Courtesy of Cleveland Press Archives—CSU Library Special Collections.)

Charles V. Rychlik was a prominent composer and violin teacher in Cleveland. Born in 1875 and raised on Forest (East 37th) Street near Orange Avenue, he studied at the Prague Conservatory. He is credited with teaching Antonin Dvorak the English language before his historic trip to the United States. Rychlik was a member of the Cleveland Orchestra before leaving to concentrate on composition and teaching. (Courtesy of Cleveland Press Archives—CSU Library Special Collections.)

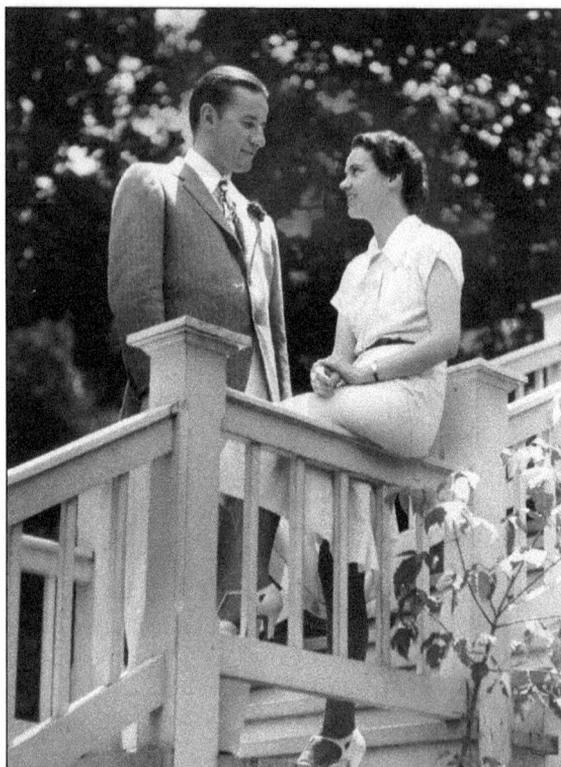

Thomas L. Sidlo, shown with his wife Elisabeth in 1935, was a noted Cleveland-born attorney of Czech ancestry who served in the cabinet of Cleveland mayor Newton D. Baker. He was a founding partner of the law firm Baker, Hostetler, Sidlo and Patterson (now Baker and Hostetler) in 1916. In 1938, he retired from law to devote his time to artistic causes. (Courtesy of Cleveland Press Archives—CSU Library Special Collections.)

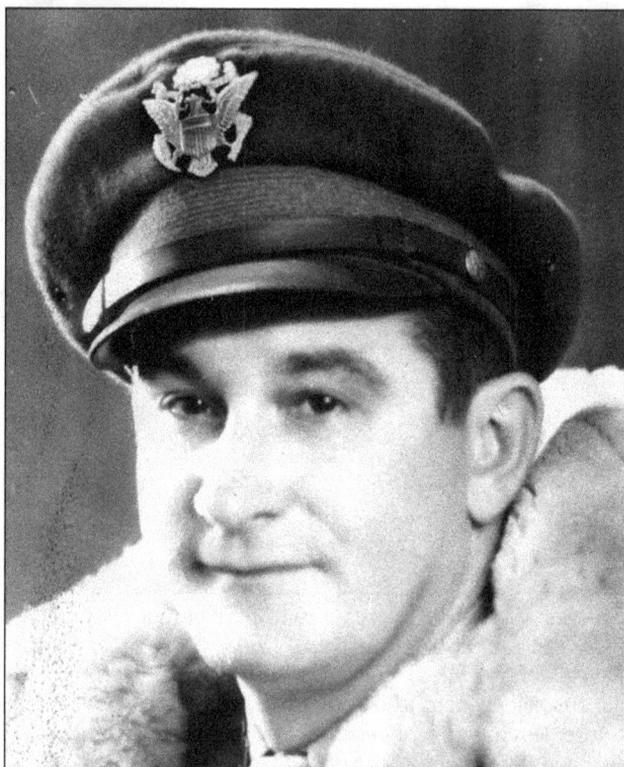

Fr. Frank Masin was a U.S. Army chaplain serving in New Guinea during World War II. Noticing a newly dug grave near Milne Bay bearing his name and serial number, he realized that someone had been killed in a raid and he (Father Masin) was named as a casualty. After his discharge in 1945, the very much alive Father Masin was appointed assistant pastor of Holy Family Church in Cleveland. He later served at St. Wenceslaus and St. Procop parishes. (Courtesy of Jane Tucek Donovan.)

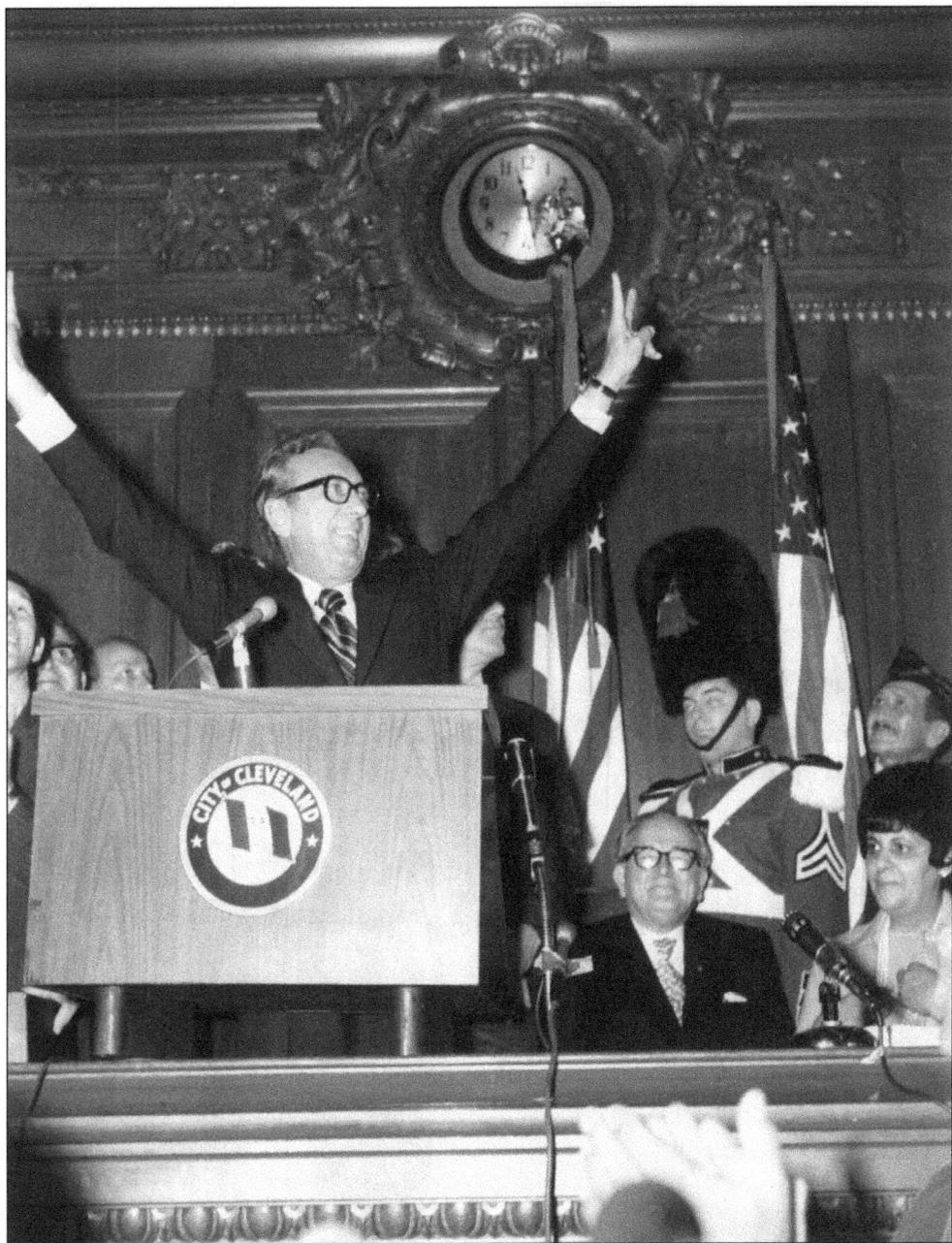

Ralph Perk's election as Cleveland mayor in 1971 was not only a personal triumph; it was a triumph for Cleveland's Czech community and for the ethnic community at large. The victor in a three-way race, Mayor Perk as shown flashing a victory sign at his 1971 inaugural. To his right are his brother George and wife, Lucille. (Courtesy of Judge Ralph Perk, Jr.)

Ralph Perk graduated from Our Lady of Lourdes School in 1927. The Perk family at that time lived near East 50th Street and Dalton Avenue, close to the East 49th Street house Perk would purchase in 1946. (Courtesy of Judge Ralph Perk, Jr.)

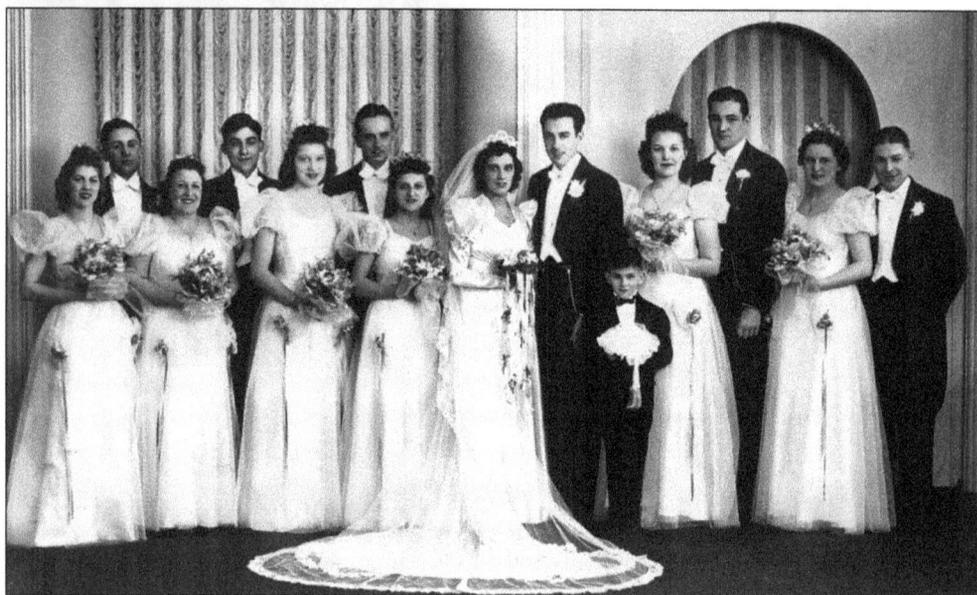

Ralph Perk, later to be mayor of Cleveland, and Lucille Gagliardi were married in 1941. The two bridesmaids on the right in this photograph are Lillian Fanta and Mary Kahoun, classmates of Lucille Gagliardi at Our Lady of Lourdes. Although the area around Our Lady of Lourdes was generally Czech, it was cosmopolitan enough to accommodate the Italian Gagliardi family, who lived on East 49th Street near Guy Avenue. Lucille's father Sam operated a barbershop in the area. (Courtesy of Ellen Howard.)

Ralph Perk, shown in his in Knights of Columbus suit in 1947, served as a parish councilman and sang in the choir at Our Lady of Lourdes Church. He was also active at St. John Cathedral in Cleveland. (Courtesy of Judge Ralph Perk, Jr.)

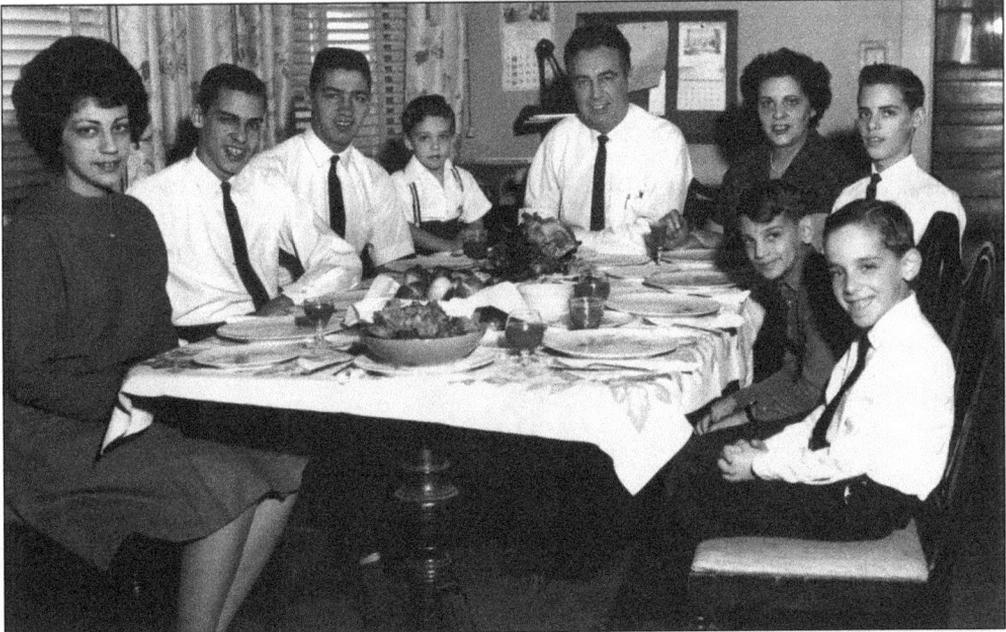

The Ralph Perk family is shown in the dining room of their house on East 49th Street, which Ralph Perk purchased in 1946 and which served as his center of operations throughout his public life. Shown clockwise, from left to right, are Virginia, Kenny, Ralph Jr., Ricky, Ralph, Lucille, Tommy, Michael, and Allen. Most of the Perk children served in public life. (Courtesy of Judge Ralph Perk, Jr.)

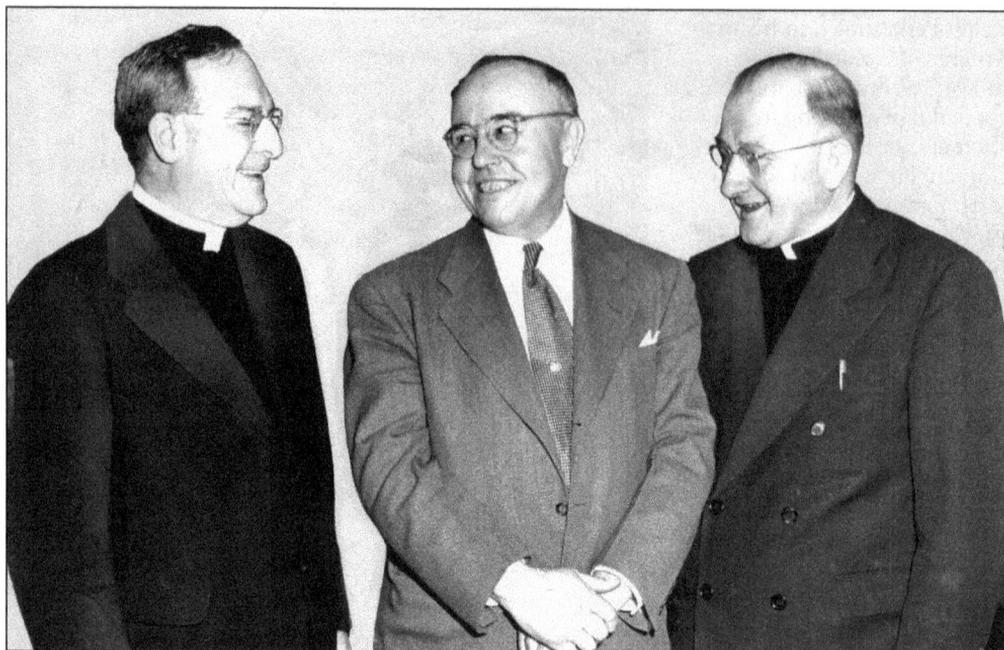

A prominent member of Cleveland's Czech community was Charles Hronek, shown here with Fr. Ray Matousek and Fr. Joseph Andel at the 25th anniversary of the Federated Czech Societies in May 1951. Widely known as "Mr. Broadway-55th," he also served as mayor of Newburgh Heights. (Courtesy of Joseph Kocab.)

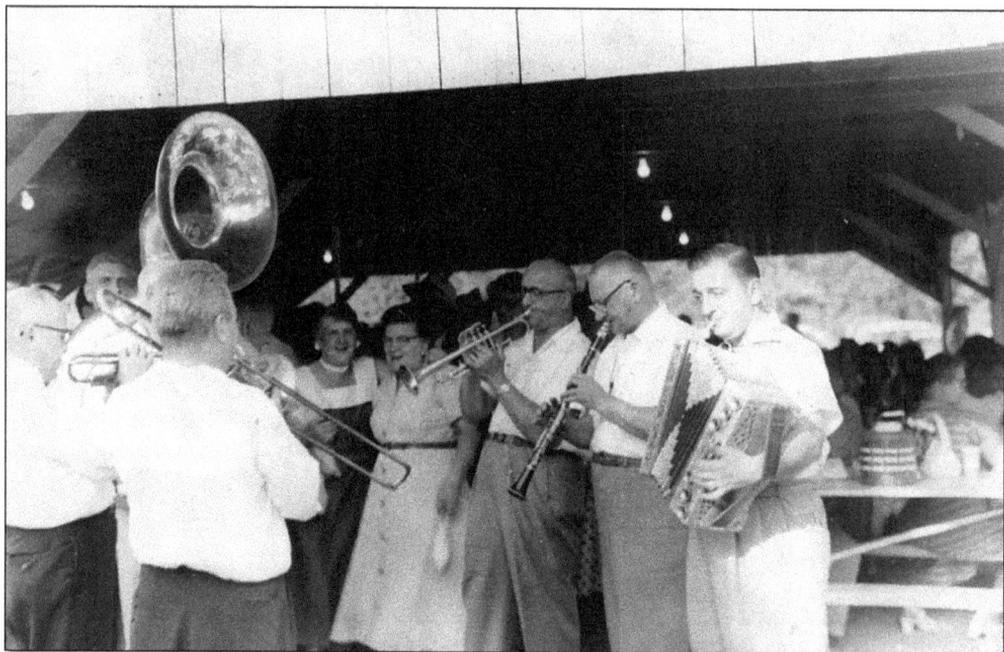

One of Charlie Hronek's abiding loves was music, as shown here by this appearance of the Charles Hronek Brass Band at a picnic in Walton Hills in 1959. At least twice a month through the year, Charlie, his cousins, and friends played for picnics, celebrations, and even funerals throughout Cleveland's Southeast Side. (Courtesy of Joseph Kocab.)

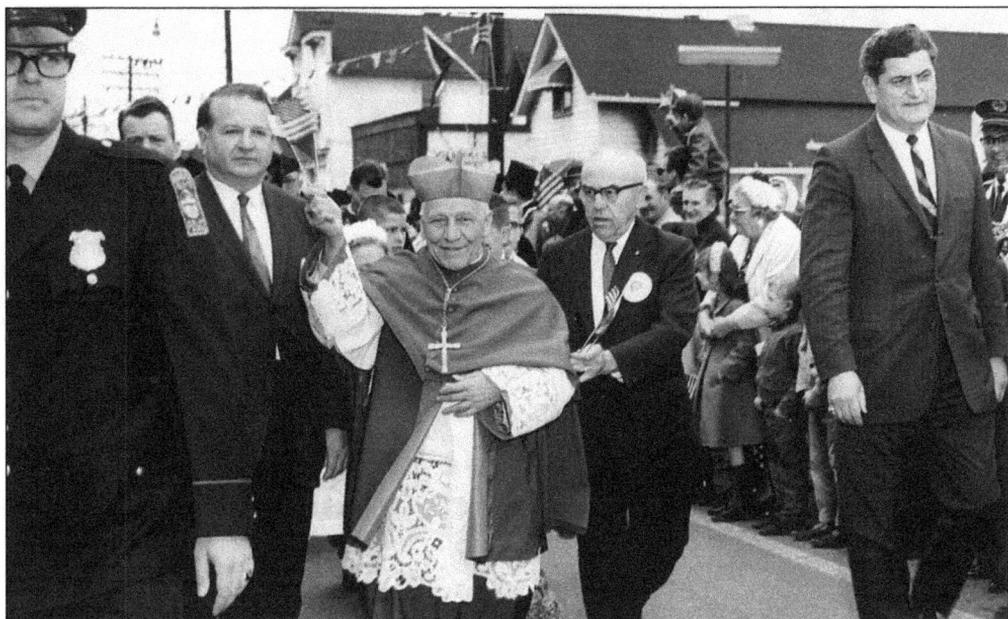

Cardinal Joseph Beran's visit to Cleveland would have been incomplete without a personal escort from "Mr. Broadway-55th," Charlie Hronek (second from the right). Very active in Czech fraternal societies, he was president of the St. Joseph Society, vice president of the National Czech Catholic Union, and president of the National Alliance of Czech Catholics. (Courtesy of Joseph Kocab.)

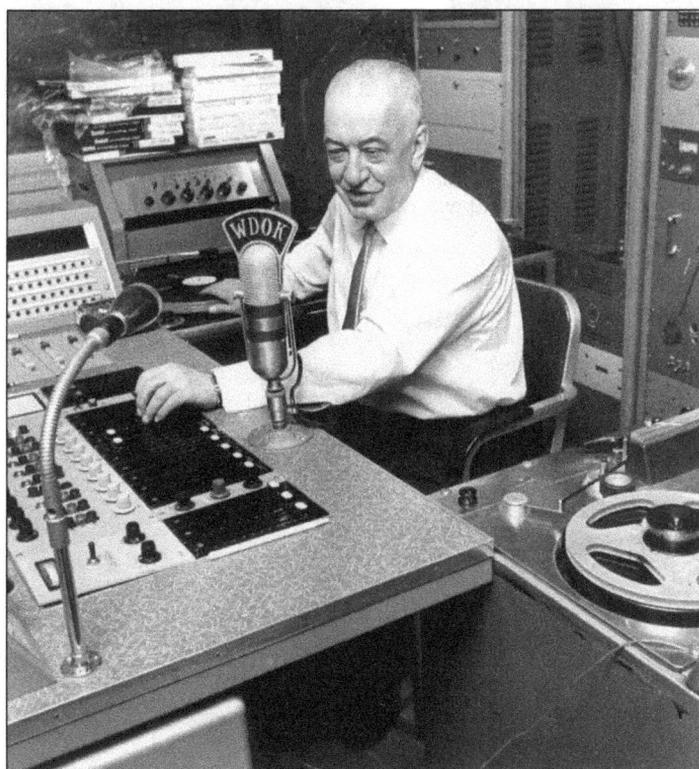

Besides serving as the host of a Czech music program on Cleveland radio, Fred Wolf owned the Cleveland Recording Company, which recorded a number of local bands, including the famed Frankie Yankovic in his early days. (Courtesy of Cleveland Press Archives—CSU Library Special Collections.)

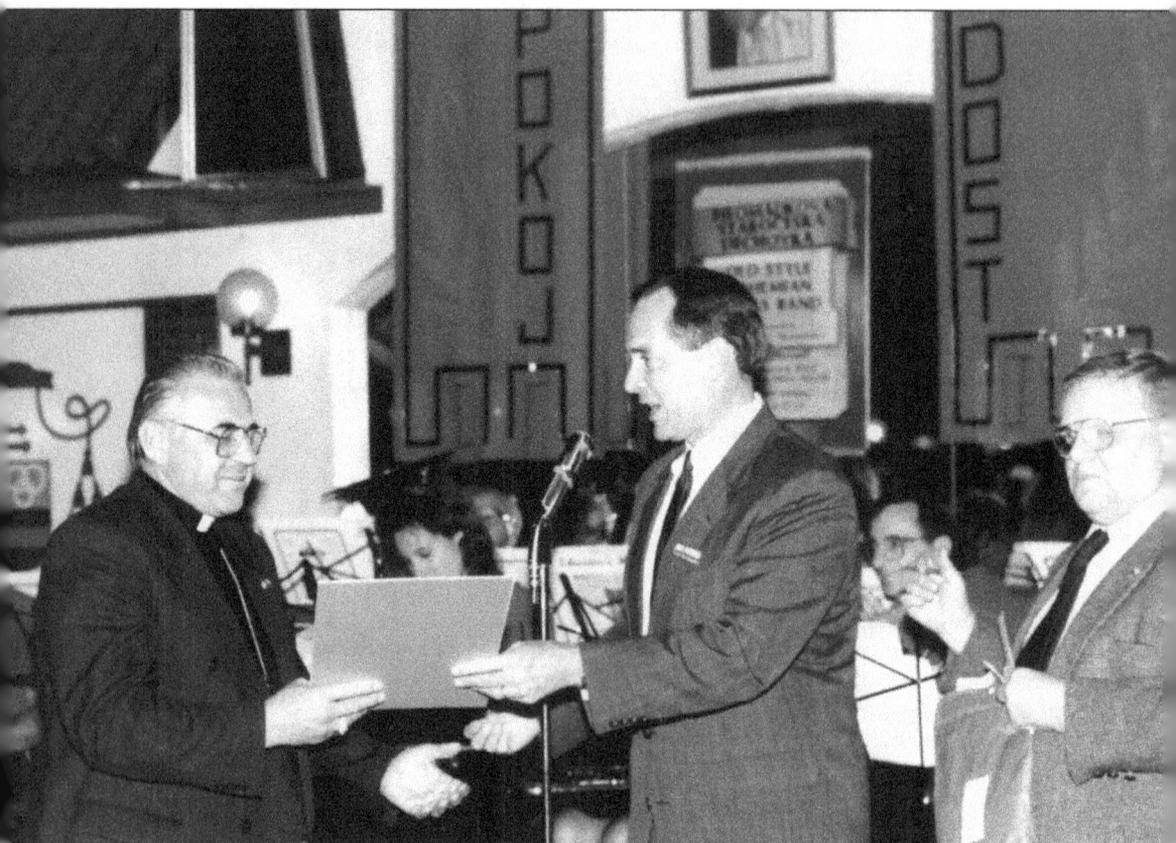

A significant visitor to Cleveland in 1992 was Cardinal Miloslav Vlk, archbishop of Prague. The Cardinal, shown on the left at a reception at Karlin Hall, had been named Prague archbishop the year before. For several years under the communist government in Czechoslovakia, he carried out his pastoral duties in secret. He became bishop of Ceske Budejovice in 1990 following the Velvet Revolution and was named as a cardinal and archbishop of Prague in 1991. (Courtesy of Joseph Kocab.)

Nine

COMMUNITY

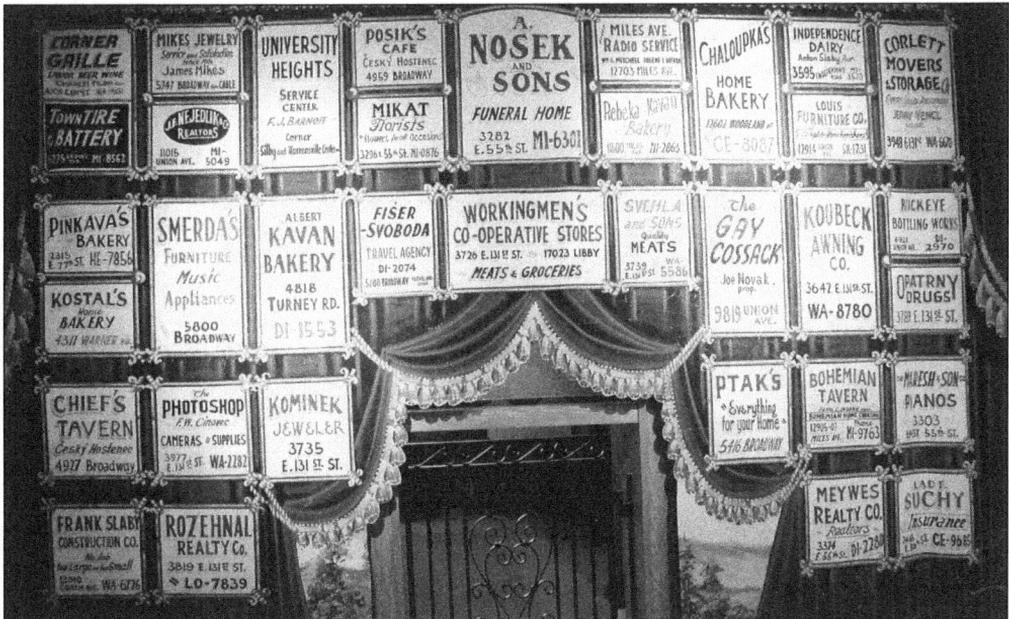

For many of Cleveland's Czechs, the areas around Broadway and East 55th Street, Fleet Avenue, East 131st Street, and others represented principal retail areas, with many Czech-owned businesses. This old stage curtain now on display at the Czech Cultural Center of Sokol Greater Cleveland (Bohemian National Hall) once hung at Sokol Cleveland Cech-Havlicek Hall on Harvard Avenue and is a visual reminiscence of these areas and the business that once thrived there. (Courtesy of the Czech Cultural Center of Sokol Greater Cleveland.)

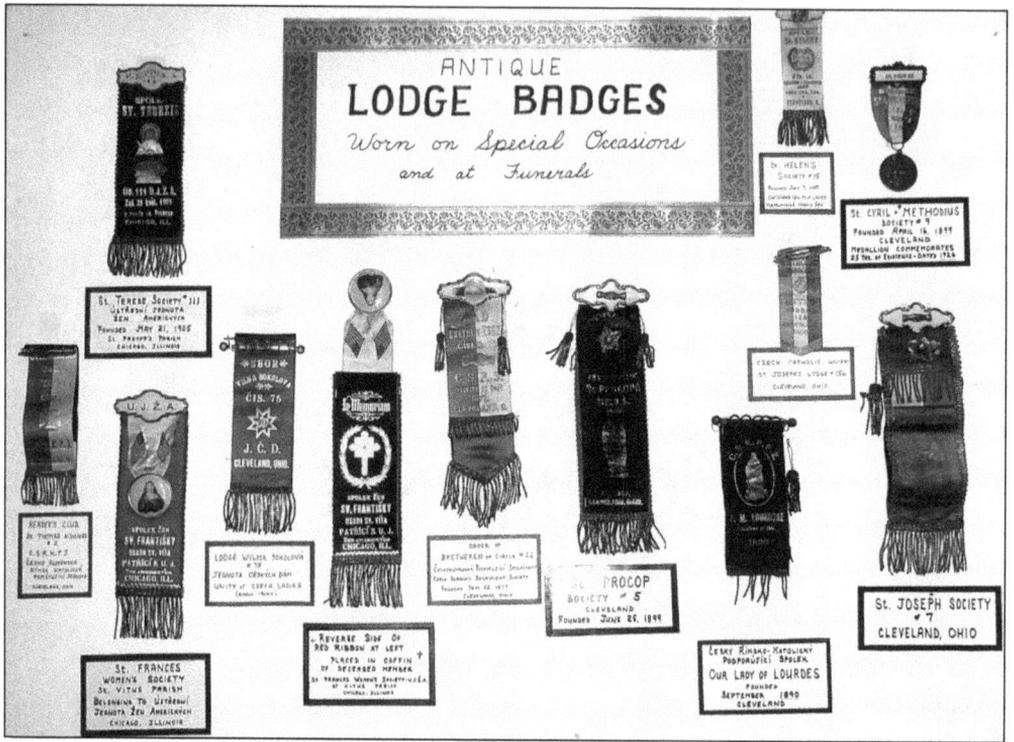

These badges from Czech Catholic and freethinker lodges are part of a display at the Czech Cultural Center of Sokol Greater Cleveland (formerly Bohemian National Hall). For most of its history, the hall was a bastion of freethinker societies. Since its purchase by Sokol Greater Cleveland in 1975, it has come to represent an amalgamation of the Czech community. (Courtesy of the Czech Cultural Center of Sokol Greater Cleveland.)

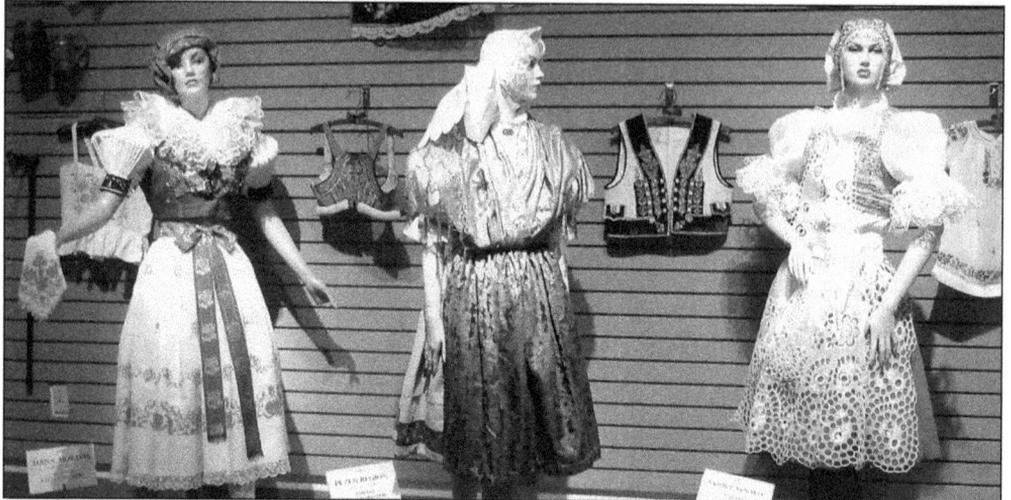

The traditional Czech or Slovak folk wear, Kroj, represents the land and traditions left behind for their new life in America. Many early immigrants brought these articles of clothing with them because each one speaks individually about the village or region where they were born. These Kroje are on display at the Czech Cultural Center of Sokol Greater Cleveland (formerly Bohemian National Hall). (Courtesy of the Czech Cultural Center of Sokol Greater Cleveland.)

96

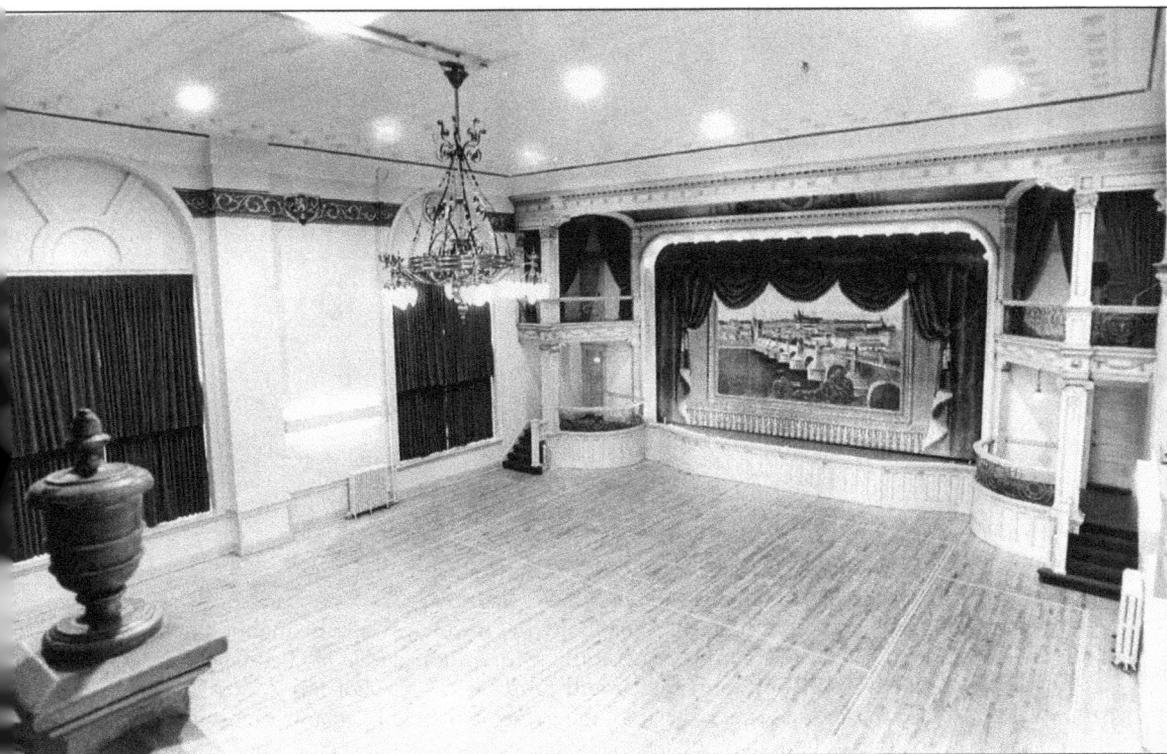

This is the ballroom of Bohemian National Hall in 1977. Besides social events, the hall has been the site of Czech lodge meetings and gatherings for societies and drama clubs. By 1919, 73 societies met at the hall, and in 1911, rooms were added for Czech language classes. In 1975, the building was sold to Sokol Tyrs, which deeded it to Sokol Greater Cleveland. A major expansion after 2000 added a separate athletic facility, refurbished much of the interior, and added room for a museum. The building has now been renamed as the Czech Cultural Center of Sokol Greater Cleveland. (Courtesy of Cleveland Press Archives—CSU Library Special Collections.)

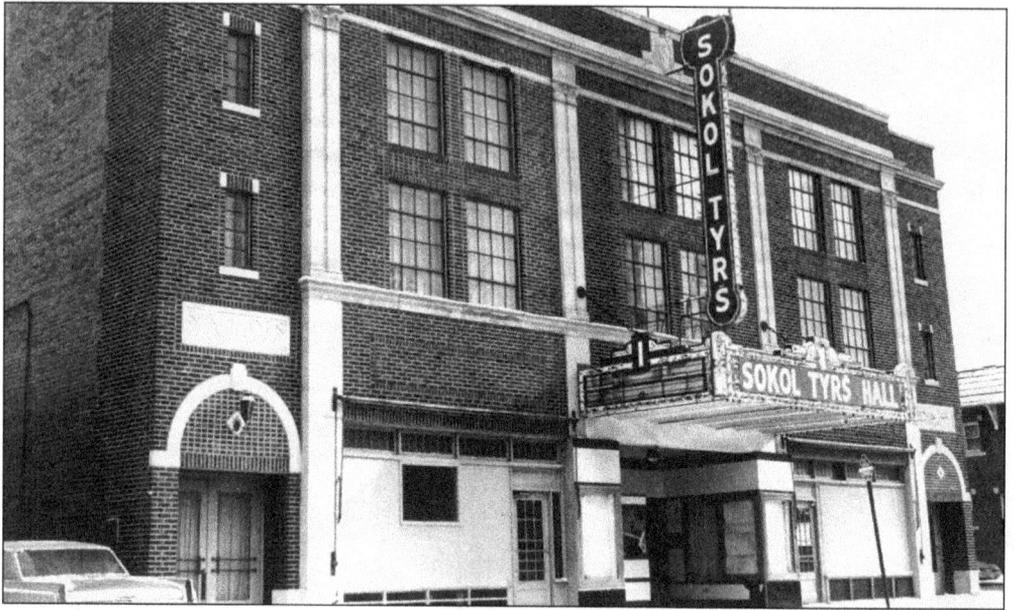

Sokol Tyrs Hall on East 131st Street and Melzer Avenue was an anchor for the Mount Pleasant/Corlett Czech community. According to the *Encyclopedia of Cleveland History*, Sokol Tyrs was formed in 1919 by John Sebek and John Fencl as Sokol Jan Amos Komensky. On May 22, 1920, the group joined the national American Sokol Organization, and in 1926, it became Sokol Tyrs. (Photograph by Bernie Noble; courtesy of Cleveland Press Archives—CSU Library Special Collections.)

Sokol Tyrs Hall, 3689 East 131st Street, was built by Czech immigrants in 1926, when the Corlett area of Cleveland's Southeast Side was undergoing its most rapid development. It was principally used for gymnastic events but also featured a banquet hall and stage. This mural was a feature of the hall. Sokol Tyrs later merged with Sokol Nova Vlast. (Photograph by Tony Tomsic; courtesy of Cleveland Press Archives—CSU Library Special Collections.)

The annual celebration of St. Wenceslaus Day rotates among Cleveland's Czech Catholic churches. This is a glimpse of the 1990 celebration at Our Lady of Lourdes Church, featuring women from St. Procop Parish in Czech costumes. (Courtesy of St. Procop Parish.)

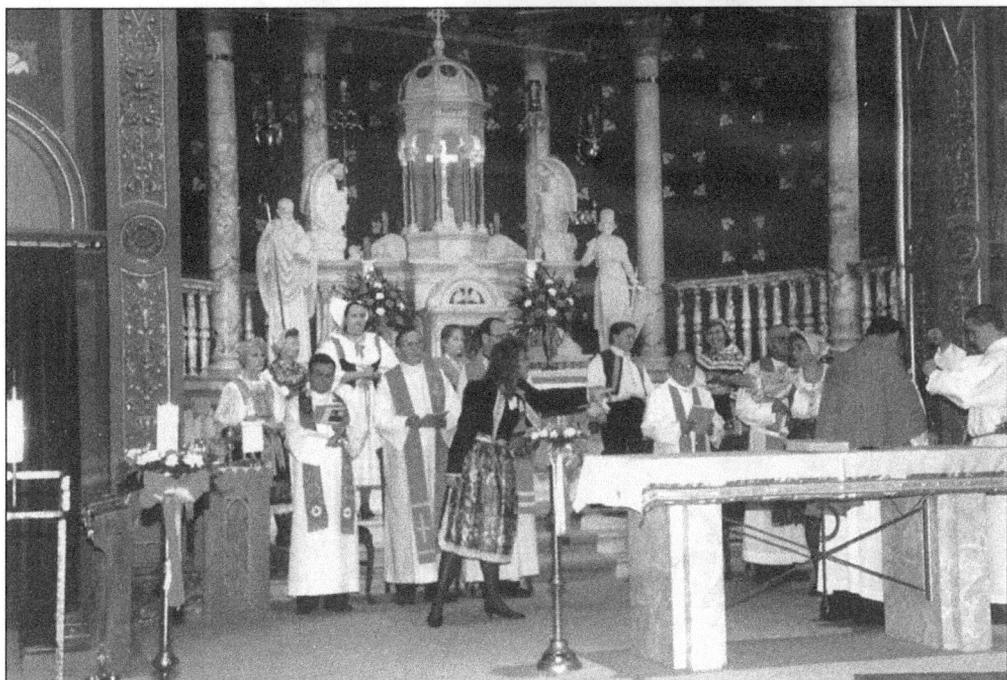

In 1993, it was St. Procop's turn to host the annual celebration of St. Wenceslaus Day at the end of September. Shown here are clergy and lay participants in national costumes. (Courtesy of St. Procop Parish.)

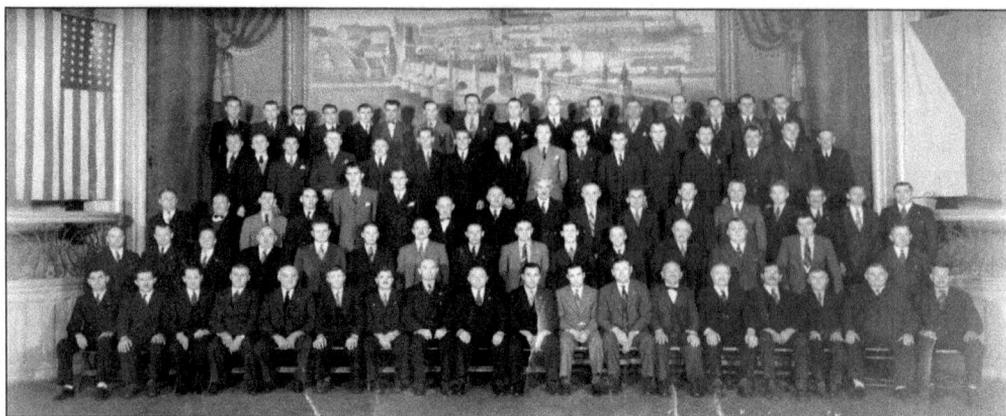

The Czech Bakers Union gathered at Bohemian National Hall on their 50th anniversary, November 23, 1941. In her book *The Czechs of Cleveland*, Eleanor Ledbetter states that "bakeries are numerous, since Czech baked goods are distinctive and too good to be given up." (Courtesy of the Czech Cultural Center of Sokol Greater Cleveland.)

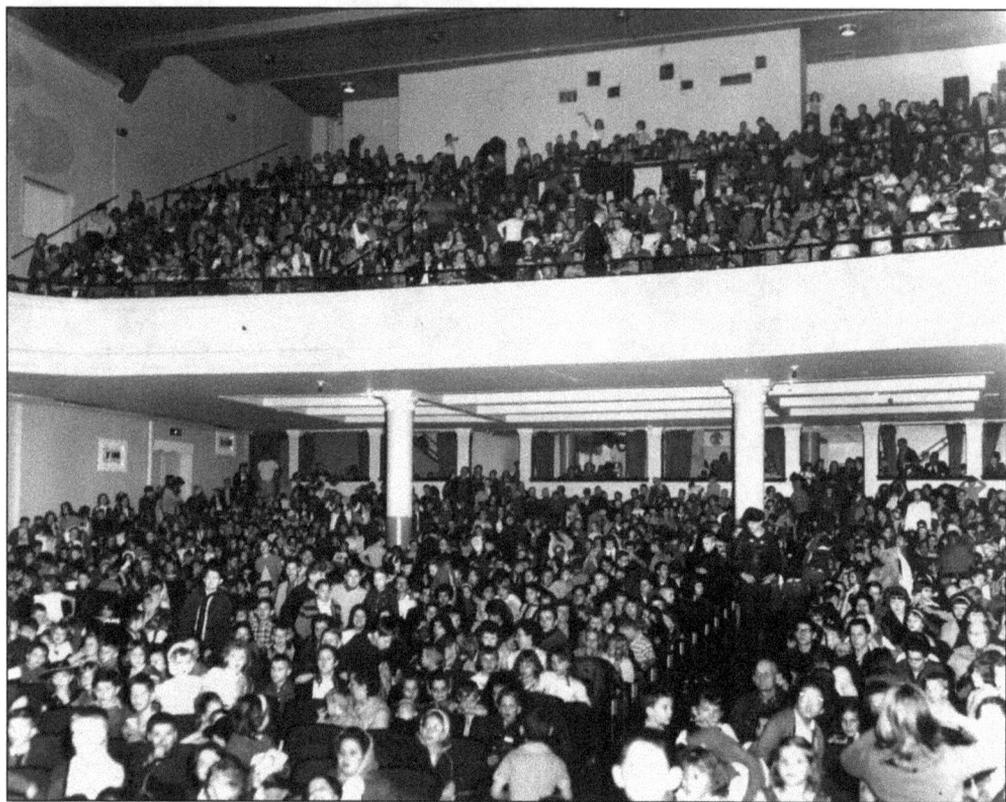

Each year on the day after Thanksgiving, the Broadway Merchants Association and the Perk family would rent the Olympia Theater at East 55th Street and Broadway and open it up to neighborhood children. Mothers from local PTAs also helped to host the event, turning it into a true community effort. Children were treated to films, cartoons, and an occasional live stage act. Each child received a bag of candy plus the chance to win numerous door prizes. (Courtesy of Judge Ralph Perk Jr.)

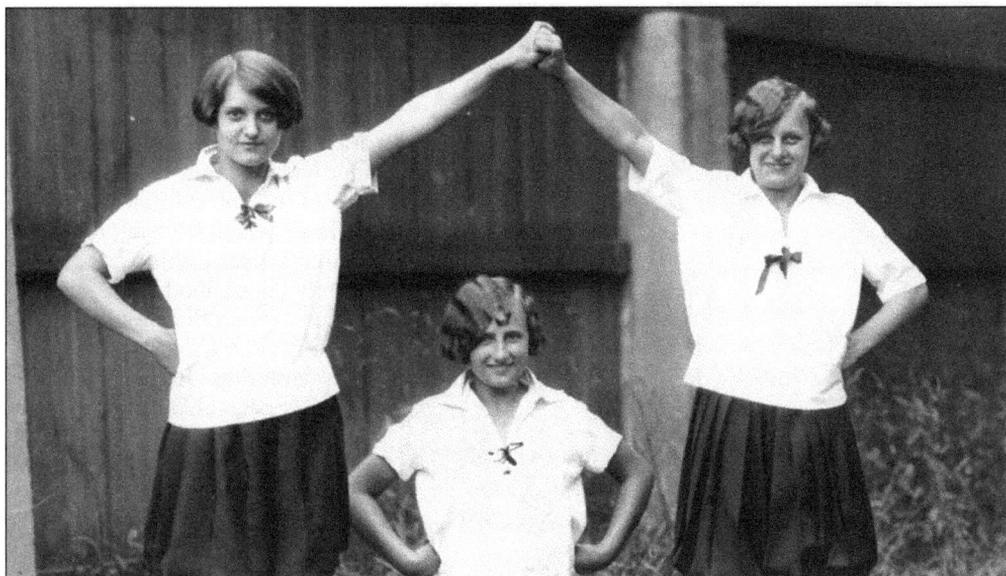

Old country traditions handed down from parents to children were evident as the older generation and their offspring participated in Czecho-Slovak Day at Ceska Sin Sokol Hall on Clark Avenue August 8, 1927. Participating in gymnastics from Sokol are, from left to right, Adelina Stedronsky, Elsie Bohdal, and Martha Chaloupka. (Courtesy of Cleveland Press Archives—CSU Library Special Collections.)

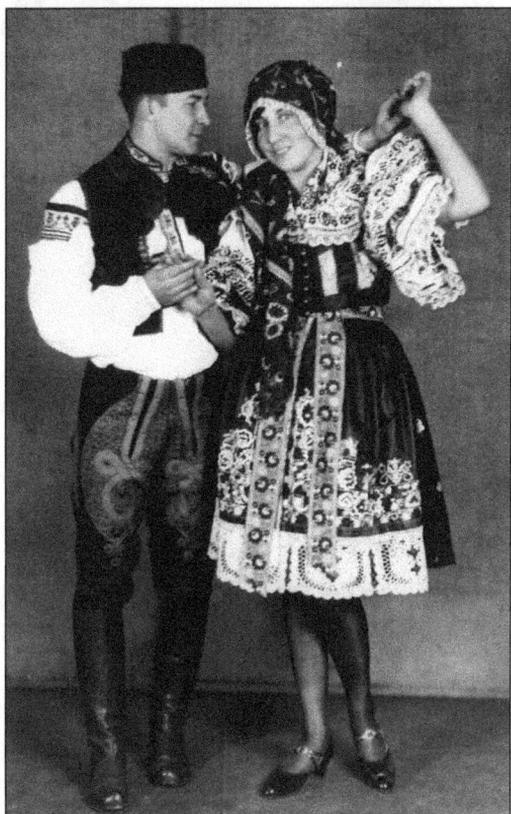

Dressed in Czech costumes and getting ready to dance the Beseda for an all-nations costume ball in November 1929 are George Krause and Marie Kodes. The City of Cleveland and the *Cleveland Press* sponsored the event. (Courtesy of Cleveland Press Archives—CSU Library Special Collections.)

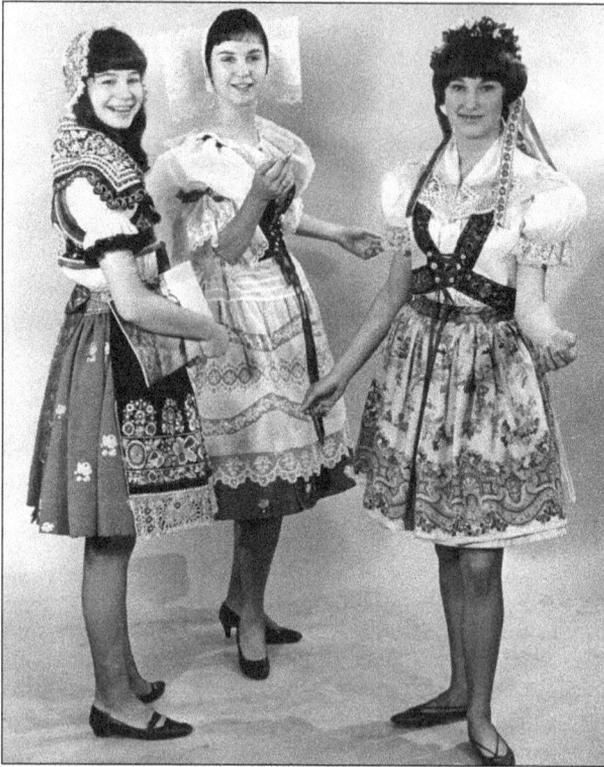

For many years, Cleveland Czechs held a charitable event, Night in Old Bohemia, to benefit the Holy Family Home. In 1967, the dinner and entertainment was held at Our Lady of Lourdes Parish. Part of the entertainment that night included, from left to right, Lauren Pilous, Denise Ptak, and Wendy Pilous, modeling authentic costumes from Bohemia, Moravia, and Slovakia. (Courtesy of Cleveland Press Archives—CSU Library Special Collections.)

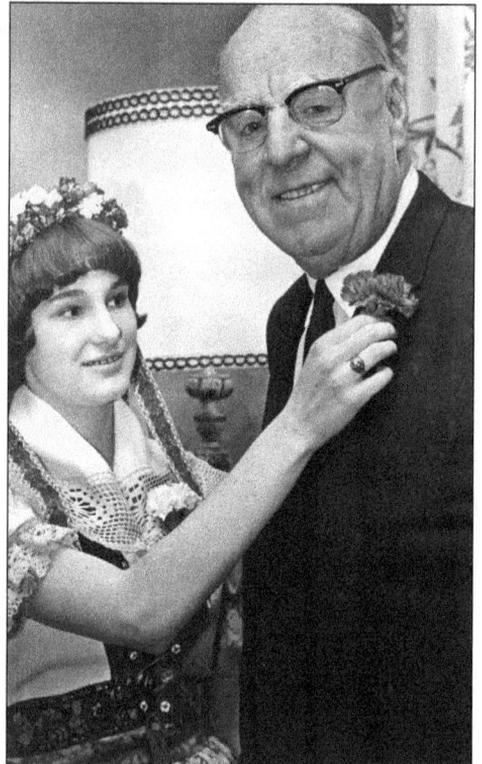

Wendy Pilous of Solon pins a carnation on the lapel of Probate Judge Frank Merrick, who was main speaker at the Night in Old Bohemia in 1967. (Courtesy of Cleveland Public Library/ Photograph Collection.)

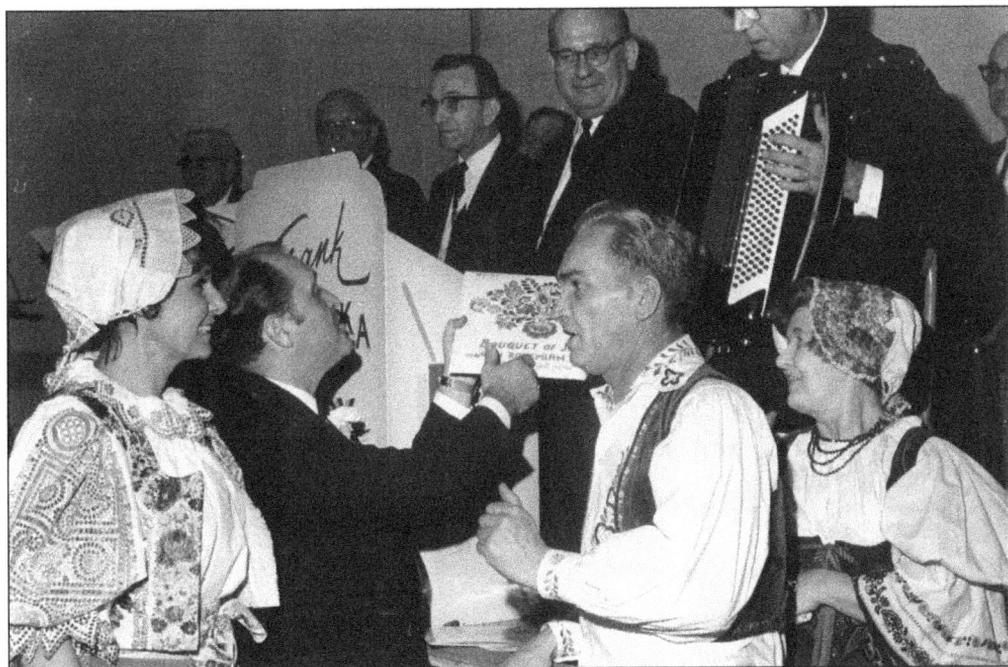

Entertaining at the 1967 Night in Old Bohemia was the Frank Makovicka Bohemian Brass, assisted by Lu Hromadka (second from the left) and Alex Mikula (second from the right). (Courtesy of Cleveland Public Library/Photograph Collection.)

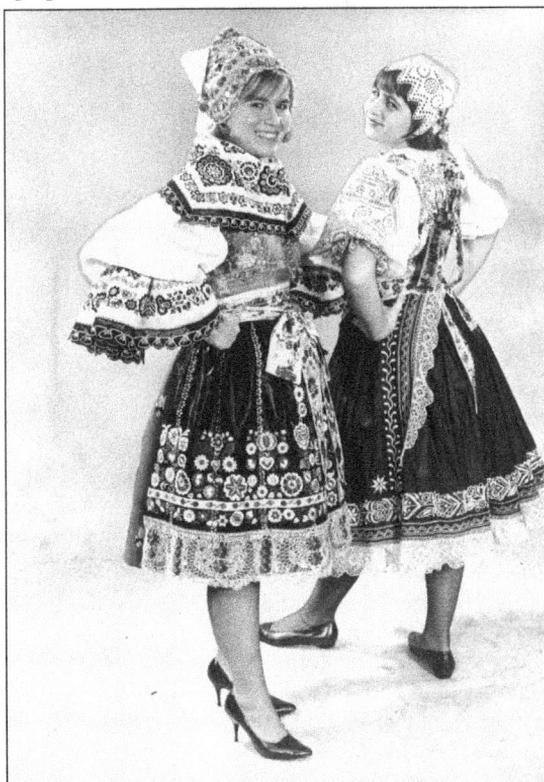

Hana Voris and Ludmila Hyvnar model Czech Kroje that were on display at the Night in Old Bohemia Benefit at Our Lady of Lourdes parish hall in 1966. (Photograph by Bill Nehez; courtesy of Cleveland Press Archives—CSU Library Special Collections.)

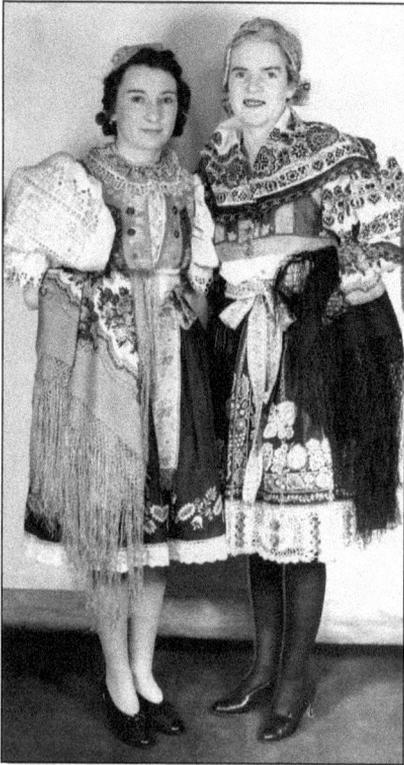

As an anchor for the Czech community, Bohemian National Hall continued to fulfill its mission to keep Czech traditions alive almost 100 years after the arrival of the first Czech settlers. On January 24, 1942, the hall was the site of a "Patriotic Evening." Among those participating in the program sponsored by the Czech-American National Alliance were Dorothy Martanovic and Marie Nejedly. (Courtesy of Cleveland Press Archives—CSU Library Special Collections.)

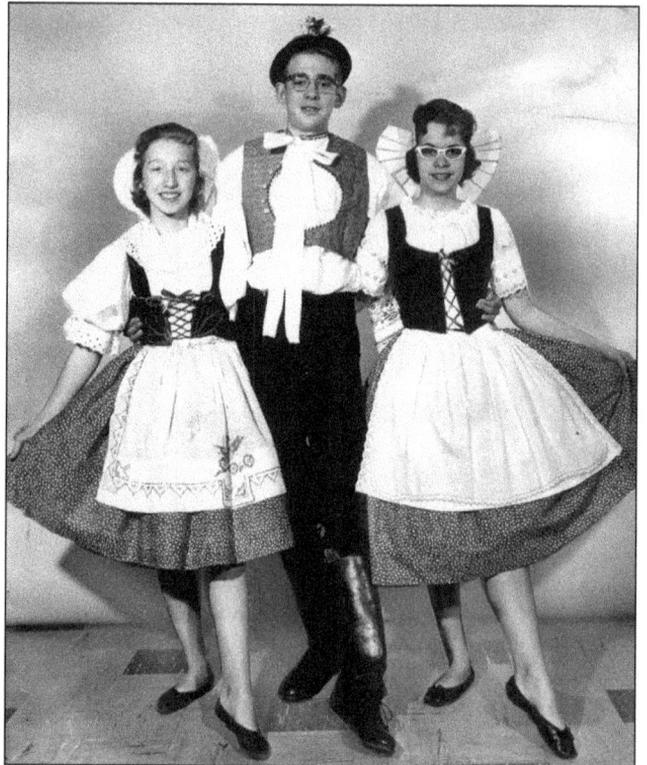

At Cleveland's 11th annual Folk Festival in May 1960, this trio was part of a group that performed a Czech-American folk dance—part of a musical comedy written by Clevelander Zdenek Ptak, who was chairman of the theatrical guild of Sokol Tyrs. Shown are, from left to right, Lydia Pokorny, John Darovec, and Patricia Polivka. (Courtesy of Cleveland Press Archives—CSU Library Special Collections.)

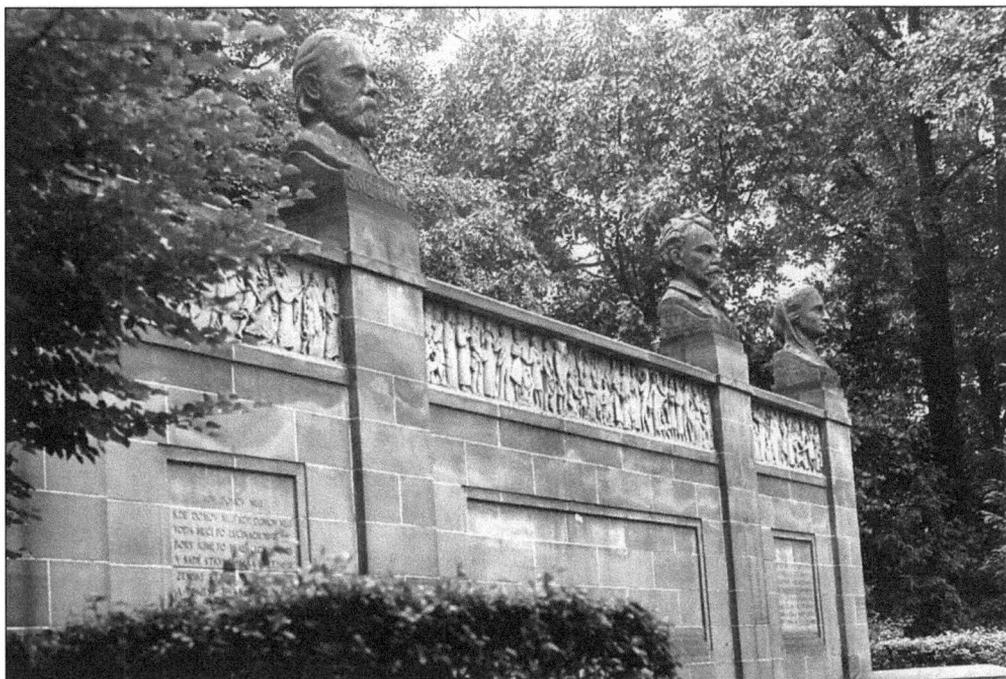

The Czech Cultural Garden, part of the network comprising the Cleveland Cultural Gardens in Rockefeller Park, was opened in 1935. The circular plot features statues and busts sculpted by Cleveland Czech artist Frank Jirouch. The display includes figures of Tomas G. Masaryk, founder and first president of Czechoslovakia; Jan Amos Comenius (Komensky), renowned Czech educator; and Czech composer Antonin Dvorak. (Photograph by Walter Kneal; courtesy of Cleveland Press Archives—CSU Library Special Collections.)

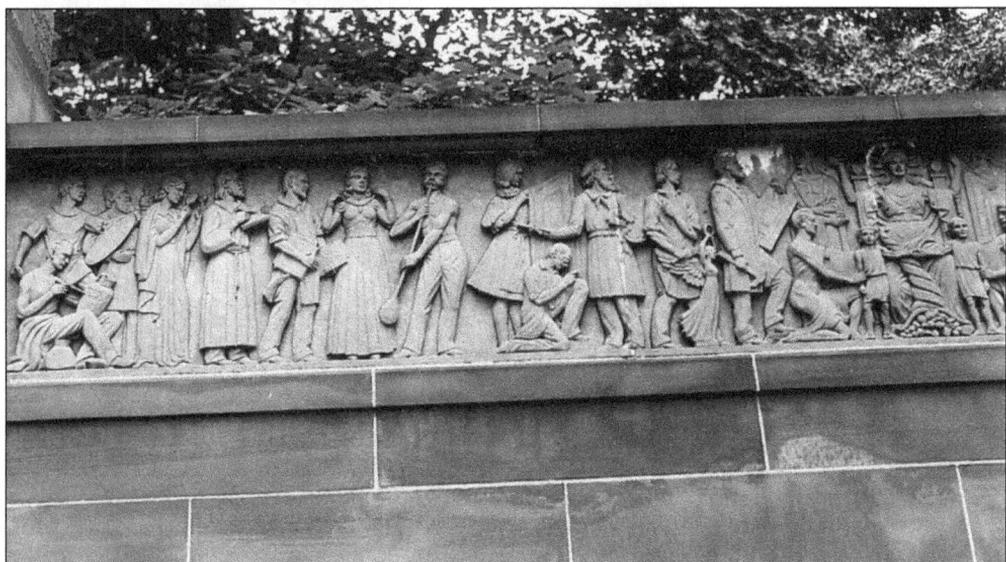

This frieze at Cleveland's Czech Cultural Garden was designed and sculpted by Cleveland artist Frank Jirouch and depicts the history of Czech migration—first to the area now known as the Czech Republic and later to the United States. (Photograph by Walter Kneal; courtesy of Cleveland Press Archives—CSU Library Special Collections.)

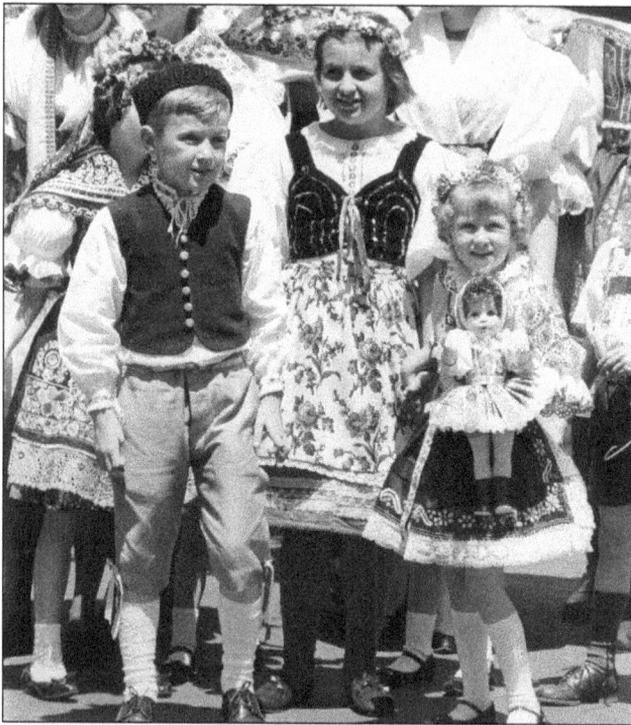

Costumed Czech folk dancers entertained on June 4, 1962 as the statue of Tomas G. Masaryk, founder and first president of Czechoslovakia, was unveiled. The statue was the work of Cleveland Czech artist Frank Jirouch and was added 27 years after the garden was opened. (Courtesy of Cleveland Press Archives—CSU Library Special Collections.)

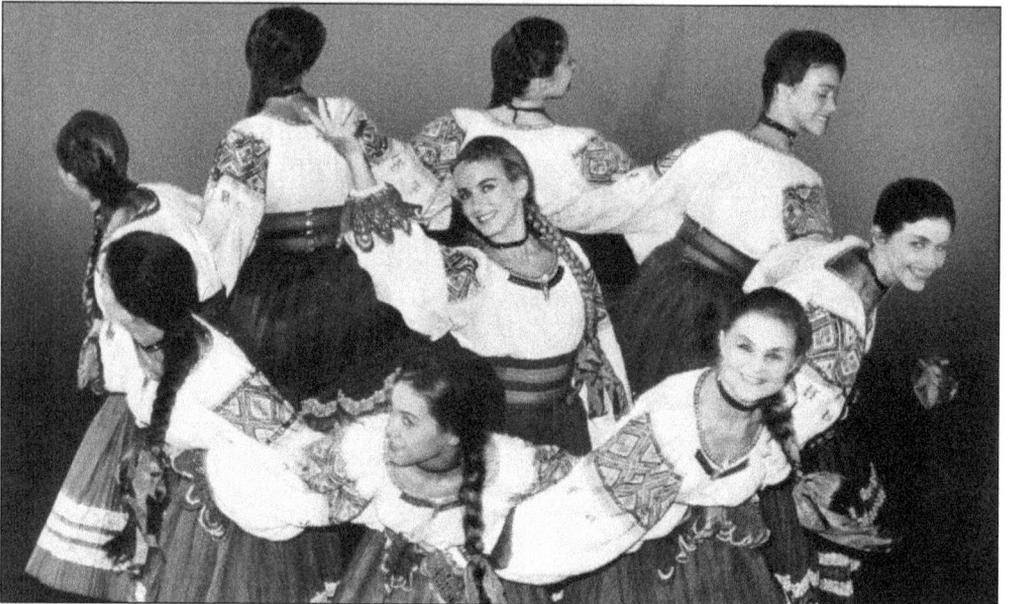

Because of Cleveland's high concentration of Czechs and Slovaks, the city has always been a magnet for touring groups, particularly from Czechoslovakia and now the Czech and Slovak Republics. In December 1964, the Czechoslovak State Folk Dance Group appeared at the Cleveland Arena to present characteristic dances from Bohemia, Moravia, and Slovakia. The group's appearance in Cleveland at that time was viewed as a sign that the Iron Curtain countries wanted to establish more contacts in the United States. (Courtesy of Cleveland Press Archives—CSU Library Special Collections.)

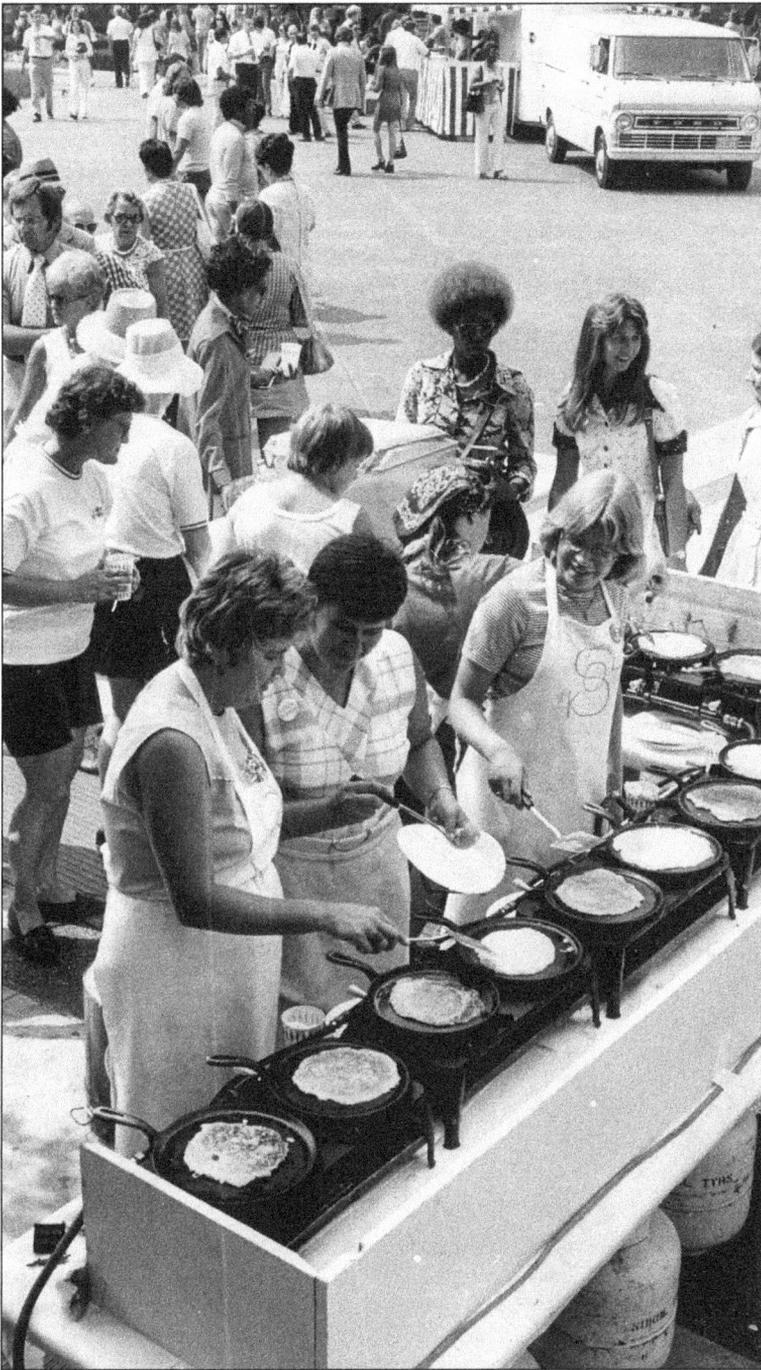

An annual summer event in Cleveland during the 1970s was the All Nations Festival, which took place at the Hanna Fountains Mall, next to the Cleveland Convention Center. Included in the array of nationality groups offering ethnic delectables to attendees are, from left to right, Joanne Prochazka, Audrey Roth, and Karen Prochazka, who made potato pancakes at the Sokol Tyrs gymnastics booth. (Photograph by Bill Nehez; courtesy of Cleveland Press Archives—CSU Library Special Collections.)

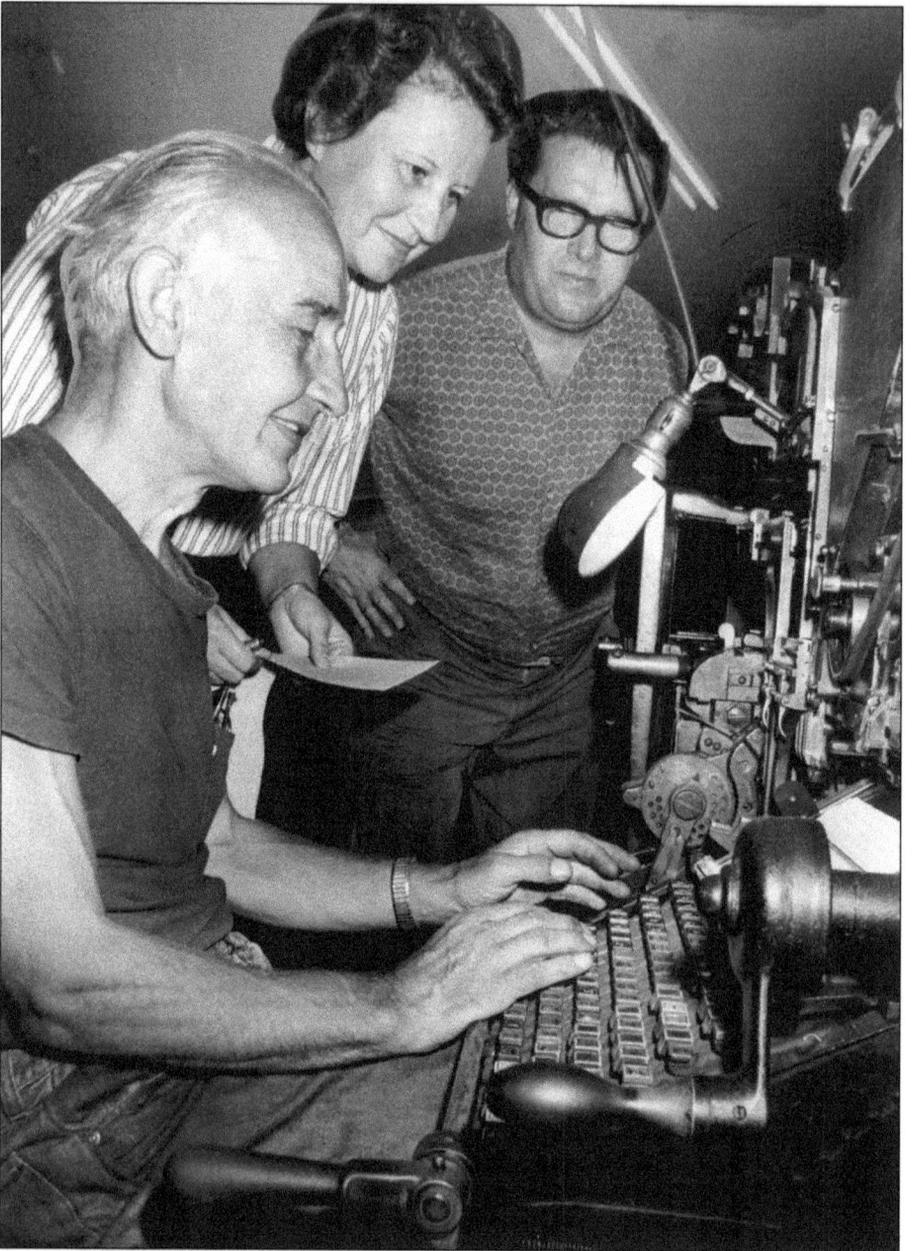

The Czechs—like many of Cleveland's ethnic groups—had their own daily newspapers, which included the *American*, *Svet* (*World*), *Svet-American*, *Pokrok*, *Dennice Novoveku* (*New Era Journal*), *Americke Delnicke Listy*, and the *Novy Svet*. The *Novy Svet* began publication in 1950, printing 10,000 copies of a 28-page issue. In the words of one of its organizers, Lada Kiml, the *Novy Svet's* stockholders wanted a Czech newspaper that would inform its readers about the true conditions in Czechoslovakia, fight communism, and "guard the good name of our nationality." The paper celebrated its 20th anniversary in September 1970. Shown here are Miloslava Hyvnar, editor (center), and typesetters Karel Vavra and Vaclav Hesoun. The paper ceased publication in 1977. (Photograph by Tim Culek; courtesy of Cleveland Press Archives—CSU Library Special Collections.)

When newspapers for Czechs and other nationalities flourished in Cleveland, it was common practice to buy advertisements extending congratulations to their countrymen for events such as weddings. The wedding of Bozena Masin and Jan Tucek brought these advertisements in Cleveland's *Novy Svet*. (Courtesy of Greg Sejd.)

Many Czechs and Slovaks on Cleveland's Southeast Side, Cuyahoga Heights, Newburgh Heights, and other nearby suburbs got their local news from the *Neighborhood News*, a weekly newspaper edited by James Masek, shown here on the left with Ohio governor John Gilligan in 1979. The photograph was taken at John's Cafe, one of the most popular Czech restaurants in Cleveland at the time. (Courtesy of Joseph Kocab.)

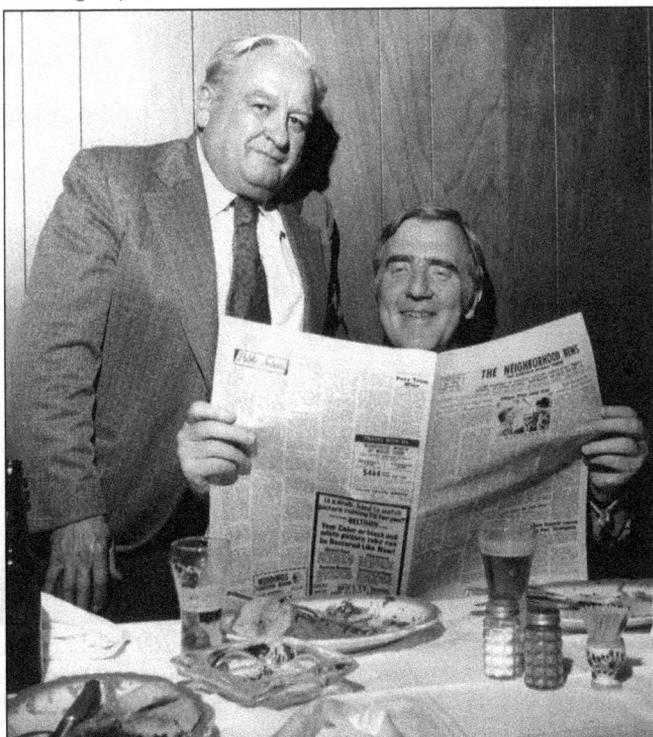

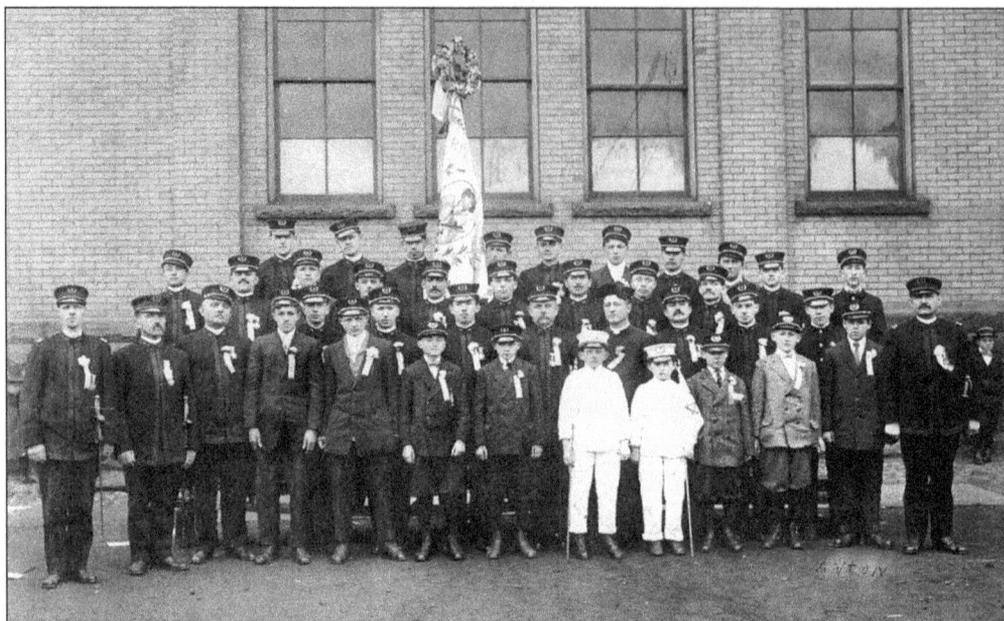

The Knights of St. John at St. John Nepomucene Parish dates back almost to the founding of the parish in 1902. It is one of two uniformed societies, the other being the Knights of St. John Ladies Auxiliary No. 267, which began in 1932. The men's and women's groups were familiar sights at parish celebrations and represented St. John Nepomucene at other parishes throughout the city. (Courtesy of Joseph Kocab.)

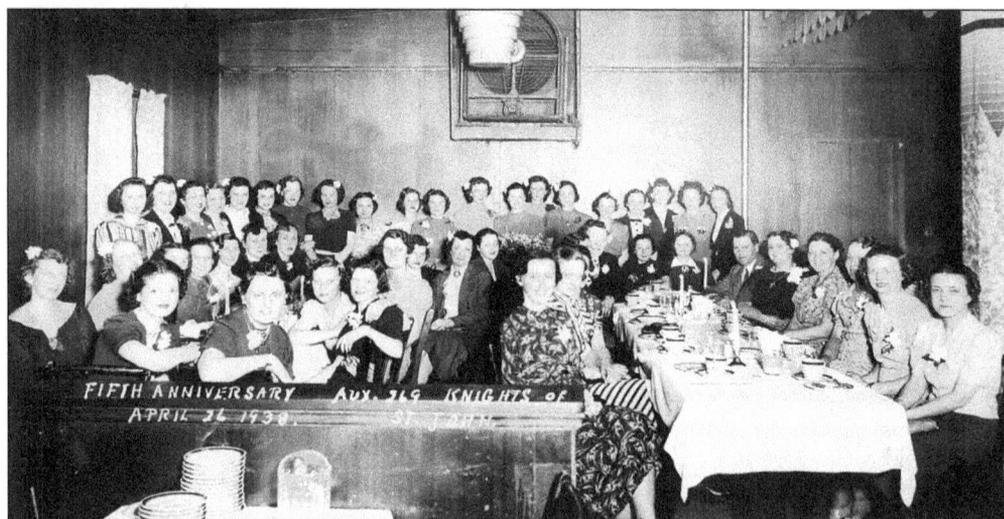

The Knights of St. John Ladies Auxiliary No. 269 celebrated its fifth anniversary in April 1938 with this dinner, probably at Our Lady of Lourdes. Directly above the word "anniversary" in this photograph is Mary Kahoun, who was first sergeant for the marching group. (Courtesy of Ellen Howard.)

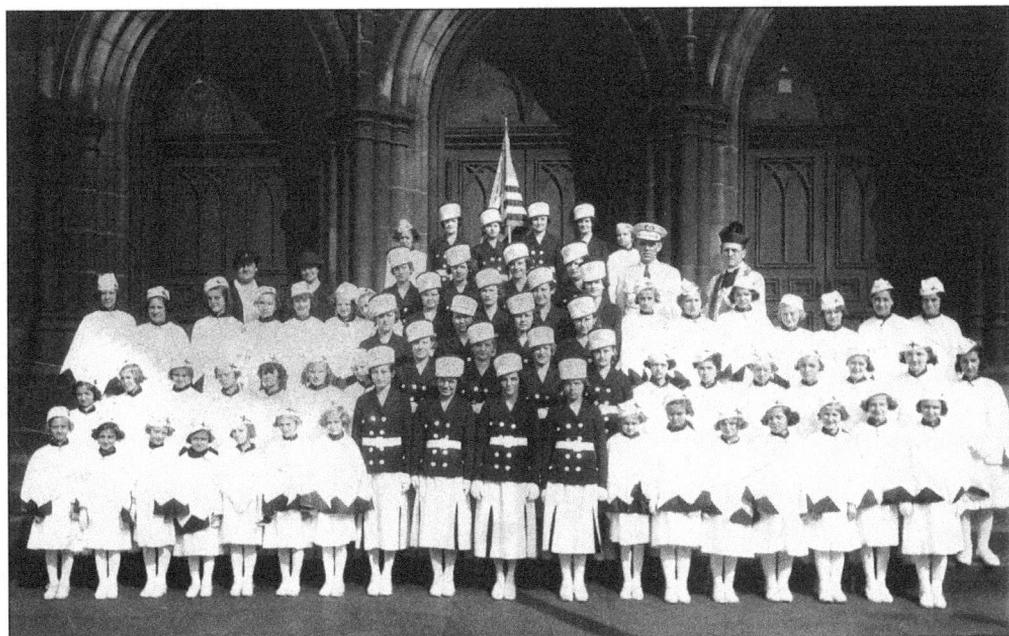

According to Eleanor Ledbetter in her book *Czechs of Cleveland*, there were more than 45 societies at Our Lady of Lourdes Church, including Knights of Columbus, Cadets of St. Alexander, and the Hunters of St. George. Shown here are members of the Auxiliary of the Knights of St. John. (Courtesy of Joseph Kocab.)

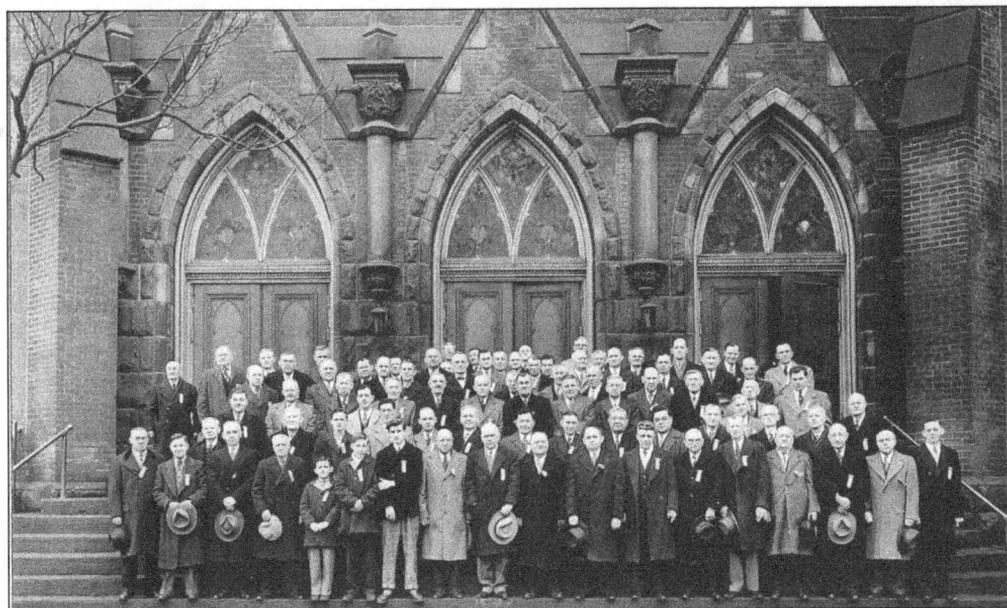

By 1881, the Bohemian Roman Catholic Central Union of Women had 629 members, and in the 1930s, it merged with the Czech Catholic Cleveland Union of Men and the Czech Catholic Cleveland Union of Women. The name changed to Czech Catholic Union in 1939. This is the St. Joseph Society of the Czech Catholic Union in front of Our Lady of Lourdes Church in 1947. (Courtesy of Joseph Kocab.)

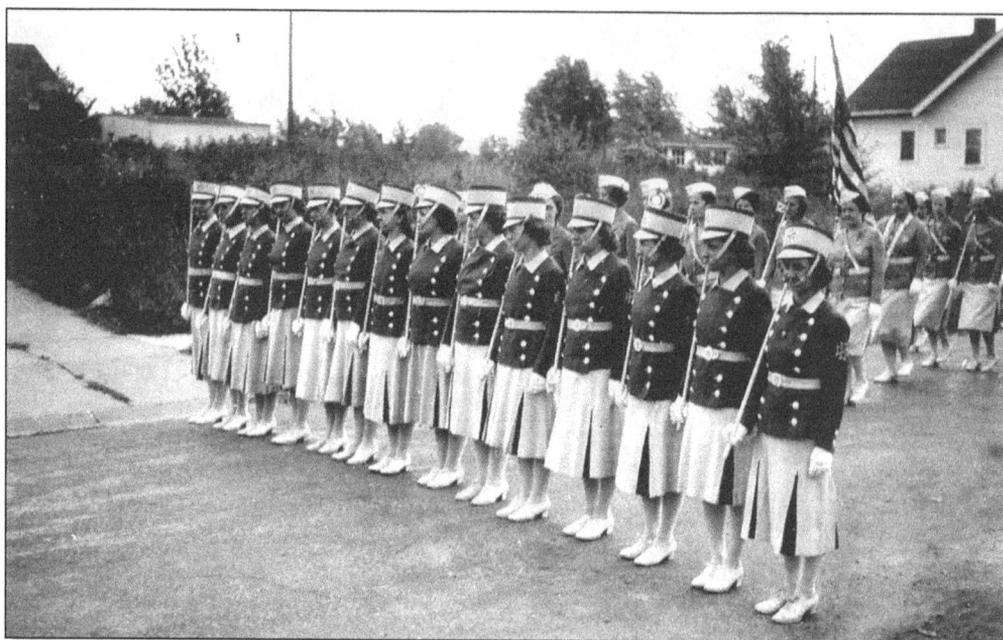

Cadets from the Knights of St. John Auxiliary parade at St. Wenceslas, Maple Heights, on September 10, 1939. The cadets in front are possibly from Our Lady of Lourdes Church. Cadets in the back are from St. Wenceslas. St. Wenceslas retained its status as a nationality parish until 1952, when it changed to a territorial parish. (Courtesy of John Straka.)

The Czech Catholic Union traces its roots in Cleveland to the St. Anne's Society of the Bohemian Roman Catholic Central Union of Women, organized at St. Wenceslaus Parish in 1867 by Fr. Anton Hynek, according to the *Encyclopedia of Cleveland History*. In 1939, the merged entity changed its name to the Czech Catholic Union. This is a scene from the society's 1958 convention. (Courtesy of Czech Catholic Union.)

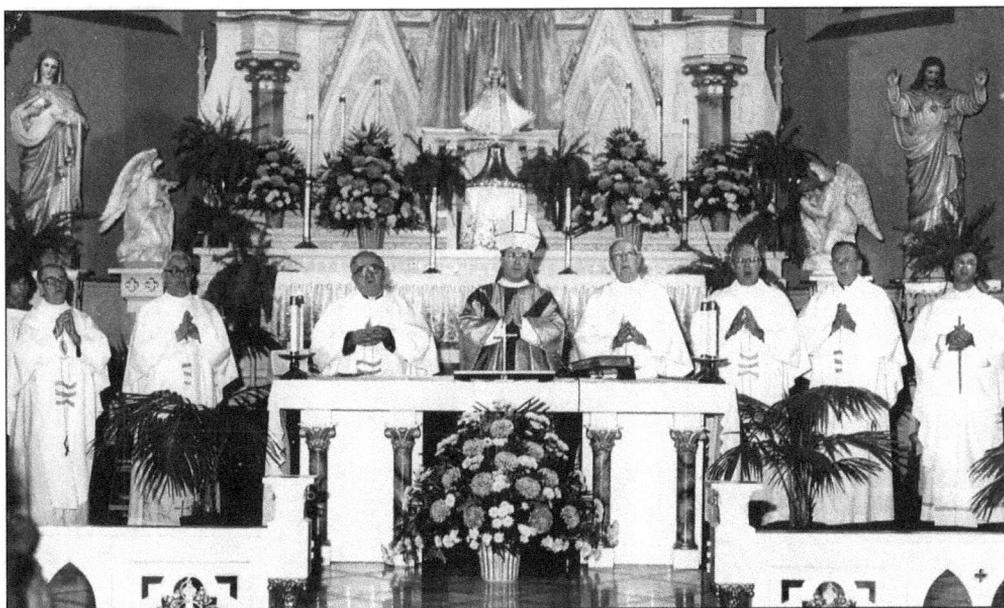

An important visitor to the Cleveland Czech community in 1978 was Bishop Daniel Kucera, OSB, of Joliet, Illinois. Bishop Kucera, who at 36 was the youngest president of St. Procopius College (now Benedictine University) at Lisle, Illinois, went on to become Archbishop of Dubuque, Iowa. He is shown here at mass at Our Lady of Lourdes Church. He came to Cleveland to address the convention of the Czech Catholic Union Fraternal Insurance Society. (Courtesy of Czech Catholic Union.)

Matching aprons was the order of the day for hostesses at this Czech Catholic Union luncheon card party. Seen here are, from left to right, Lenore Geller, Elsie Malec, and Mary Ann Mahoney. (Courtesy of Czech Catholic Union.)

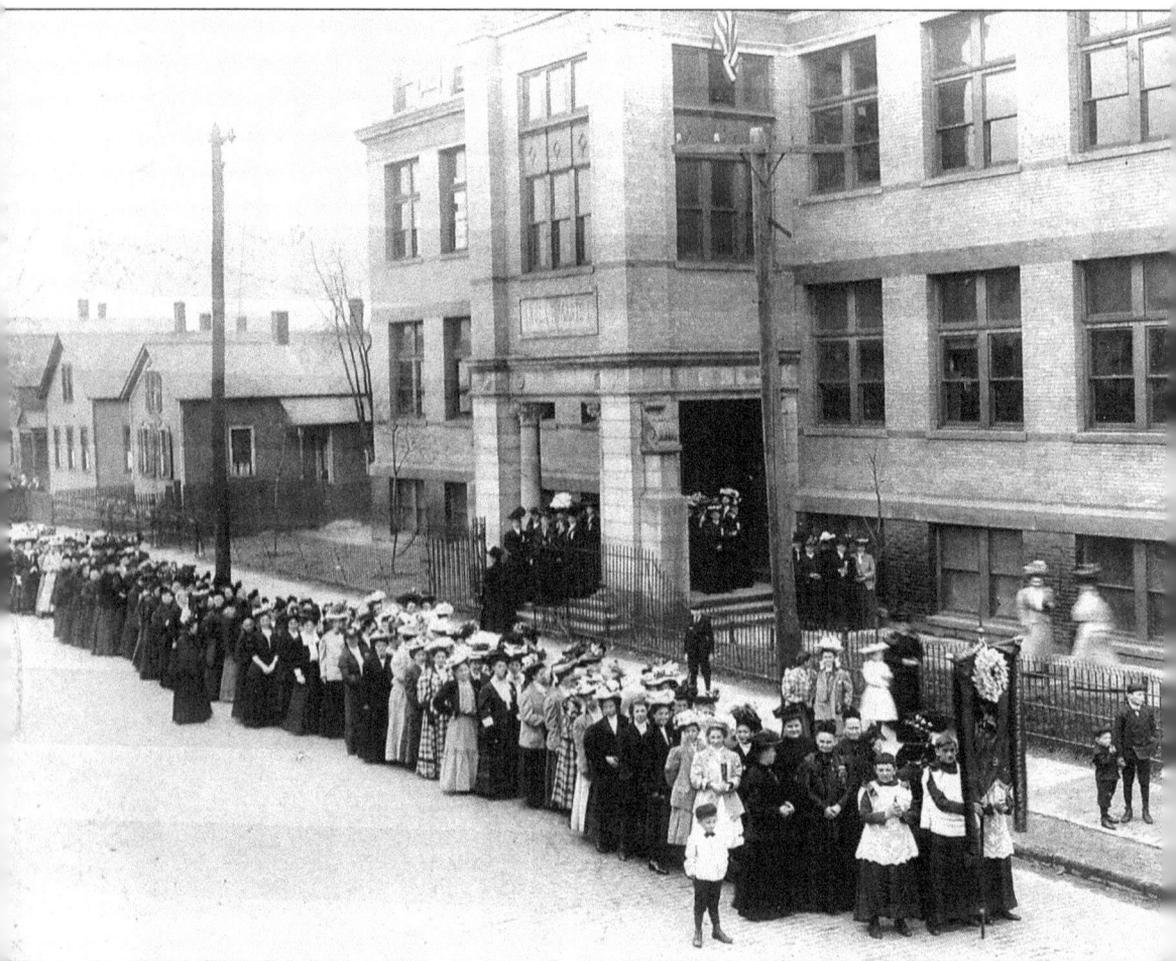

It is likely that this is a procession of the St. Agnes Society of the Czech Catholic Union into Our Lady of Lourdes Church. The society, which was headquartered at Our Lady of Lourdes, raised up to $13,000 for the parish during its early days. The St. Agnes Altar at Our Lady of Lourdes is dedicated to the society's patron, St. Agnes of Bohemia. It was said that when Agnes of Bohemia became a saint, Czechs would gain their freedom. This occurred in 1989, when Agnes of Bohemia was canonized, and the Velvet Revolution brought about the fall of communism in Czechoslovakia. (Courtesy of Our Lady of Lourdes Parish.)

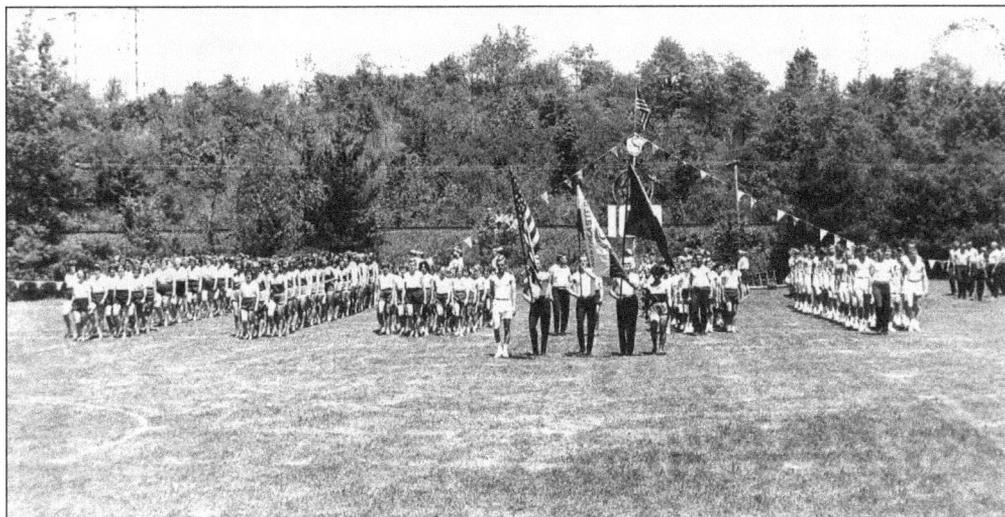

The Odd Fellows Fresh Air Camp in Glenwillow is often the site for gymnastics exhibitions, including this meeting of the Northeast District of the American Sokols. (Courtesy of Sokol Greater Cleveland.)

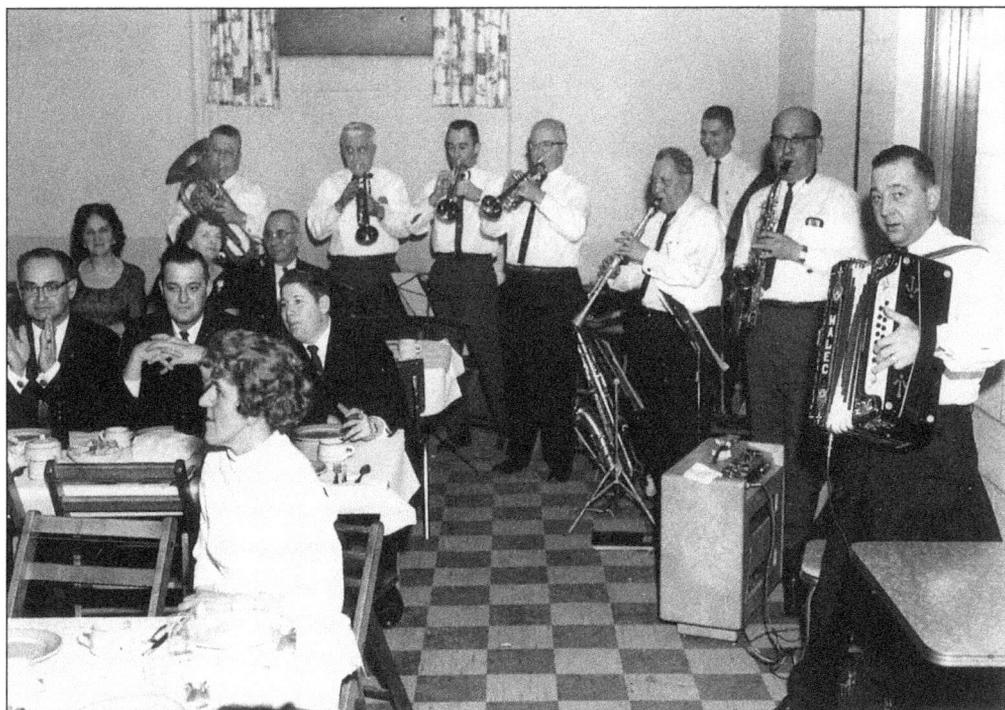

The Karlin Brass Band, directed by Emil Hronek and Frank Makovicka, entertained at a variety of venues including this fund-raiser for Cleveland Mayor Ralph Perk at the Association of Polish Women Hall on Broadway in the 1970s. (Courtesy of Joseph Kocab.)

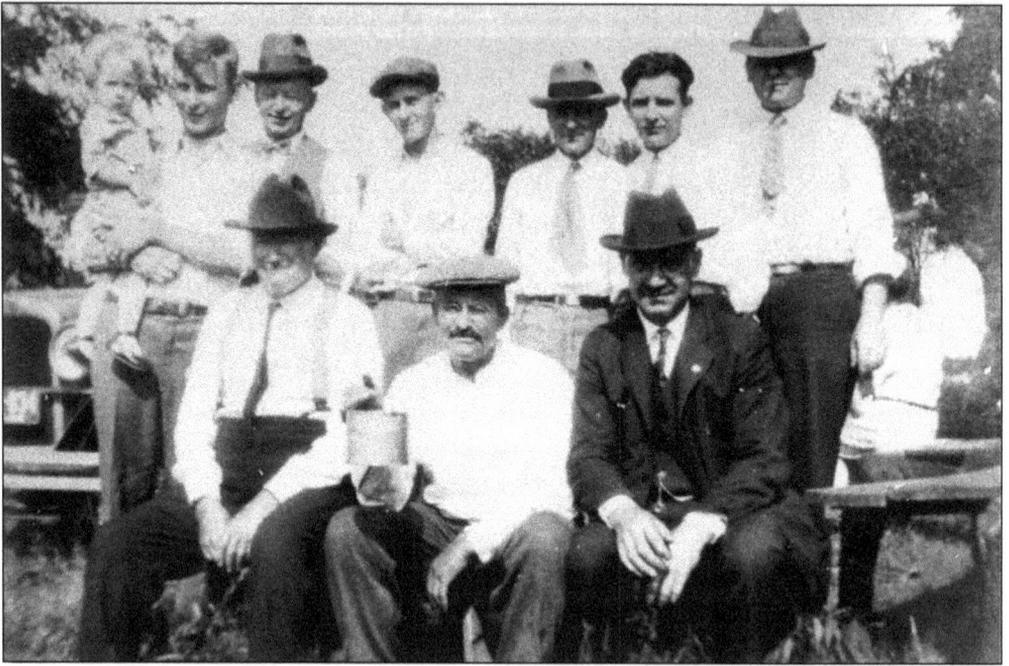

Members of the Kocab and Hronek families in Cleveland's Czech community are related, and as far back as the 1930s, they celebrated together at events such as this picnic at Chapek's (now Klima's) Grove in Cuyahoga Heights. (Courtesy of Joseph Kocab.)

One of the ways early Czech settlers kept their old-country ties was to form clubs such as the Bohemian-American Club, shown here at its first outing at the Divis Farm in July 1912. The farm possibly belonged to John Divis of Boston Township in Summit County. (Courtesy of Joseph Kocab.)

A large chunk of Cleveland's Czech neighborhood was taken in the 1950s for the Willow Freeway (later I-77). Two of the streets to disappear were Devoy Avenue and part of Vivian Avenue. Shown in the backyard at Vivian and Devoy Avenues at the September 1926 wedding of Helen Srnka and Edward Kocab are, from left to right, Theresa Moravec Kahoun, Julia Hajek, and a woman identified as Auntie Spevacek. (Courtesy of Ellen Howard.)

The Kahoun family gathers in a decorated basement to celebrate the 35th wedding anniversary of Charles F. and Theresa Kahoun (seated, center) in November 1948. Seen are, from left to right, (first row) Lillian Kahoun holding Bonnie Kahoun, Mary Fasko holding Jerry Fasko, Josephine McGlumphy holding Charlie McGlumphy, and Mary Janca Kahoun with Charles A. Kahoun; (second row) Jacob Fasko, Joseph Kahoun holding Joey Kahoun, Charles J. Kahoun, and Mack McGlumphy holding Walter McGlumphy. (Courtesy of Ellen Howard.)

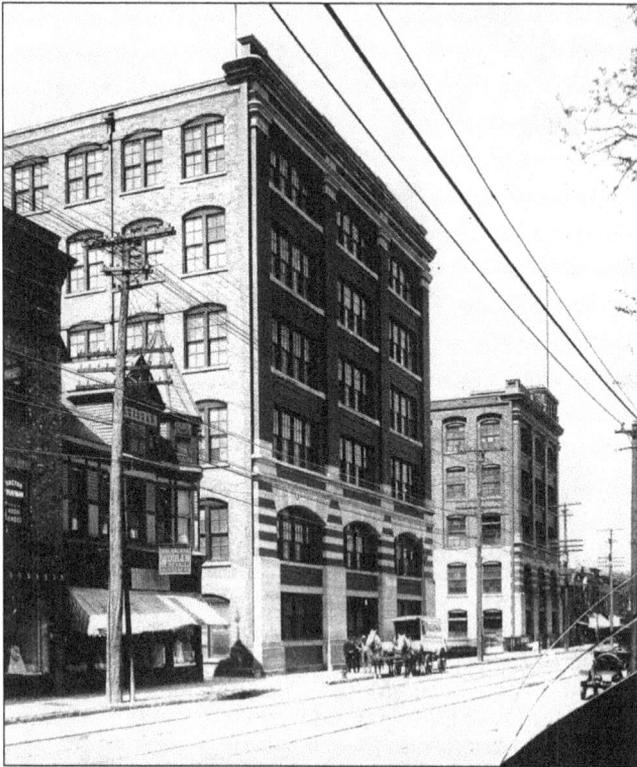

In the midst of the Zizkov Czech neighborhood, the Cleveland Worsted Mills stood as a community anchor and source of employment for many in the neighborhood. Located on Broadway between East 55th Street and Union Avenue, the mill produced mainly serge and gabardine fabric. The date of this photograph, made from a glass negative, is unknown. Note the horse-drawn milk wagon from the Telling-Bell-Vernon Company of Cleveland. (Courtesy of Cleveland Public Library/Photograph Collection.)

Helen Borski, director of the Cleveland Worsted Mills on Broadway, looks over the work of some of the women employees in 1949. The company employed Czechs and Poles from what is now called Slavic Village in Cleveland. After a bitter strike in 1956, the company's board voted to liquidate rather than unionize. The building, which became vacant, burned to the ground July 4, 1993. (Courtesy of Cleveland Public Library/Photograph Collection.)

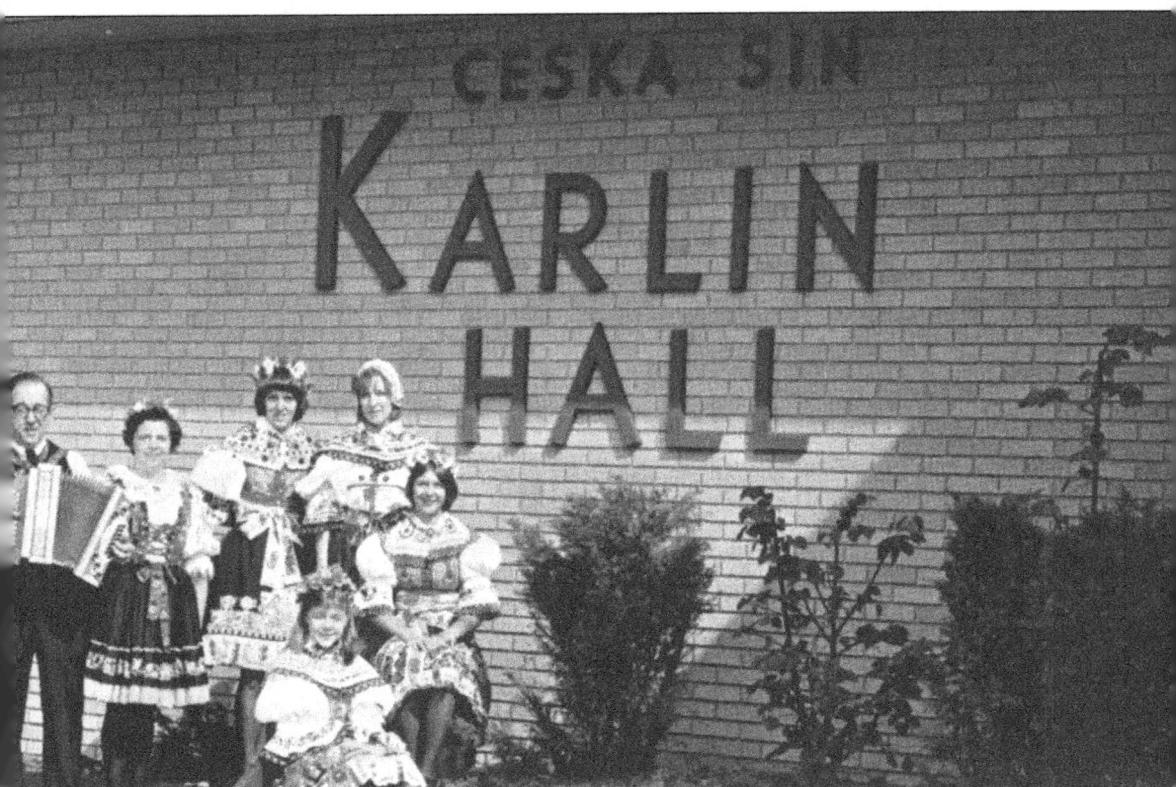

Ralph Malec on the accordion and a group of Sokol Dancers entertain in front of the newly dedicated Karlin Hall in 1973. At the right is one of the two Czech Linden trees (Lipy), brought from Czechoslovakia to be planted at the hall. The linden is the national tree of the Czech Republic. (Courtesy of Joseph Kocab.)

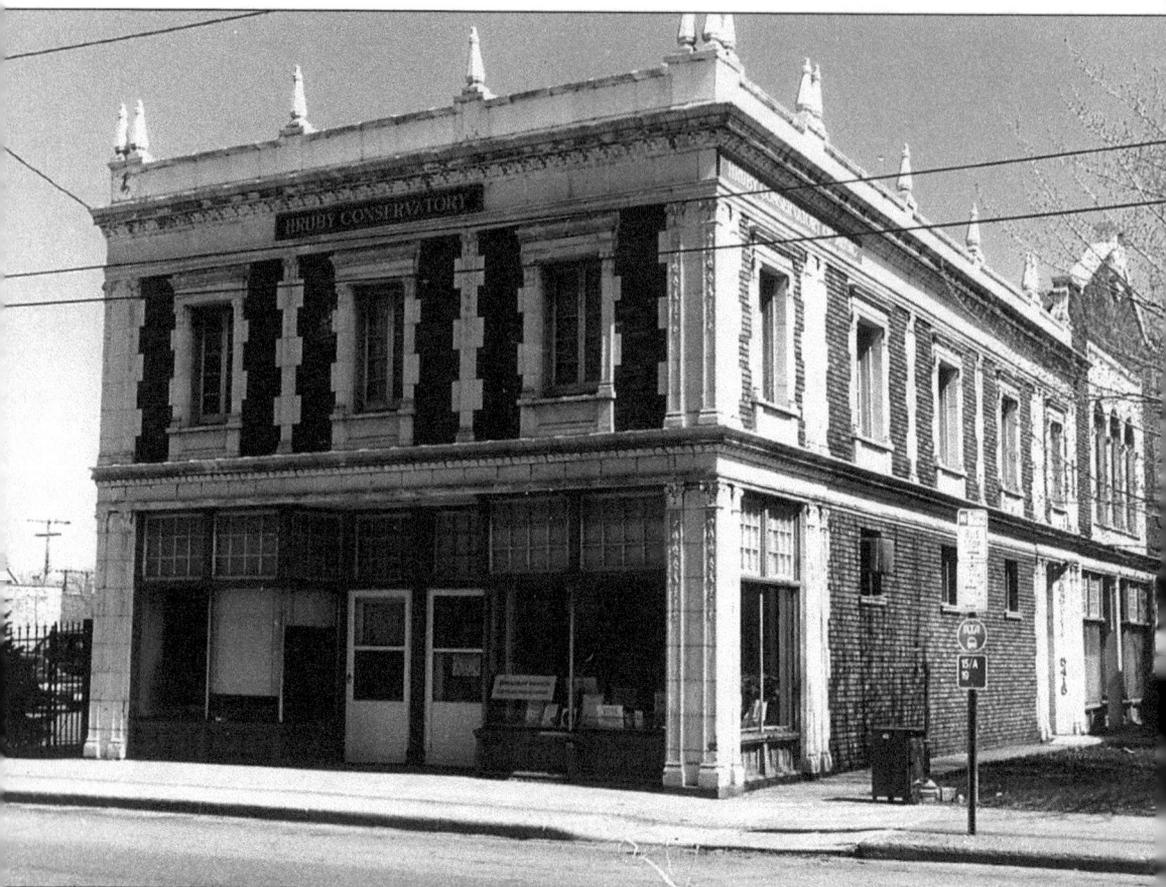

A landmark to this day along Broadway near East 55th Street is the Hruby Conservatory Building, where the musical Hruby family and other teachers gave lessons on musical instruments to generations of Clevelanders. The building was constructed by Dr. J. V. Kofron, whose daughter, Mary Rita, married Fred Hruby. It is said that Dr. Kofron had no objection to his daughter marrying a musician, as long as he stayed in Cleveland as a teacher rather than as a traveling instrumentalist. After opening the Broadway school in 1917, the Hrubys opened two more branches, and in total the conservatory had 25–30 teachers. The school closed in 1968. (Courtesy of Mary Kay Wisnieski.)

Ten

CHANGING TIMES

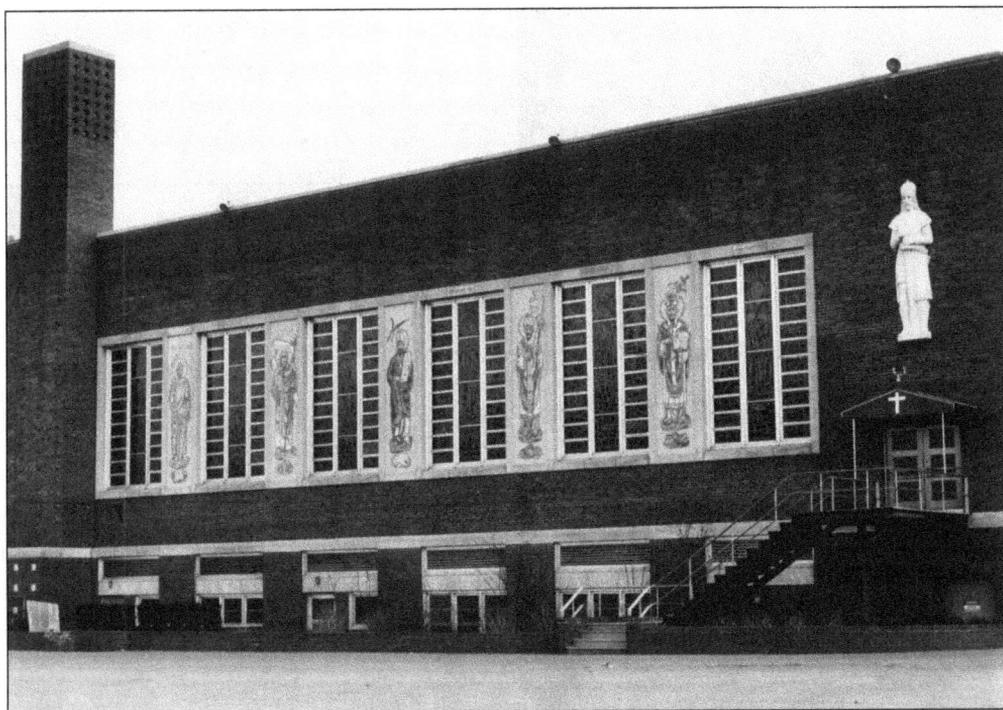

Around the end of World War I, a number of Czech families began to migrate from the older Czech neighborhoods to the Cleveland suburb of Maple Heights, newly established in 1915. Two resident clubs—the Clement Street Rollers and the Arch Street Howlers—competed to raise money to establish a Catholic parish in the new neighborhood. The two clubs became the Maple Heights Catholic Club, and St. Wenceslas in Maple Heights was established at Libby Road and Cato Street in 1923. To differentiate it from the Czech mother church, the Maple Heights church was spelled without the *u*. (Courtesy of Cleveland Press Archives—CSU Library Special Collections.)

The Maple Heights St. Wenceslas community was served at first out of a frame chapel heated by two pot-bellied stoves. For a while some parishioners worshipped at the second St. Wenceslaus church on Broadway in Cleveland. This resulted in the parish being the only Catholic parish in Cleveland to be served by three church buildings at once—the original church on East 34th Street, the big church at East 37th Street and Broadway, and the new church off of Libby Road in Maple Heights. Altar boy Joseph Straka is shown outside the door of the Maple Heights church in 1938. (Courtesy of John Straka.)

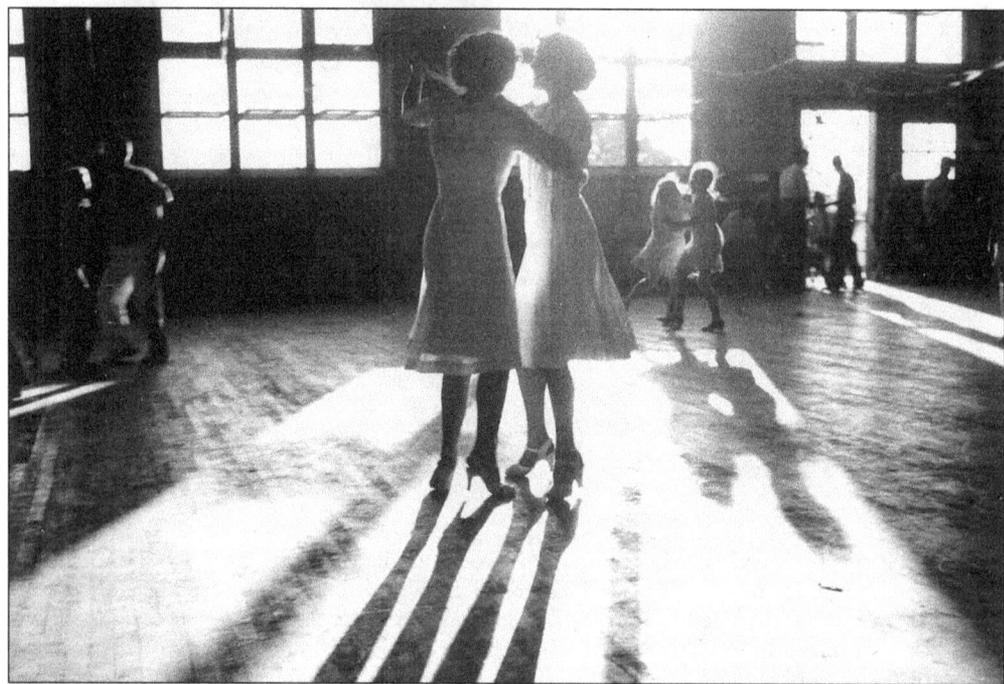

St. Wenceslas quickly became the center of the suburban Czech community as the site for many weekend dances. Shown here is a dance that took place probably in the late 1930s in the St. Wenceslas social hall, which later became the church. (Courtesy of John Straka.)

There is no doubt, though, that the early St. Wenceslas neighborhood in Maple Heights was truly Czech, as a group of Czech ladies gathers in a basement, stripping goose feathers to make a comforter in 1939. (Courtesy of John Straka.)

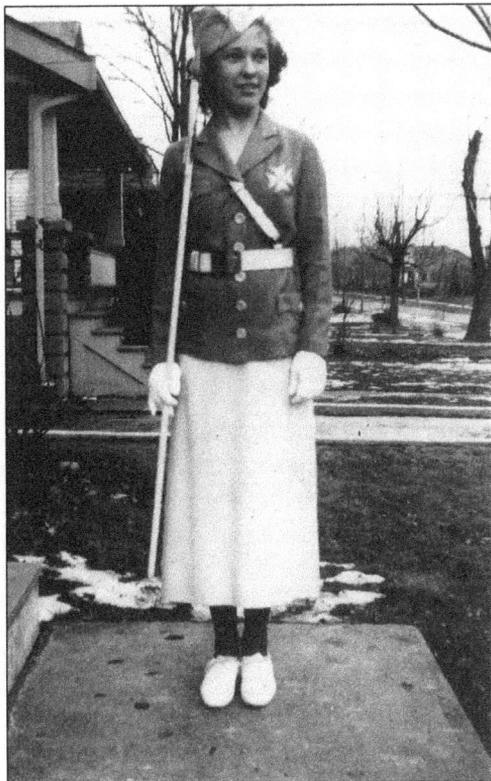

On Christmas Day 1936, Mildred Straka posed in her uniform for the Auxiliary of the Knights of St. John at St. Wenceslas in Maple Heights. The parish had still retained much of its Czech character; although that would change as the neighborhood changed to a more cosmopolitan area. The parish eventually became territorial. (Courtesy of John Straka.)

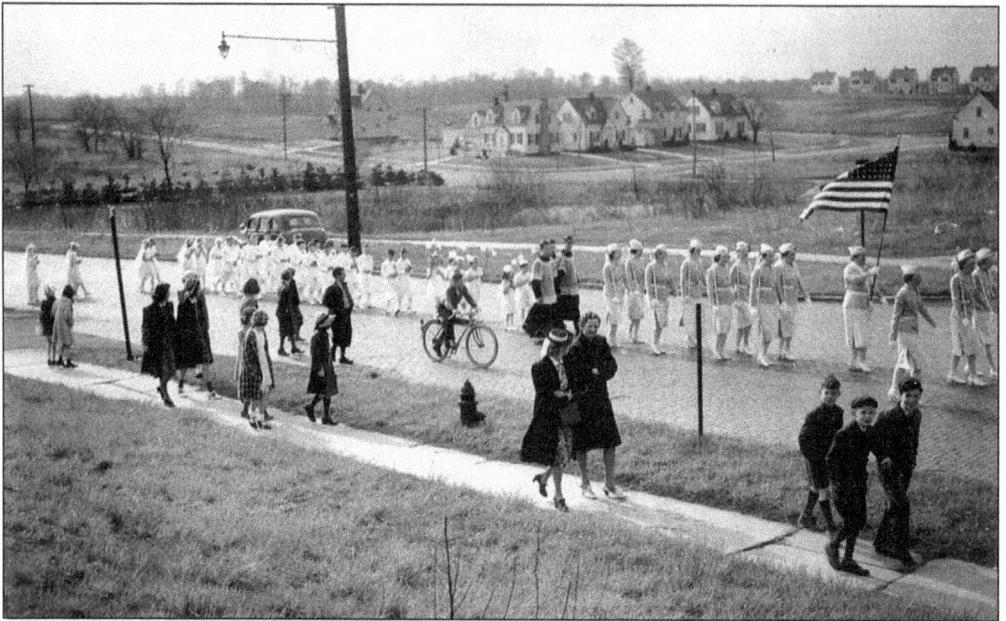

Building and expansion in Maple Heights did not begin in earnest until after World War II, but the St. Wenceslas Czech community still thrived. Shown here is a St. Wenceslas First Holy Communion procession along Libby Road in May 1940. The community, which thrived through the 1950s, saw its Catholic population dwindle. The parish eventually closed in 2008. (Courtesy of John Straka.)

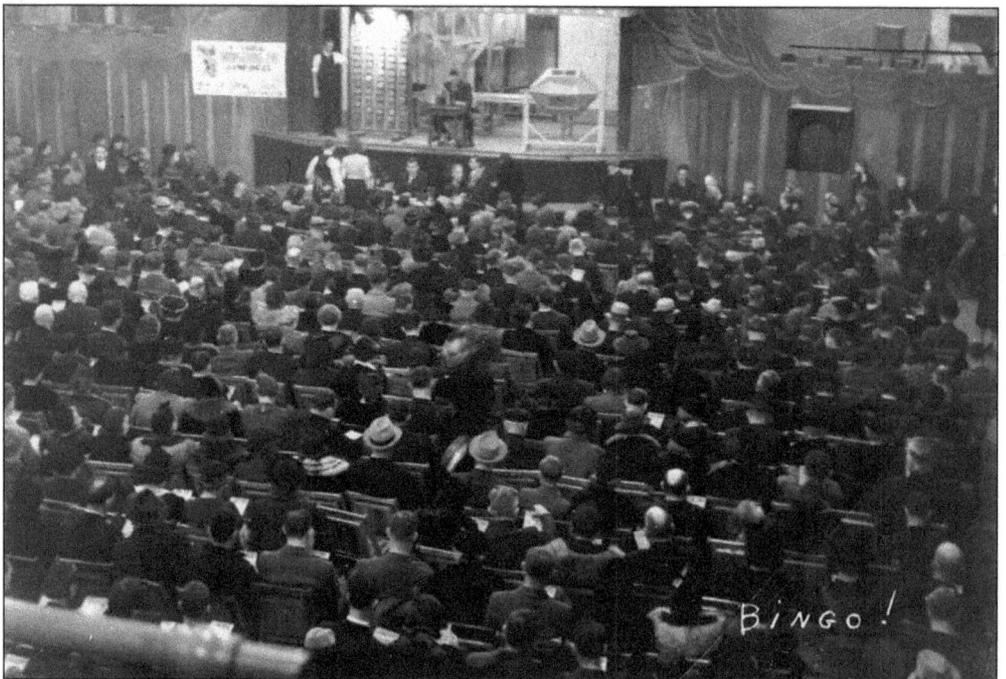

This space at St. Wenceslas parish in Maple Heights was used for a variety of events. In 1939, it was crowded with bingo players. It would eventually become the church. The bingo caller at the time was long-time parishioner Joe Kunesh. (Courtesy of John Straka.)

Fr. James Mosovsky, administrator of St. Wenceslaus parish at East 37th Street and Broadway, points out the statue of the Holy Family—Jesus, Mary, and Joseph—shortly before the church closed in 1963. The statue was moved to the motherhouse of the Sisters of St. Joseph on Rocky River Drive in Cleveland. During its final months, parishioners who had since moved away crowded into the church on Sundays for one last chance to worship there. (Photograph by Tony Tomsic; courtesy of Cleveland Press Archives—CSU Library Special Collections.)

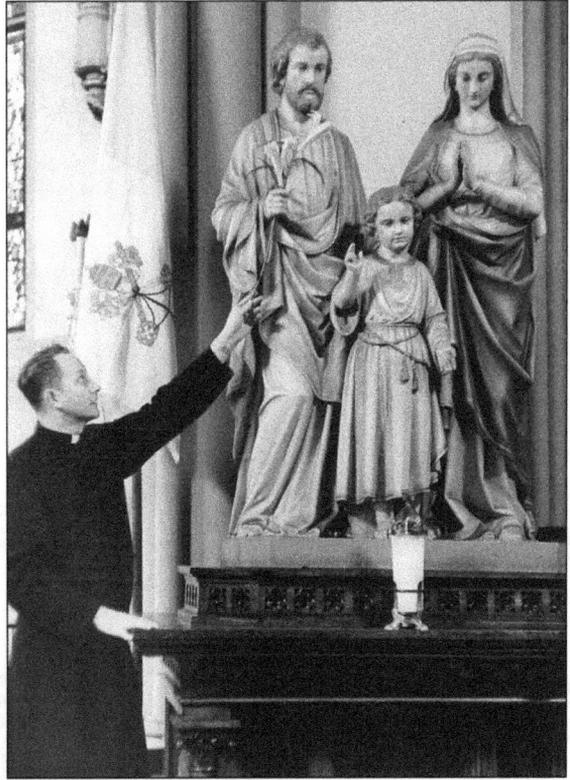

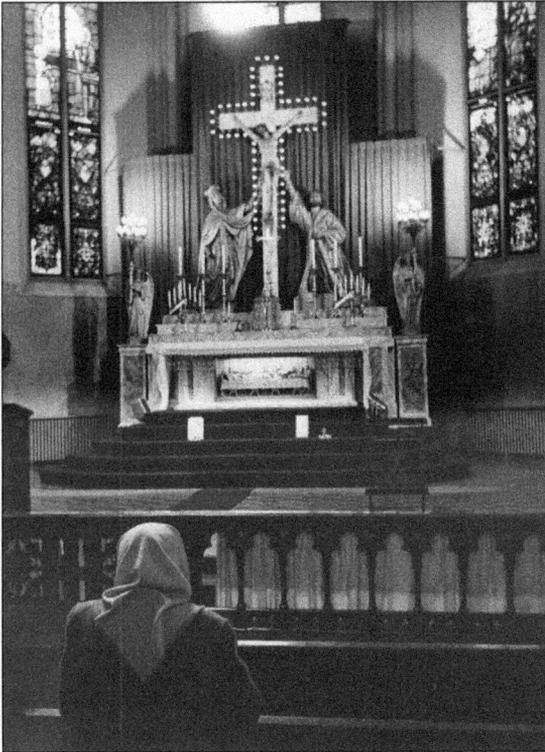

A lone parishioner prays before the main altar at St. Wenceslaus Church, shortly before it was closed in 1963. For those parishioners who stayed till the church's closing, it was a difficult time. The church had been an anchor for the original Czech community. From 1867 until its closing, St. Wenceslaus Church was the site of 16,274 baptisms, 4,496 confirmations, 4,640 first communions, 2,695 marriages, and 4,631 burials. (Photograph by Tony Tomsic; courtesy of Cleveland Press Archives—CSU Library Special Collections.)

Time and the interstate highway system finally caught up to Cleveland's oldest Czech neighborhood in 1963—about 100 years after it was first settled. Most of the houses and business in the North Broadway area are gone, with St. Wenceslaus Church, shown in the distance, being the 465th structure to be razed for what would become the I-77/I-490 interchange. (Photograph by Tony Tomsic; courtesy of Cleveland Press Archives—CSU Library Special Collections.)

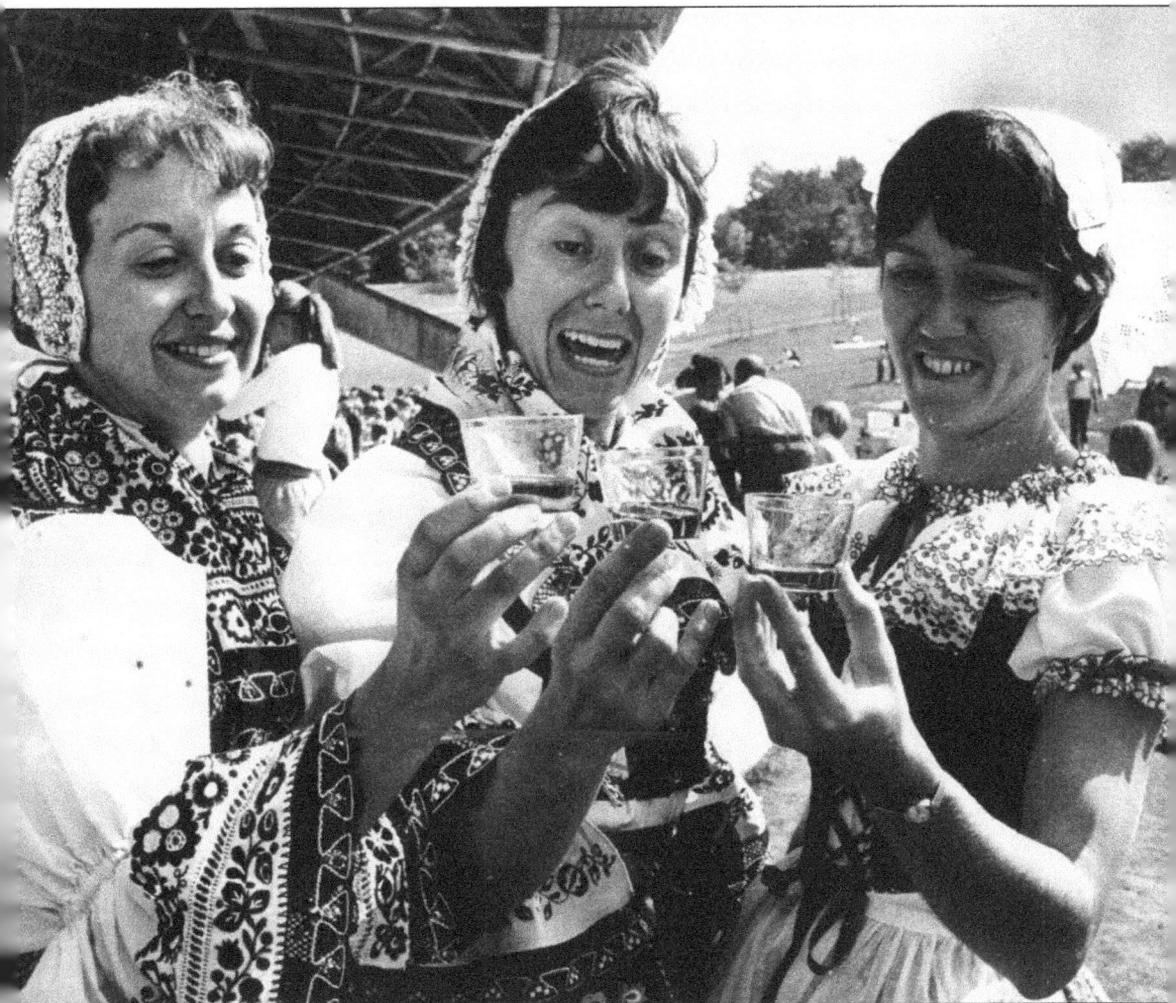

For Cleveland's Czechs, good times are always where they are. And toasting good times with Czech wine at the Blossom International Festival at Blossom Music Center in 1973 are, from left to right, Dolly Baca and sisters Jean Dusek and Marian Peterka. (Courtesy of Cleveland Public Library/Photograph Collection.)

Visit us at
arcadiapublishing.com

www.ingramcontent.com/pod-product-compliance
Lightning Source LLC
Chambersburg PA
CBHW080613110426
42813CB00006B/1495